THE NEW SPIRIT
OF WATERCOLOR

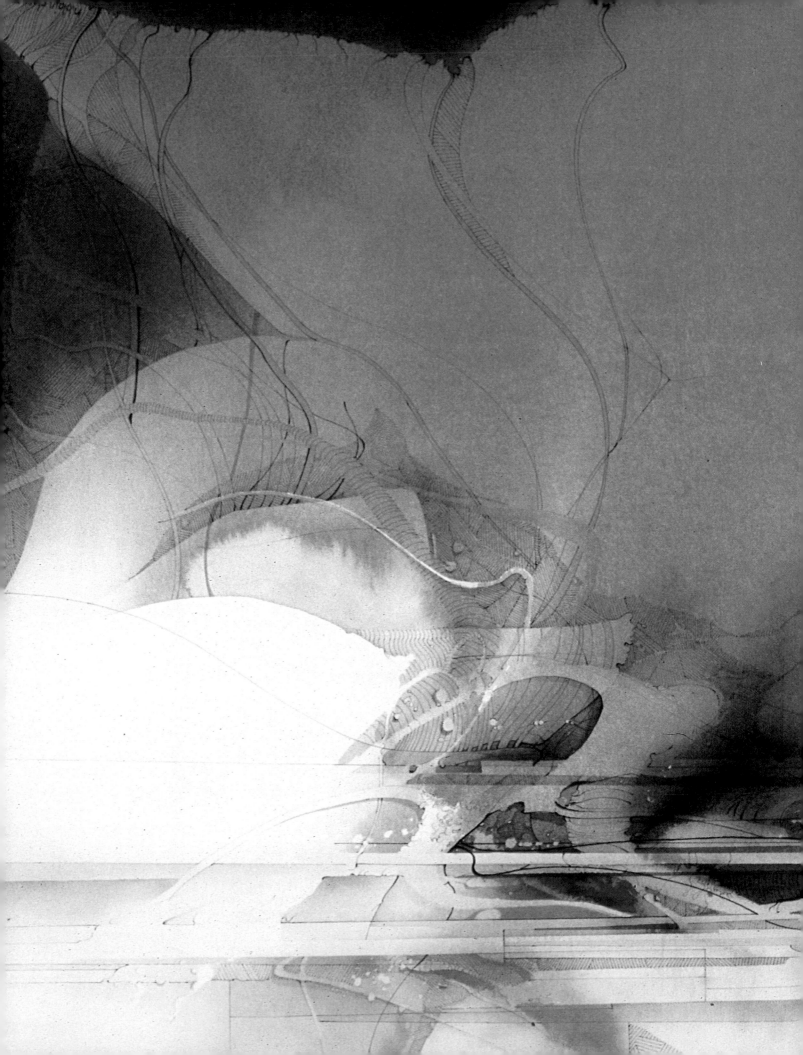

THE NEW SPIRIT OF WATERCOLOR

MIKE WARD

NORTH LIGHT BOOKS

Cincinnati
Ohio

About the Author

With degrees in art, English, and education, Mike Ward began his career by teaching at the secondary and college level before becoming a freelance writer. Working as an editor of *Art Material Trade News* helped hone his knowledge and expertise of artists. In 1984 he became the editor of *The Artist's Magazine*, which has enabled him to survey the work of thousands of watercolorists across the country, studying their working methods and techniques up close. You'll find the results of years of experience in this book — a selection of the most intriguing ideas and concepts in watercolor today.

The New Spirit of Watercolor. Published by North Light, an imprint of F&W Publications, 1507 Dana Avenue, Cincinnati, Ohio 45207. First paperback printing 1991.

Manufactured in Hong Kong

95 94 93 92 5 4 3

Library of Congress Cataloging-in-Publication Data

Ward, Mike
 The new spirit of watercolor/by Mike Ward.
 p. cm.
 Includes index.
 ISBN 0-89134-410-1
 1. Water-color painting — Technique. I. Title
ND2110.W37 1989
751.42'2 — dc19 88-26807
 CIP

Editor: Greg Albert
Associate Editor: Mary Cropper
Designer: Clare Finney

Acknowledgments

Landscape watercolor sketch and colored pencil sketch of a cat copyright © by Cathy Johnson. Used by permission of the artist.

Sunrise, Sunset (collection of the artist) and Moon Dawn (collection of IBM) copyright © by Carol Lyons. Used by permission of the artist.

Inlets of the Sea, Coastal in Red, This Good Earth, and Mountainscape copyright © by Carole D. Barnes. Used by permission of the artist.

Red, Light, & Blue and a chart of overlapping colors copyright © Barbara K. Buer (1072-11 Lancaster Blvd., Mechanicsburg, PA 17055 717/697-6505). Used by permission of the artist.

Summer Wind copyright © by Pat Mahony. Used by permission of the artist.

Peony Thrust and a Luma watercolor dye chart copyright © Allison Christie. Used by permission of the artist.

Ode to Eden Park, Growth Patterns, and Hidden Birds copyright © by Joan Rothel. Used by permission of the artist.

Seastone Series, Dancing on the Green, and Rites of Spring copyright © by Elaine Harvey. Used by permission of the artist.

Wheeling Ave., Words Not Spoken, Keeper of Time, Frosty Morning copyright © by Mary Beam. Used by permission of the artist

Hammock at Narragansett, St. Augustine Evening, Houses by the Sea, and After the Fair, copyright © Barbara Santa Coloma. Used by permission of the artist.

Born of the Sun, Knock on Silence, Wintry Forms, One Fine Day and Winter Bloom copyright © by Avie Biedinger. Used by permission of the artist.

Big Red Canna, Magnolia in Sunlight, Essence of Bromiliad, Protea and Rattan, Par Terre Gardens at Woodlawn, Red Silk and Butterfly, Teatime and Van Gogh, and The Artist's Magazine Color Charts copyright © by Barbara Thelin Preston. Used by permission of the artist.

Spoons, Dark Shadows, Plum Good, and A Van Gogh Collection copyright © by Pat Malone. Used by permission of the artist.

Mexican Dancer copyright © by Oscar Velasquez. Used by permission of the artist.

Eccentricities, Alla Tedesca, Double Fugue, Kirlian Suite #7, Pangaea, and Paper Fugue copyright © by Joseph Way. Used by permission of the artist.

Mountain Crest, Time of Frozen Tears, and Summit copyright © by Judy Richardson Gard. Used by permission of the artist.

Florida Sunset File, Grand Larceny, and New Snow, Boston Mills copyright © by Miles Batt. Used by permission of the artist.

Foxfire, Evening Glow, and three acrylic sketches copyright © by Margo Bartel. Used by permission of the artist.

Sea Wall, Amalgam, Garden Memories— now in private collections—and Emergence—collection of the artist— copyright Marilyn Hughey Phillis. Illustrations by permission of the author.

Splash (collection of Mr. & Mrs. Harry S. Frazier, Jr.) and Outer Banks Revisited (private collection) copyright © Sara Roush. Used by permission of the artist.

Streaking Towards Home copyright © by Janice Pollard; used by permission of the artist. Criss-Crossing Paths copyright © by Janice Pollard; courtesy of Zimmerman/ Saturn Gallery, Nashville, Tennessee.

Tree Forces #3, Charcoal Sketches #1 and #2, Tree Forces #2, a color chart, and a photo of her studio by Lois Schroff, copyright © 1985 Newlight Books (911 Elden St., Herndon, VA 22070). Used by permission of the artist.

Golden Pond, Memory, Secrets of the Universe IV, and Secrets of the Universe II copyright © by Barbara Osterman. Used by permission of the artist.

Palm Patterns #102, Palm Patterns #104, Palm Patterns #85, and Palm Patterns #125 copyright © by Edith Bergstrom. Used by permission of the artist.

Distance Fantasy, Arizona Strata, and Spendrift copyright © by Nancy Livesay. Used by permission of the artist.

Camouflage Series: Painted Lady #5, Hybrids #2, and Pool Series #6 copyright © by Donald K. Lake. Used by permission of the artist.

Sea Garden (collection of the artist) and After the Spring Rain (private collection) copyright © Joan McKasson. Used by permission of the artist.

Autumn Confetti (private collection) copyright © 1987 and Magnolias (private collection) copyright © 1987 by Susan McKinnon Rasmussen. Used by permission of the artist.

Paper Smoke and two photos showing his drybrush technique copyright © 1988 by Gary Akers. Used by permission of the artist.

B.C. Coast copyright © 1988 by Amy Storey. Used by permission of the artist.

Winterized (private collection of the artist) copyright © 1986 by Roland Roycraft. Stormy Seas (private collection of the artist) copyright © 1986 by Roland Roycraft. The Lone Fisherman (private collection of Barton and Constance Erickson) copyright © 1986 by Roland Roycraft. Anticipation (private collection of the artist) copyright © 1987 by Roland Roycraft. Used by permission of the artist.

Two pencil, watercolor and gouache portraits; a pastel, ink, and gouache painting; a marker, colored pencil, and ink painting; Tarpon Springs Gulls, and Tarpon Springs II copyright © by Paul Melia. Used by permission of the artist.

Ocean Series: Deep Blue, Float, Aquarium, Stingray and Hidden Conch II copyright © by Nanci Blair Closson. Used by permission of the artist.

Underwater Rocks (collection of the McAllen State Bank, McAllen, Texas) Fourth of July, and Cocks Comb (both collection of the artist) copyright © by Diane Peters. Used by permission of the artist.

Santa Fe Weaver I (collection of Ike and Suzanne Kalangis), Conversation in the Park (collection of Claude and Kay McCausland) and Harp in the Window copyright © J. D. Wellborn. Used by permission of the artist.

Contents

3
IMAGINATION
Take Ideas to the Limit

4
NEW TRADITIONS
New Effects from Familiar Tools

5
TECHNICAL INNOVATIONS
More Mediums for Your Message

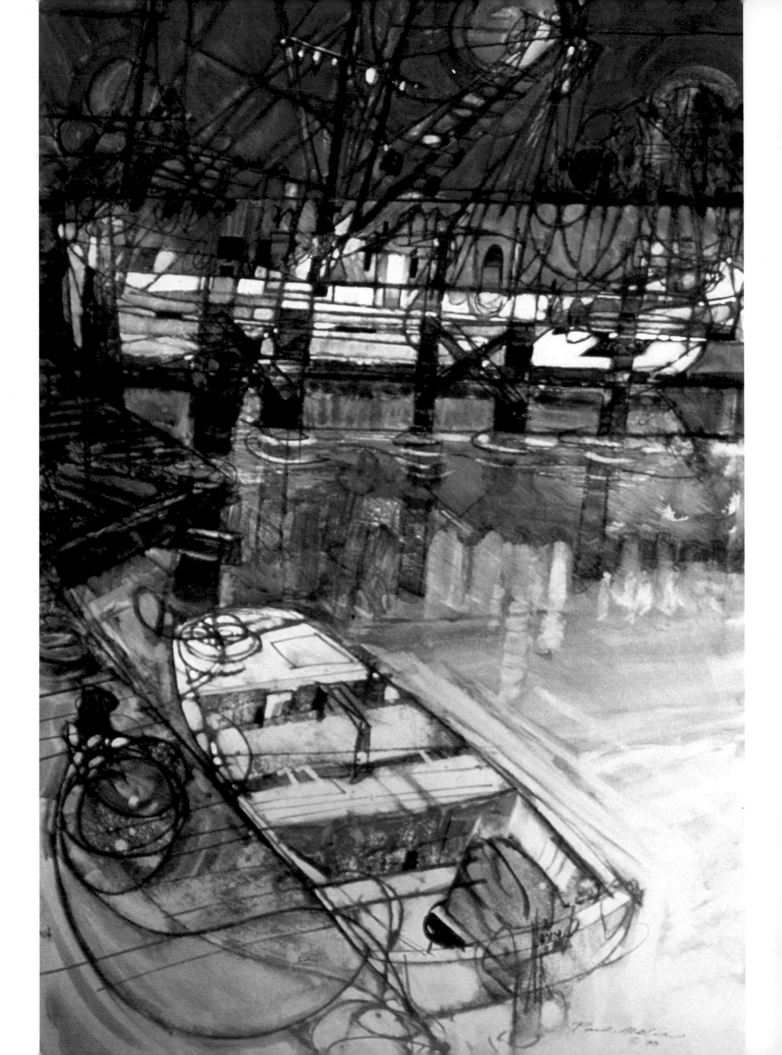

M A T E R I A L S

1

Finding Your Roots

Before you can begin to match your vision to the medium itself, you need to know watercolor intimately—as well as you know your family, friends, and, most important, yourself. What exactly is watercolor? How does it react, and why? How thin or thick can it get? How opaque or transparent? How luminous or glowing? The answers to these questions will encourage a way of thinking that will help you make your own creative leaps, discover new ways of painting, and match your vision to the medium itself. They're the basics that can be manipulated and "pushed" to make watercolor say what you want it to say.

In this chapter we'll look at some of the characteristics, such as the unique color, texture, and transparency, of watercolor and how you can use them. But first take the time to remember how it felt when you first started to work with watercolor. Kick back a little, try to recapture that feeling of endless possibilities. Or if you still enjoy that sense of awe and wonder, get set to enjoy that feeling to the fullest. And if you've just reached that uncomfortable point where you've learned a lot but still can't get what's in your head down on your paper, ease up on yourself.

Whatever mode you're in, try this trick to loosen yourself up. Get out your paints, brushes, and paper and just play a little bit. Mix some washes, brush on some color, slide it around, scumble it on different surfaces, rub it with your thumb, scratch it with your fingernail. Do anything and everything you've ever tried—or just wanted to try, no matter how weird it seems. See what watercolor does under different conditions. Enter into a relationship with it, but don't do all the talking yourself. Let it speak to you at times, and let it guide your hand and your thinking.

Tarpon Springs II by Paul Melia (30x40)

Transparency

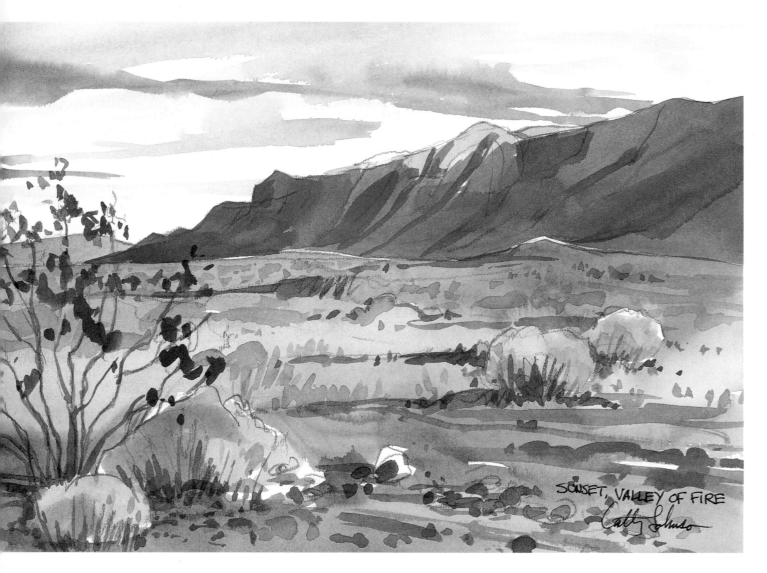

SUNSET, VALLEY OF FIRE

In this quick watercolor sketch, Cathy Johnson first used a pencil underdrawing to locate the major shapes and allowed the lines in some areas to remain part of the finished work. To capture the effect of late afternoon light, she used a simple color scheme, with strong, cool shadows and warm, red-glowing sunlit areas. She first applied initial washes of transparent watercolor, but in various densities. Compare the distant light-blue mountain on the left to the right side of the foreground mountain. Each area was made lighter or darker by the density of the wash. When that was dry, additional, thicker washes were added in calligraphic strokes to describe the scene. On the dry paper, these heavier marks show up clean and distinct.

A thin layer of dry watercolor on your paper is, by its very nature, transparent (some colors, of course, more than others) for several reasons. First, the pigment particles are not of a high concentration. Second, the pigment layer on your paper is very thin. And third, some of the pigment is actually absorbed by your paper.

Pigment particles themselves are generally not of a very high concentration when suspended in water and binding agents. As the water evaporates, what's left is a very thin layer of pigment held together and slightly locked onto your paper by the gum

arabic binder. If there's a higher proportion of pigment in the watercolor mixture, your wash will appear denser and darker, with more pigment left on the paper.

You can use this way to control transparency (as well as value and color): adjust the ratio of paint to water when you mix your washes. The more water you mix with the paint, the thinner and weaker the wash will be when applied to your paper, and fewer pigment particles will be suspended in the water. Or you can let your wash dry in puddles and end up with higher concentrations of pigments in those areas, which means a darker color and, in some cases, texture, too.

The pigment layer that dries on your paper is very thin. On the other hand, the thicker the mixture, the more opaque it will be. Arne Nyback, a California watercolorist, is one of the few painters who works with watercolor in a more opaque fashion in order to capture the thick, velvety feel of flowers. Although even dark passages of pure watercolor will retain some amount of transparency, this can be reduced by applying layer after layer of color, as Nyback often does.

Most watercolorists work on white paper (or perhaps, in some cases white gesso paper) because watercolor allows light to filter through the pigment layer, strike the white paper fibers, and reflect back through the thin layer of pigment. This produces brilliant tints and shades of color without the addition of white or black paint. The light comes from the paper itself, and this is the hallmark of watercolor painting.

When mixing your washes, just remember that they'll look much darker and more color-saturated when wet; watercolors generally dry a bit lighter in value and color. So if you're flooding your paper with a beautiful blue sky, don't be afraid to saturate your wash with paint and start with a deep hue.

In addition, some watercolor paints

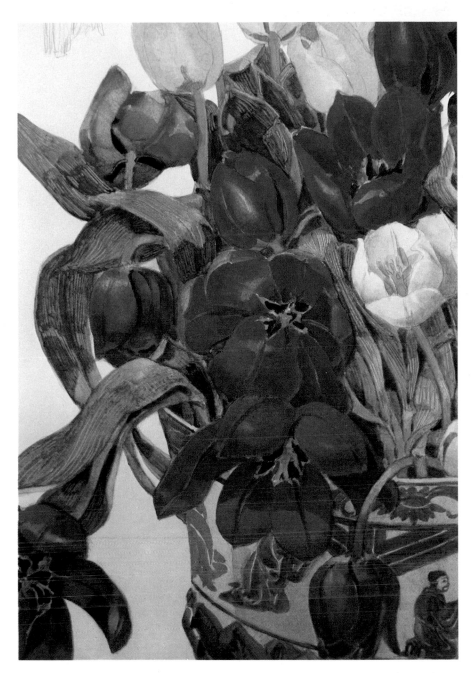

This detail from watercolorist Arne Nyback's painting on page 117 shows the various levels of transparency he created in the same painting. He started the velvety flowers by applying thin washes of color, as in the upper section of this detail. But by adding layer after layer of color, sometimes in increasing density, he made the transparency slowly wane while building a rich opacity, which formed an interesting contrast between transparent and opaque areas. The light, "solid" areas of the vase are built up with layers of opaque gouache. (See pages 114-117 for more details on Nyback's technique.)

by their very nature are more transparent than others. Noted watercolorist Cathy Johnson pointed out the problems this can cause: "Have you ever wanted to cover an area heavily to get a solid mass, only to find that the pigment you chose looked as transparent as Salome's veil? Or, conversely, when you wanted your underpainting to shine through, did your paint obscure it completely?" Like Johnson, Nyback is very aware of the role transparency and opacity play in his paintings and has made a careful study of the effects of different colors.

"In general, the inorganic earth colors—yellow ochre, raw sienna, burnt sienna, and burnt umber—are the most opaque, while the organic compounds—carbon-based pigments such as alizarin crimson, phthalo blue, and phthalo green—are more transparent. And there's a whole range of in-betweens: For example, the cadmium colors are generally quite opaque, as are sap green and cobalt blue—two important colors in my palette. Test your own palette for opacity by brushing a stripe of each color over a band of India ink.

Another way Nyback brings greater opacity to his paintings is his use of Chinese white. "Some watercolorists scoff at the use of opaque white, but it's important in my work for building convincing heaviness and opacity. The white of the paper doesn't have the same weight as the rest of my painting, so I build the white as much as I build the other color areas. Sometimes the white areas in my paintings have as many as fifteen layers of paint on them.

"Chinese white is a 'dead' white; that is, by itself, it produces a flat, opaque surface. But when mixed with other colors, it becomes less dense (but still adds heaviness). Chinese white, when used alone, can also cover a flaw or define large negative spaces. And when combined with other colors, it sometimes looks even more solid than it does by itself, because it becomes less flat."

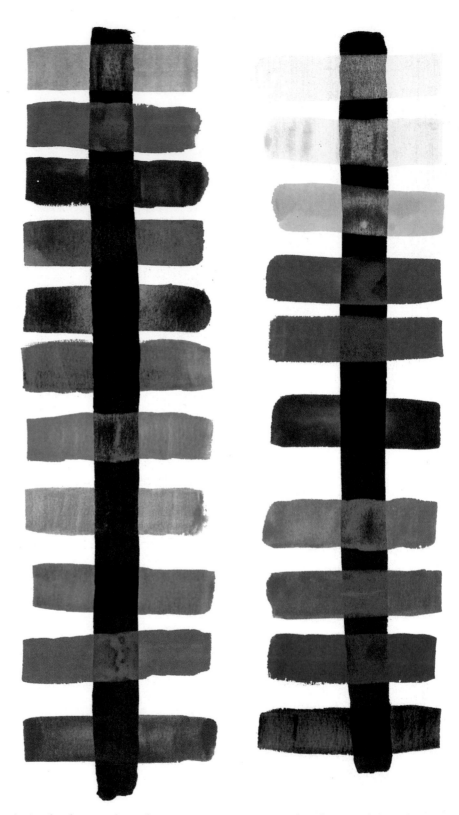

A simple chart such as this one can serve as a quick indicator of the relative transparency or opacity of a particular color on your palette. To create your own guide, paint a 1-inch band of India ink on a piece of paper. After it has dried completely, apply a wash of each of your colors over the black band, cleaning your brush well between each application. Some will cover it almost entirely, and some will appear to vanish against the black. This will show you the relative transparency of colors at a glance.

Sedimentary and Staining Colors

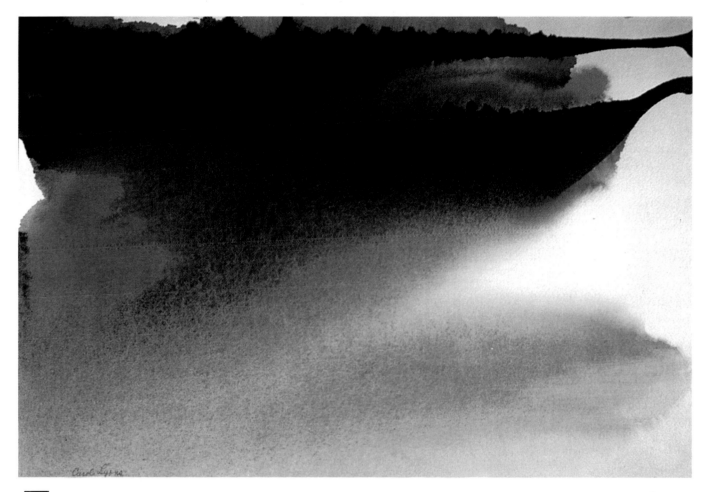

The he process of brushing on washes and allowing them to dry in layers doesn't explain all of the unique looks that watercolor paint can take on. You'll also need to think about the characteristics of each particular color you use, to create new and interesting effects. Most paints in general are made from pigments derived from a number of sources—earth compounds, minerals, and carbon compounds, among others (including some good synthetic pigments). The colors made from these pigments generally fall into two categories: sedimentary colors and staining colors. Each reacts differently when applied to paper, and unique results occur when these colors are used in various combinations.

Sedimentary colors are usually the earth colors—yellow ochre, raw sien-

Watercolorist Carol Lyons made use of sedimentary colors and other techniques to produce the spontaneous flow, rich color, and texture in Sunrise, Sunset *(24x30). The orange hue was poured on the paper first—a mixture of vermilion, cadmium yellow medium, and raw umber, all sedimentary colors. On wet paper, the pigments spread and diffused in areas. While this was still wet, Lyons poured a mixture of Prussian blue, lamp black, and a touch of ultramarine from the upper-left corner. The light-blue areas were created as the pigments in the mixture separated, some staining the paper, the rest granulating in the dark area. In the central section, the blue dispersed and separated over the wet orange wash, creating dramatic textures.*

When applied to wet paper, the sedimentary pigments disperse and granulate, creating interesting textures. Here you can see the grainy nature of the pigments.

na, burnt umber, burnt sienna, ultramarine blue, cerulean blue, manganese blue, cobalt blue, and most of the cadmium colors. Together, these colors create a great palette of browns, blues, and grays. When you apply a wash of one of these colors, you'll find that the pigments are coarser and a bit grainier than other watercolors. Because of this coarseness, the paint has a tendency to sit more on top of the paper and to be more opaque than other watercolors. The pigment particles can create interesting textures and can settle onto your paper with greater and lesser density in certain areas, depending on how you apply the wash and with what tools.

Because these pigments are grainy and tend to sit more on top of the paper, they can be lifted right off your paper easier than most other colors. In some instances, you can remove them altogether by scrubbing with a wet brush or sponge. Susan McKinnon Rasmussen has found that colors such as cerulean blue, French ultramarine, cobalt violet, and yellow ochre do lift back to white, but the cadmiums may resist complete lifting.

Because it can become resoluble with the addition of water even after it's completely dry (the sedimentary colors are especially prone to this),

watercolor is completely unlike other paints except gouache. When oil paint, for example, is completely dry, you can glaze over it with color, scrub over it with turpentine, or do just about anything to the surface without changing the quality of the painting very much.

The best part about the lifting character of sedimentary colors, then, is that after you start your painting you can work back into an area with a wet brush and scrub lightly to soften the edges of shapes or the color and value of large areas. You can also just move the paint around a bit to make the pigment particles settle in various areas, creating patterns of texture, depending on how much pigment was left on the paper.

But now comes the drawback. There are times when you're simply in love with the wash you've applied just the way it is, but you'd like it to be a bit darker. So you let the wash dry and then try to add another darker wash over top. As you brush it on, you find that the first wash is lifting and absolutely ruining those lovely paint textures and patterns.

To avoid this problem, you first need to be sure that the area is totally dry. Then, mix your color into the density wash you want and use a large, soft brush to apply the additional glaze in one light, swift pass

over the color. Don't get in there and start scrubbing or overbrushing the wash—just use one swift, wet pass, and let it dry. This way, you'll have better luck in glazing (that is, adding additional washes) over areas that you want to darken or whose color you want to change, while saving the original texture, graininess, and quality of the original wash. It takes a bit of deft brushwork, but give it a try.

The other broad category of colors are the ones made with staining pigments. These include alizarin crimson, sap green, and the phthalo colors. Unlike the sedimentary colors, when mixed with water and brushed on paper, these colors will soak into the tooth and fiber of the paper and will in effect "stain" it. The pigments in these colors are much finer than the sedimentary colors, so your washes will produce a much more even, saturated layer of color. These colors are difficult, if not impossible, to lift or remove from the paper, but that's not all bad. With the staining colors, you can apply one wash over another without the first wash lifting very much. By doing this, you can create very subtle or dramatic changes in the color, intensity, and value of a given area.

But just because I've noted two separate categories of watercolor doesn't mean that you have to use them separately. In fact, some of the most interesting results can be made by alternating washes of staining and sedimentary colors or by mixing them together into new washes of color. Cathy Johnson has noted that some interesting atmospheric effects can be made by mixing together staining and sedimentary colors.

"The staining colors may spread to form a halo around the heavier-textured settling colors," she says, adding, "A wash of staining color is good for your first layer or underpainting and then should be allowed to dry completely. Then, when you glaze over this with a sedimentary color, the paint will form hazy, foggy effects."

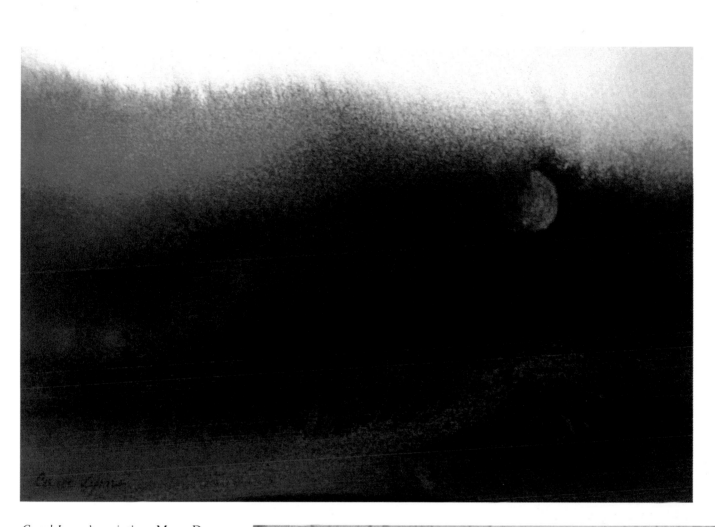

Carol Lyons's painting, Moon Dawn (11x14), was done by pouring various sedimentary colors onto wet paper, taking great advantage of the pigments' natural reactions. But because of the "liftability" of sedimentary colors, she was able to render the moon dramatically, without having to save its light value with masking or liquid frisket. That semicircle was lifted by using a wet bristle brush and gently scrubbing the area. The yellow, staining wash still shines through, and the texture that remains is created by the granulating pigments left in the valleys of the paper's tooth. With a gentle touch, Lyons lifted pigment only from the ridges of the paper.

In this detail from Roland Roycraft's painting on page 121, you can see the clear, atmospheric effect of painting with washes of pure staining color. The color soaks into the paper fiber, leaving a transparent, textureless tint that Roycraft used to depict atmospheric distance.

Permanency

Harp in the Window *by J.D. Well-born (30x22)*

*B*ecause watercolors dry to such a thin transparent layer of color on your paper, the tinting strength and lightfastness of the pigments become very important. Even slight changes in a color's hue or intensity can adversely affect the look of your painting. Manufacturers, such as Winsor & Newton, Grumbacher, and Liquitex, use a four-point rating system for judging the lightfastness of colors. These generally divide colors into extremely permanent, durable, moderately durable, and fugitive.

Fugitive colors can present a real problem for preserving your artwork, as they fade rather easily. However, according to Grumbacher's catalog, "Many of these colors can last indefinitely, if they are protected from high levels of direct light." Overall there are really only a handful of them; some to watch out for are carmine, mauve, rose carthame, rose madder and Vandyke brown. It's best to check the tubes of watercolor that you buy for ratings printed on the labels. And in general, use the best watercolors you can afford.

Grumbacher System

"*Extremely permanent colors* (the designation on the tube is ****) are totally lightfast."

"*Permanent colors* (***) are normally lightfast but can be damaged by extreme exposure to sunlight, and weak tints or thin glazes might eventually fade."

"*Moderately permanent colors* (**) are generally lightfast when un-thinned, but tend to fade slowly in thin glazes or when tinted with white." Avoid exposure to direct sunlight, high levels of incandescent light, or unfiltered light from fluorescent lamps.

"*Fugitive colors* (*) will fade, but may be suitable for commercial art created for reproduction."

Experiment with Other Mediums

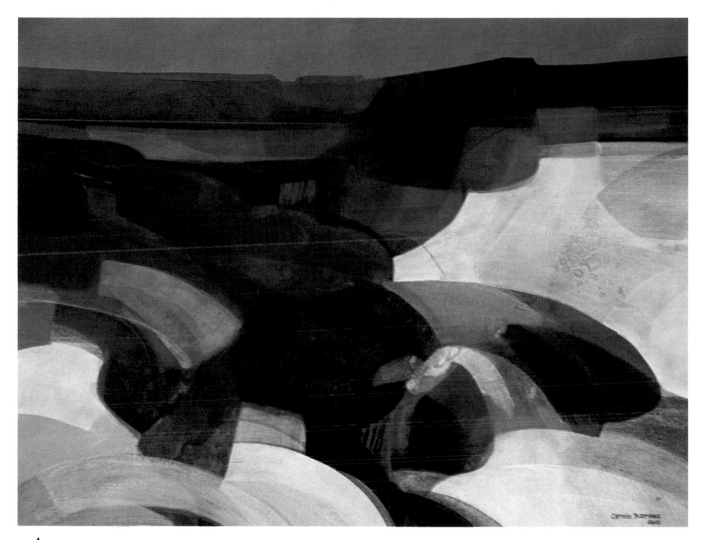

A traditional watercolor painting is made only with layers of pure, transparent watercolor and nothing else. Period. Paintings of this type have a definite look that has characterized watercolor painting from the start. But limiting yourself to only transparent watercolor can be confining, to say the least, not to mention downright irritating. If your first love is transparent watercolor, fine. But if your imagination is running rampant, or you're envisioning paintings simply with a different look than traditional watercolor, you'll probably want to experiment with one or all of the following mediums in combination with watercolor.

The most important criterion in de-

Inlets of the Sea (28x34), by Carole Barnes, was painted with acrylics on watercolor paper. When mixed thinly with water, the paint produces washes of color that flow, run, intermix, and absorb or settle onto the paper much like watercolors but dry into water-resistant layers. In the upper portion of the painting, you can see the deep darks you can get with acrylics. Thin transparent washes can also be overglazed for layered atmospheric effects, as at the horizon line. In addition, opaque white and other colors can be added for more mottled effect, as in the lower-left section. Alcohol, however, is a solvent for acrylics and can be used to lift and move paint that is bone dry. It must be handled very carefully, as it will easily lift several layers with the lightest pressure of a cloth.

Because acrylic washes dry to a water-resistant film, you can build up numerous layers of color to slowly deepen the value and intensity. Here, Barbara Buer has overlapped ten layers of the same watery acrylic wash to demonstrate this buildup.

termining what goes with watercolor is whether *you* like it. Here we'll only talk about how each medium works with watercolor on its own. This doesn't mean that you have to use watercolor and only acrylics, or watercolor and only colored pencil. The fact is, any combination of the following mediums is possible. In painting, it's a good idea to have an entire range of materials at your disposal. Then, as you work, let the painting tell you what it needs—a touch of gouache to brighten the light, a pastel stroke for definition and color accent, or a really dark acrylic shadow, for instance. The idea, to paraphrase a quotation, is to match the medium to your personal vision and message.

Acrylics as Watercolor

A good number of artists today are trading in their watercolors for acrylics—or at least a few select tubes here and there. And for good reason. Acrylic paint is probably the most versatile form of color made today. Most of the acrylic paintings you've probably seen fall into a couple of categories: those that are hard-edged abstractions done in bright colors that have a very plastic look and feel to them, and those that resemble traditional oil paintings in technique. In fact, when acrylics first came onto the art scene, they were touted as an economical water-based substitute for oils. Well, it's taken acrylics a good long time to live down that reputation. Besides, acrylics are not a very blendable paint because of their fast drying time, and making them look like oils takes fast brushwork, a good amount of preplanning, a ton of patience, and trial and error.

Actually, acrylics more closely resemble watercolors than oils in their working characteristics. Just squeeze a dollop of acrylics from the tube and mix it with a fair amount of water and you'll create a wash with much the same qualities as watercolor. You can mix washes in a great range of colors and values, and the tinting strength and transparency of

acrylics is excellent. But when a wash of transparent acrylic is applied to paper, it soaks into the fibers like watercolor or dyes and dries into a nearly waterproof film, making it extremely durable and permanent.

You can use various mediums to modify the texture and brushing consistency of acrylics. If you add only water to your acrylics, you will get paints that act like traditional watercolors. You can also add gloss or matte mediums to create effects completely different from watercolor. These additives give you a new control of the brushing qualities of your paint, unusual luminosity of color, and surface finish. Gloss medium will give the colors an inner light like a varnished oil painting. Both it and matte mediums give a thicker texture to your brushstrokes, creating interesting passages in your painting. Acrylic medium can be used by itself to create a variety of effects or as a tool for collage.

Barbara K. Buer has provided an excellent list of reasons for using acrylics:

1. With transparent acrylics you can glaze over and over because the washes made with acrylics stay put; you can scrub on additional glazes (subsequent washes) without disturbing the underlying paint layers.
2. Because of this strong adhesion of acrylics to paper you can build up wonderfully deep, rich darks by applying glaze after glaze of color.
3. With acrylic glazes you can build up your darks in two effective ways. (See her discussion of these.)
4. Like watercolor, transparent acrylics can be lifted from the paper while wet. If allowed to dry, they can be partially lifted with the aid of a short bristle brush, water, and a paper towel for blotting.
5. If you're patient, you can white out an area with white acrylic and repaint it so that even the most critical eye will have a tough time spotting the reworked area.
6. You can also resoak and re-

You can create the same luminous, transparent glow that you get from watercolors by glazing with acrylics, which is also somewhat easier to do. This technique is especially useful for depicting sunlight through flower petals. Here's how Buer does it:

Step 1: "In this first step, I did an underpainting with watery acrylic washes. The underpainting redefined the basic drawing, outlined the foreground areas (as well as those areas which remained white), and blocked in the background color shapes."

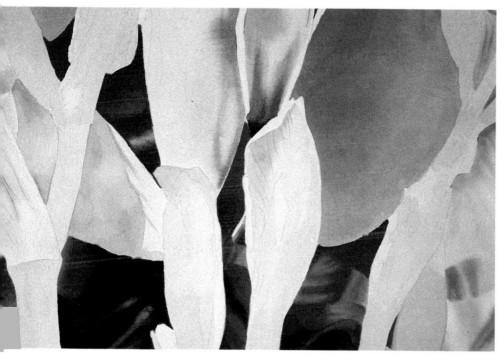

Step 2: "I then built up the background reds by glazing over the underlying yellow and orange washes. In addition, I painted the dark shapes into the reds, maintaining soft, transitional edges by first rewetting the reds. Remember—with acrylics you can rewet time and time again without disturbing the underlying work."

stretch the finished painting to achieve a perfectly smooth paper surface for matting and framing.

7. And on the practical side, acrylics can be cleaned up from a porcelain tray with a little hot water and a sponge. And the big tubes of acrylics go a lot farther than those little tubes of watercolor!

Getting deep darks just right with watercolor can be an incredible challenge, but the buildup of value and color you can achieve with acrylics works beautifully. Barbara Buer gives two ways to achieve this: "One, you can mix a wash of the exact color you want on your palette, then apply numerous glazes of this wash until the color and value reach the desired depth.

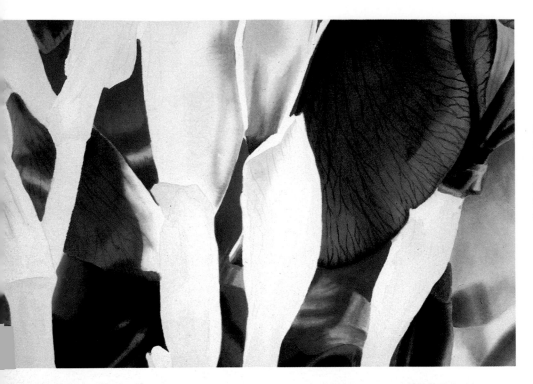

Step 3: "After establishing the brilliance of the background reds, I proceeded with the purple petals. I retained some pink wherever I thought the red poppies could be seen through the transparent purple petals of the iris."

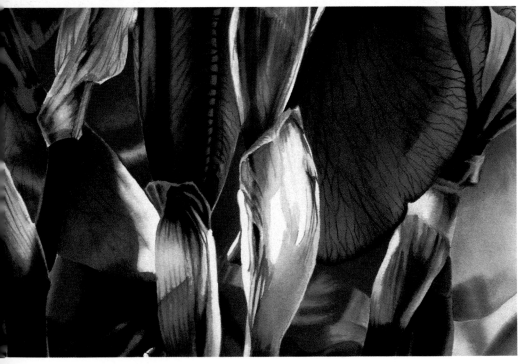

Step 4: "One of the most crucial steps was the execution of the backlit stems of the iris and capturing the sunlight as it passed through the paper-thin calyx (the leafy, protective covering) and bounced off the glossy stems. All of the linework in the calyx, bud, and petals was done by incising the paper with a knife and allowing the pigment to 'float' into that line to create a delineation of shapes."

"The second method is to break down the color into its component parts—for instance, yellow and blue to produce green. Then, simply apply one wash of pure color over another; each successive transparent glaze will change and deepen the color right on the paper itself. This method gives you almost infinite control. If the glaze mixture is laden with pigment, the color and value will deepen quickly. But if the glaze is very thin and watery with little pigment content, the buildup progresses slowly, with infinite possible variations in color and tone."

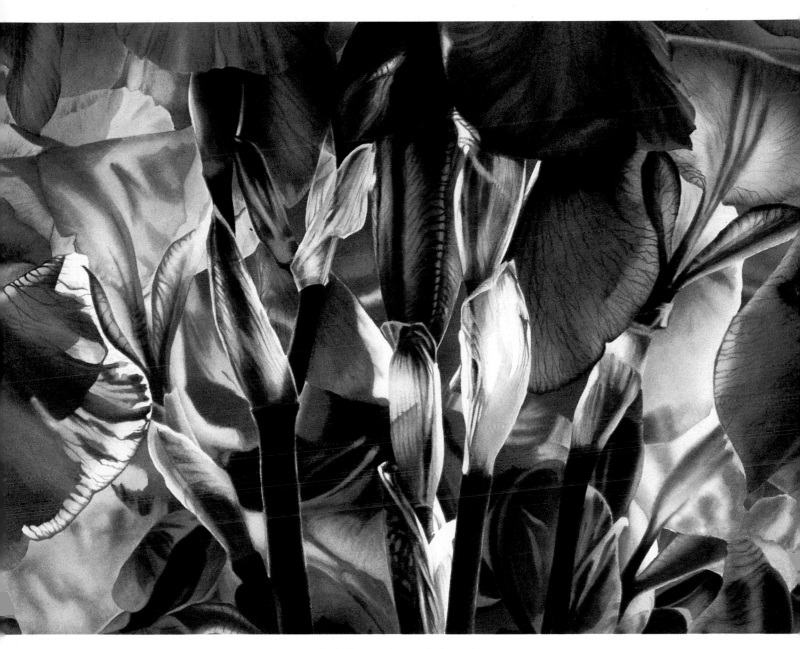

Step 5: *"I was very aware of the need for the dark shapes that trail through the lower portion of the composition, holdling up and tying together the vertical lines. These dark shapes were just as important to the total look of the piece as was capturing the sunlight and flowers' transparency. The result: Red, Light & Blue, 22x30."*

This detail from Pat Mahony's Summer Wind *(18³/₄x22¹/₄) shows how smoothly gouache and transparent watercolor can work together. There's a marvelous contrast between the opaque and the transparent passages.*

Gouache

Gouache (sometimes referred to as "opaque watercolor" or "designer's colors") is essentially an opaque, water-based paint. It is packed with enough pigment, and in great enough density, that it creates an opaque effect. "In such cases," says one art materials expert, "white has to be added to the paint to bring out its color; otherwise some of the shades are likely to dry dark and dull. . . . A small addition of white also makes it much easier to lay down a flat area of color that shows no brush marks." Some of the colors manufactured for reproduction work are extremely fugitive and should not be used for pictures intended to last. Check the la-

bels carefully before you buy and, if you've any doubt, consult your local art supply dealer.

So what does this all mean when talking about watercolor? First of all, gouache will mix with watercolors. In most instances, the binding agent in gouache is a gum (gum arabic or perhaps cherry gum), the same as in watercolor, making both paints mixable and water soluble. Excluding the addition of wetting agents or other fillers, you're basically bringing together two forms of the same paint, but one with much more finely ground pigments in a higher concentration. However, unlike watercolor, it is possible to work from dark to light with gouache, adding white on

the palette to lighten the paint instead of thinning it with more water as with traditional watercolor. It's also important to remember that gouache will appear a little darker when it's dry than when it's wet—just the reverse of transparent watercolor.

Gouache is a very versatile medium. You can use it like transparent watercolor or in thicker layers, even a heavy impasto. You can apply it right out of the tube and even mix colors right on the paper. Different tools create completely different effects; try applying it with a brush, a palette knife, even a comb! From the tube or only slightly thinned, it lays flat and matte, creating interesting contrasts with your watercolors. Finally, gouache is a paint noted for its remarkable capacity for detail. Consider using gouache for details, small shapes and accents—touches of opaque color that might enhance or create an interesting texture and surface to your painting (these can also be reinforced with pen and ink sketching over the gouache).

Gouache dries rapidly and covers well, so it can also be used to white-out small areas of a painting in order to redo sections—a nice opportunity when working with watercolor. But gouache is a kind of paint that remains soluble in water even after it's dry. Hence, you won't be able to do too much painting over the top of it; a few passes of lightly brushed watercolor would be about it. Otherwise, the paint will lift and mix, resulting in more milky tones and textures. (Of course, you may deliberately do that to see what kind of effects you can create.)

Some artists also mix gouache with watercolor to create opaque shades and tints of color. Basically, the more gouache you add, the more opaque your color will become. As you read and look through this book, you'll notice quite a few innovative watercolors that include gouache. From an aesthetic standpoint, using gouache means controlling the balance of transparent and opaque areas in your

painting. It seems most often that an equal distribution of the two results in a painting that has a strong allegiance to neither, whereas one overall look would do better to dominate.

Metallics

Metallic paints are not new, yet they're now providing intriguing light-reflecting properties for artists who work with water-based mediums. Artists Joseph and Elaine Harvey incorporate various types of metallic paints and pigments into their work. Harvey has discovered many reasons for using them:

"Metallics can give a very innovative, contemporary feeling to one

Marilyn Hughey Phillis's Sea Wall *(30x40) is another excellent example of gouache combined with watercolor. Phillis maintains a careful balance between the opaque and the transparent, allowing the transparency of the watercolors to dominate the overall look of the painting.*

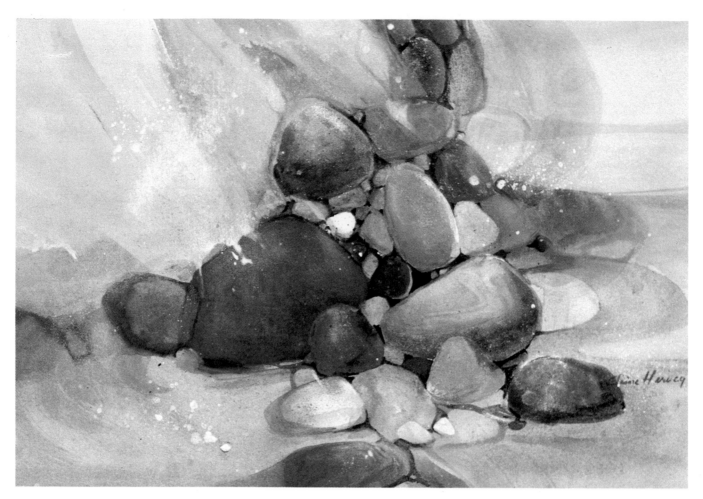

In painting Seastone Series *(30x40), Elaine Harvey used a combination of watercolor, acrylics, and powdered bronze pigments. She started by defining the basic forms with staining watercolors and then swirled thin, opaque washes of white acrylic throughout the painting. (Harvey pointed out that the white acrylic will lift the watercolor in some areas, depending on how it's brushed on.) In selected areas, such as the shadowed side of rocks, she brushed dry bronze powder into wet paper, which helps hold the powder in place. Then she added additional glazes, sometimes moving and pushing the powder with her brush. She also added spatterings of alcohol, which make the acrylics and the powder bead up, revealing the underlying layers of color and creating rocklike textures. Final washes and spatters of color were applied over the metallic areas that had been sprayed with fixative to hold them in place.*

painting, yet a time-honored, religious feeling to another. And yet to another it may impart a magical, fairy-tale quality. The 'metallic' touch is very useful, and can be achieved in several ways and types of paints/pigments.''

Metallics, Harvey further explains, are available in a wide range of media: ''Acrylics: Gold, silver, copper and iridescent acrylic paints are available. I use them slightly thinned with water in direct painting and also considerably thinned as an underpainting for watercolor. Used this way, they give a subtle shimmer to the painting, discernible through several layers of watercolor. For this latter technique, I mix the acrylic paint very thoroughly with water until it is thin enough to brush on in a smooth wash. Sometimes I use the same thin mixture over the watercolor, brushing very lightly to avoid disturbing the underlying layers of paint. Of course, the same glaze can be used over any acrylic paints. These metallic layers can be textured by spraying with al-

cohol or water. They can be allowed to drip, spatter, etc. All these textures will show through the overlying watercolor to some extent, giving interesting creative effects.

"Gouache: This is available in a variety of metallics. Because it lifts off the paper very easily, it's not very useful as an underpainting. However, it can be glazed over other colors, textured, and has the virtue of being more correctable than acrylics.

"Powdered Pigments: Several companies make metallic powders, variously called 'metallic watercolor,' 'bronze powder,' 'copper powder,' and so forth. They are finely divided particles of metal and should be treated with respect. They are a health hazard if inhaled, so I use a particle mask (or, in a pinch, a silk scarf over my face) when I use them. I also work with them outdoors whenever possible; this helps avoid having a thin layer of metallic dust all over the studio. Even with all these drawbacks, metallic powders are still worth using because of the wonderful surfaces they can produce. They can be applied in a number of ways:

1. By dipping a wet brush into the powder and then painting on the paper.
2. By brushing them on dry and then texturing with alcohol or sprayed water.
3. By brushing on dry and applying paint over them (mixing on the paper).
4. By pouring on heavily in a dry state and allowing the dry pigment to drift down the paper before texturing or applying fixative.

"The possibilities are endless. But so are the opportunities for disaster! My advice is to practice on something not precious, then paint through any unexpected results, turning them into new techniques. And, be extremely careful not to endanger your health by inhaling or ingesting the powders.

"Collage Metallics: Metal leaf

sheets may be added to a painting as collaged materials. These can be partially covered with paint or other sheer papers. Again, the glazes of paint can be textured. I apply collage materials with thinned acrylic medium. If this medium is just the right consistency, it will still allow me to use watercolor as well as acrylic paint over it. Of course, watercolor will not brush smoothly over the slick metallic surface, but it will tint it slightly. Acrylic paint or gesso will completely cover the metal leaf or rice paper if desired. Metal leaf is difficult to handle; it's best to get it on the paper in the general shape and area you want, then push it around with the brush until it pleases you. For me, this is not a precise process but an experimental one, producing results I could not have anticipated.

"Metallic Inks. A few metallic inks claim to be permanent. They are available in metallic pinks, blues, yellows, as well as gold, silver, and other standard metallic colors. I have found them useful when used full strength at a late stage in the painting, in small amounts. They are beautiful and draw much attention in a painting. They behave differently on the paper than either acrylics or watercolors, so experiment with them to discover what they're capable of.

"Finally, painting with metallics can create several problems. For one thing, the painting will look different in different lights. And it must work in all lighting. Hence, you must constantly view your painting in bright, direct light, and then look at it in indirect light to see if it still works as a painting."

Watercolor Dyes

A growing number of watercolorists are exploring the use of watercolor dyes. As the term implies, the difference here is that the color comes from a dye and not from particles of pigment, as in "regular" watercolor paints. A growing number of artists (and illustrators) have been using Luma watercolor dyes (from Steig Products).

These are samples of powdered pigments or "metallic watercolors." They can be applied in a number of ways, including dipping a wet brush into the powder and then painting on the paper as shown here.

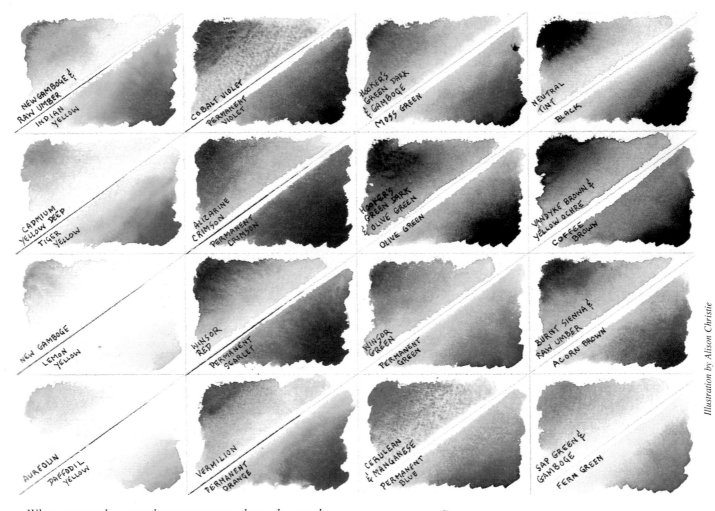

When watercolors overlap transparent dyes, the results are particularly lively and intense. Some of the sparkling effects are illustrated here by strokes of watercolor placed over round swatches of Luma dyes: Luma permanent blue with Winsor blue and French ultramarine (upper left); coffee-brown stain with raw sienna and warm sepia (upper right); permanent scarlet stain with Winsor red and alizarin crimson (lower left); moss green stain with olive green and Hooker's green light (lower right). You can use the color chart at the right to guide you when working with watercolor dyes. The color on the top of each square is Winsor & Newton watercolor; on the bottom, Luma watercolor dyes. Most match up closely, but notice the higher staining effect of the dyes and how they tend to puddle in stronger concentrations of pure color.

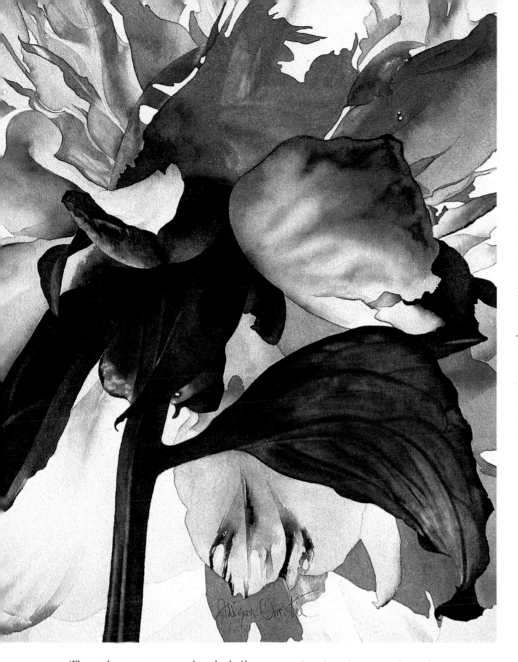

The colors are tremendously brilliant and they produce a deep stain on paper surfaces. In fact, the color is so brilliant that you may not want to use them alone. Most watercolorists prefer to use the dyes for underpainting or staining because they won't be lifted off the paper. Then, if you like, use the dyes in combination with regular watercolors. The color intensity remains good and you can literally scrub over these. They're also particularly good for glazing and layering colors.

In the past, professional artists have shied away from using watercolor dyes because the color was highly fugitive—apt to fade under direct sunlight and other sources of intense light. The dyes used in the paints simply were not permanent. Although Luma watercolor dyes have not undergone any serious lightfast testing up to this point, Steig Products and several artists have done some of their own simple tests and found no loss of color in samples that have sat in direct sunlight for more than six months. Overall, I would give these dyes a cautious recommendation—but a recommendation nonetheless.

Adding "Dry" Mediums

Ode to Eden Park *(22x30), by Joan Rothel, shows a good combination of watercolor and graphite. Rothel started the finishing stage of her paintings with pencil lines to determine the composition and shading in select areas. Then, watercolor washes are applied over the top. In some areas, the faint pencil lines are covered, but in others the markings show through the watercolor. In still other areas, the beauty of the drawing itself is left unsullied.*

Although transparent watercolor paintings are traditionally created only from layers of paint, watercolor is a very versatile medium in terms of the looks it can take on, especially when used in combination with "dry" mediums. We've talked about its use with acrylics, gouache, and metallics, but watercolor can also look great with touches of graphite, colored pencil, and pastel—just three of the combinations you'll find by artists in this book. And watercolor paper, even after washes have been applied, makes a good surface to hold these "dry" mediums.

Graphite

It's not uncommon in doing preliminary work to start with a pencil sketch. Adding watercolor over the top, since it's transparent, will not obliterate the pencil lines. They'll remain somewhat visible but more subdued as the watercolor dries over them. Since graphite is used mainly as an underdrawing medium with watercolor, you'll need to figure out how to allow the pencil to show *through* the watercolor in spontaneous, innovative ways. This combination has a nice look that speaks of your own handwriting as an artist. Look at the watercolors of Mary Cassatt for examples.

Some artists will work back into their paintings using pencil. They often do this to refind a line or edge, for slightly more definition in areas, or to kinesthetically feel out a form (using the pencil to help focus on

"Westport"
Cathy Johnson

Colored Pencil

their actions as they rehearse the movement they'll use when actually working). But once the watercolor is down on paper, graphite isn't generally good for toning large areas. This is because it has a slick, shiny surface that can distract from the watercolor. Even a multitude of lines on top of watercolor will remain unobtrusive; they remain just that—lines. Limited crosshatching will do fine, but again, not broad areas of shading. In addition, the shiny surface is also slick, meaning that a watercolor wash will slide around on its surface without settling evenly. Overall, consider graphite for small details, possibly enhancing darks with subtle crosshatching, or to add energetic linear marks to vitalize your watercolors.

There are two types of colored pencils—water-based and wax-based. Both the water-based (sometimes called watercolor pencils) and the wax-based varieties can go down underneath or over your watercolor washes. But when you brush over water-based pencils with pure water or a colored wash, the pencil marks will bleed and run as they dissolve with the water—the same effect you already get with your watercolors. However, some nice effects can be achieved by using the watercolor to soak away parts of lines, so that they fade in and out of the underdrawing.

Most artists, however, prefer the wax-based Prismacolor pencils. When used underneath watercolor, they retain their integrity—which is

This loose sketch by Cathy Johnson (8x11) was done with a combination of watercolor and Prismacolor pencils. The pencil was used first to establish shapes and value patterns. Then ultramarine blue, yellow ochre, and brown madder alizarin were used to create a variety of values and suggested hues. "A little wet-into-wet painting was done on the head and the warm light shining through her ear," explained Johnson, "making it appear pinkish." My preliminary washes were then allowed to dry before adding more watercolor and hatching with the pencil to form a combination of hard and soft, lost and found edges."

Mary Beam also used colored pencil in some of her works but in combination with a range of other techniques and mediums. Here she uses acrylics, watercolors, and plastic wrap for a highly abstracted composition.

Step 1: Beam transfers her pencil drawing to watercolor paper and applies frisket film over top as a masking agent. She then cuts out the shapes that will receive pigment.

Step 2: She then paints over areas with juicy, thick washes of acrylics in very loose puddles.

great for linear effects—but they also repel water. It would take numerous, deliberate washes of watercolor or very dark, thickly mixed tones to cover these lines.

On top of watercolor, much can be done with these pencils. With a light touch on watercolor paper, you can glaze with them. Just use shading strokes as you would with any pencil; on cold-press or rough surfaces, the pigment adhering to the ridges of the paper will produce almost a Pointillistic effect, especially when lay-

Step 3: Plastic wrap is placed over top and pressed into the painting in select areas. When the plastic is removed, it pulls, lifts, and mixes the washes to produce mottled colors and shapes and some hard edges and values. When the frisket film is removed the hard edges give definition and order to the swirling colors.

Step 4: Additional washes of watercolor are added over the top to produce soft transitions, color, and values.

ered over a contrasting undercolor. You can use colored pencils to make final tone and color adjustments right on the surface of your paper. For example, a light shading of blue over a yellow wash will result in a slightly green effect—just like glazing (see pages 108-111). This will also serve to enhance the texture of your paper somewhat. These wax-based colored pencils can also be used creatively to add details, linear elements, and other "energies" over your watercolor washes.

Step 5: Work begins with colored pencils—shading, hatching, and glazing over and around the watercolor areas. Value and color depth are controlled by the amount of pressure applied with the pencil. The light-colored strokes show up well over the dry, darker areas of the painting. They're used for adding linear effects, softening edges, glazing over to modify color, or for sharpening details.

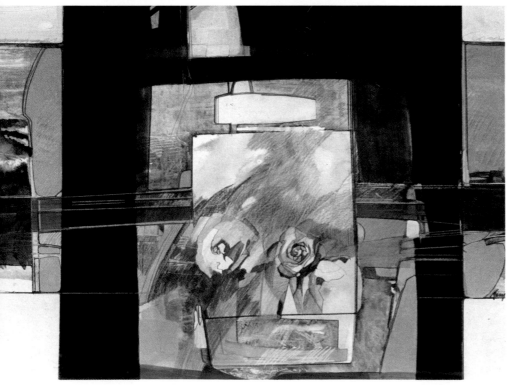

Step 6: The finished painting shows a range of color, surface textures, and detail. Many of the mottled effects of the plastic wrap are subdued with additional layers of paint and over-drawing with colored pencil.

Masking and Resist Elements

Here a wash has been applied over a drawing made with wax. The lines are still clear despite their very light tinting by the wash.

For the most part, once watercolor has been brushed on paper, it's there to stay. Some of the sedimentary colors can be removed by soaking and scrubbing your paper, but even then some staining effects might remain (depending on the color itself). So saving whites and light areas can depend on using some type of masking or block-out material.

Whether you use it often or never open the bottle, it's a good idea to have some type of liquid masking fluid on hand. Watercolorists such as Roland Roycraft (see pages 121-125) use masking at will to "save" large areas. The whole idea is that masking fluid gives you the opportunity to go wild with your colors and brush—spattering, flinging, pouring, and pushing paint around without cramping your style by worrying about, or painting around, areas you know will be light. The only problem I have with masking fluid is that, to use it, you need to predetermine what areas will stay white. I enjoy the process of finding out as I paint and sometimes I like the challenge of having to make a painting work even after I've lost some lights.

Also, simple masking tape works well as a block-out element. The artists you'll read about in this book use

masking tape mainly to retain sharp edges and lines. But you can even push masking tape a bit further. Depending on the smoothness of your paper, how hard you press the tape into place, the wetness of your wash, and when you remove the tape, you can create unique edges. For instance, if you're working on a smooth paper or board, and you apply the tape firmly and remove it only after your wash has dried, you'll create a very hard edge. On the other hand, if you're working on rough or cold-press paper, apply the tape lightly, brush over it with a runny wash, and remove the tape before the paint is dry. The edge will run and bleed a bit as the watercolor flows through the texture of the paper. Experiment with different variations of these factors and you'll create very useful edges.

Another resist technique that lends itself to experimentation is in drawing with wax much the same way it's used for batik. As you start your watercolor, you might consider taking even a broken chunk of paraffin and drawing lines with it. When watercolor is applied over those lines, the wash does not adhere to them; instead, it will leave those areas white and free of paint.

Some artists have had luck evaporating away the wax with a warm iron. Cover the painting with an absorbent paper such as newsprint. Iron over this with a cool iron. The wax will dissolve and be absorbed into the top sheet of paper. Depending on how much wax was applied, you may need to repeat this procedure several times. (Try this first on a practice painting to see if it will work for you.) Otherwise, the lines you draw with wax will stay. Many applications of watercolor over them can add a light tint, but that's about it.

Finally, working on unstretched or hot-press paper will add a certain amount of resistance to watercolor. When you soak and stretch your paper, you're actually removing the sizing added to it in manufacturing. And if you've ever tried painting on unstretched paper, you realize that until you get two, three or four washes down, the paint seems to slide around, puddling and sticking in uneven patterns. This can be a very useful technique for adding texture and interest to planes of color. Much the same happens when you paint on hot-press paper; your brush marks stand out and the paint just slides around.

25

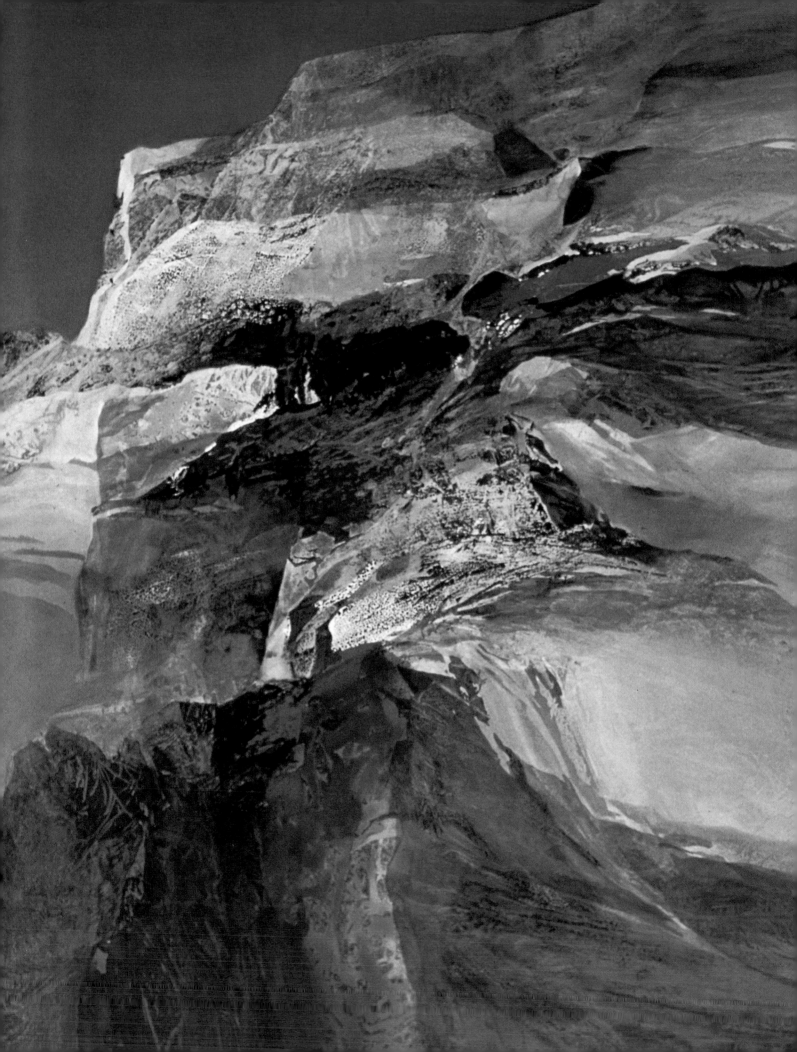

CREATIVITY 2

Where Do Ideas Come From?

The toughest thing an artist has to face is the wide expanse of a blank sheet of paper. "What will I paint, and how will I paint it?" Some questions of style and technique have to be answered before we can begin painting, others as we go. But before we do anything else we need an idea. We need to know what we want to paint. So, where do the ideas and inspirations come from? Ultimately they come from within us, but there are plenty of sources of inspiration just waiting for us to tap into them. You just have to open yourself to them. Take a good look at yourself, your work, your entire world. Then get that unique, personal vision down on paper.

There's a twist to this whole creative process, however. You need an idea, an image, a vision to begin a painting, you also need to paint to get ideas. It's a process of synthesizing thoughts and actions to generate a new approach. The artists you'll meet in this chapter do just that. Each has a unique way of approaching the creative process. Some place more emphasis on thought, others on action. For example, an artist like Mary Beam might concentrate on the concept of winter, then search out ways to communicate this. Others, such as Joan Rothel, like to "think with their hands." She crystallizes her ideas by arranging and rearranging cutout flower shapes until her compositions gel.

The creative process is an organic one. It takes reading, thinking, learning to really see the world around us, experiencing life, and the act of painting itself. There are plenty of ideas for paintings just waiting to be plucked out of this wealth of information. You need only be open to the process to find them. This chapter will stimulate your search for new ideas *and* offer exciting ways of expressing them.

Mountain Crest *by Judy Richardson Gard (32x40)*

27

Cultivating Creativity

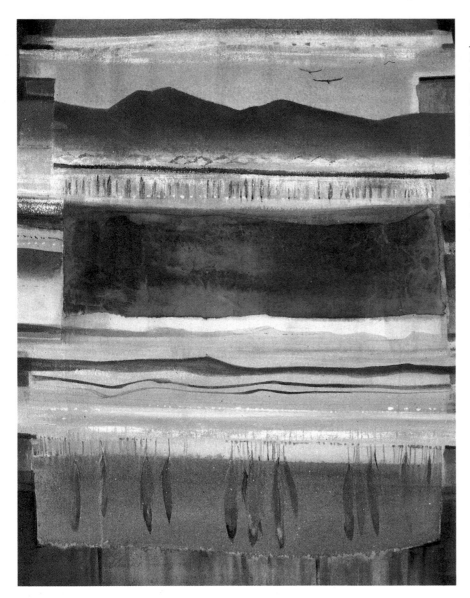

It's not easy to show concepts such as warm-ups and timing. But you can see other aspects of Elaine Harvey's creativity shining through in Rites of Spring *(watercolor, gouache and collage, 32x30). For instance, the theme evolved from Harvey's interest in the tapestry designs of Guatemalan fabrics. In terms of technique, Harvey used most of the basics in this piece: glazing colors, subtle gradations, and even fluid drips of paint. Notice the beautiful textures, paint separations and various levels of transparency that you see throughout the bands of color. These were the result of her experimenting with gouache in various mixtures with watercolor and with using combinations of sedimentary and staining pigments. This kind of experimentation is a good example of the freedom-to-fail attitude necessary for creative new works.*

*F*or Elaine Harvey, "rendering an astoundingly real or cleverly liquid scene" is not enough. "If we as watercolorists wish to be considered real artists, we must say something, not just talk glibly in our painting. We must put into our work something of what is important to us—our beliefs, inspirations, insights, and understanding of the world around us. Since we all bring different backgrounds to our art, we can each produce paintings that are unique and creative. Our real task is to discover who we are, what we believe, and to develop the competence to present it convincingly. Not an easy task."

Strategies to Get You Going

Discovering who we are and what we believe—and doing it justice in our art is not an easy task, indeed—and on some days, it's nearly impossible. At such times, we need to find different ways to get our creativity into high gear. We wish for a magic formula to help us look at the world around us in new ways, to tap our innermost feelings, to break down our personal barriers. Although nobody's ever come up with a foolproof way to generate new, exciting ideas, many people have found little secrets to help them slip into trying something a little different. These are some of Elaine Harvey's strategies for getting to the core of her creativity:

"Although perfecting technique is not my final goal, it is one means to better creative expression; that is, the better my knowledge and control of the materials, the more I'm free to create. The handling of watercolor should be so natural and automatic that you don't have to think about it. To master technique, I experiment, read, study the work of other artists and, most importantly, practice. Even a short time without painting interferes with my ability to handle the medium.

"My planning includes much more than the traditional thumbnail sketch-

es. At different times, it may include research, meditative thought, visualization, the painting of other complete preliminary paintings, and even the writing of descriptions or lists of possible components of the painting. However, along with the planning, I try to stay flexible. If I see an opportunity during the actual painting process to add to my original concept or even go off in another, better direction, I take it. This becomes a sort of planning-on-my-feet process.

"We all experience a certain mode of thought and action when everything goes smoothly, almost without effort. Creativity is at its peak. This is sometimes called the 'flow' by performing artists, writers, and visual artists alike. It is not only highly productive, but enormously satisfying, and is almost a reason for painting by itself. Unfortunately, the 'flow' is also elusive. To capture and use it in painting I resort to warm-ups and hope that I can find the right timing to make the most of the 'flow.' Although some artists feel at their best for the first forty minutes or so, I'm a slow starter and must either paint with reckless abandon at the beginning or warm up on something old and unimportant to me. I think this gives my critical component something to think about so that the creative component can be heard. The trick is to begin working on the important painting at just the right time and to quit when the creative attention span ends. A lot of self-knowledge and self-control are involved in doing this, and it doesn't always work. If it did, being an artist would be easy.

"Timing is also involved here. I find I must give myself time to experiment without any thought of producing a finished painting. But I must also put myself under some pressure to complete paintings that are perfected to the best of my ability—all by a certain date. Without the deadline, I tend to feel that nothing is ever quite finished or good enough. The deadline for a 'product' keeps my self-critical component

Dancing on the Green *by Elaine Harvey (30x22)*

Sometimes you know you want to paint a particular scene but just can't find the right way to get it down in a painting. This happened to Mary Beam with the painting that evolved into Wheeling Ave *(acrylic, 60x30). "I've walked this street at least five hundred times, always wondering how I could capture the feelings I have about it. Symbolically, this old street has a richness of meaning for me. It was once the National Road, and my ancestors from Ireland probably used this passage to a better life. To come up with a painting idea I imagined myself above the street looking down, flattening the planes of the hills. Then I tried to digest the scene in one gulp. In my studio I found that I could use the images stored in my inner visual computer. Flattening the planes helped me to simplify the design and to get the three hills of the city street in one painting."*

busy so that I can be creative. Gallery obligations and competitive shows often furnish the deadlines.

"Since, as I said at the beginning, I believe that art must contain the experience, values, and insights of the artist, I spend time learning about fields other than art. I devote most of my time to painting, but I consider all of my experiences to be important. Like having many techniques at my command, having many ideas at my command will make me a better, more creative artist."

Getting Started Again

Mary Beam has some creative techniques that she uses to get out of a rut. If you happen to fall into one and feel that your work is becoming stale or that you've hit a plateau, you may want to try taking some risks with your painting by trying any or all of her suggestions:

Try new materials. "Go into the art supply store and buy things you'd never dream of buying," she says. "Try opaque paints, pencils, rice papers—and use all of these in unconventional ways. Look in the lumber store for new supports; think about ways to bring your work literally off the wall."

Turn your usual methods upside-down. "Materials are not sacred or holy. The only sacred things are your ideas. And these can be wonderful with or without the use of special brushes or paints. So make a list of all your no-no's, and do every one (but maybe not all on the same painting). This will help you develop your 'feel' and sensitivity. For example, think of all the colors that you've been told don't go together, and put them together!

"Try using different values together. Put close values of clashing colors together. See if this jogs your creativity." Or, she suggests, "try using only black and white for two or three paintings, and do them with a large brush (use house-painter's brushes)."

On those days when nothing seems to work, we all start to wonder why we ever wanted to paint in the first

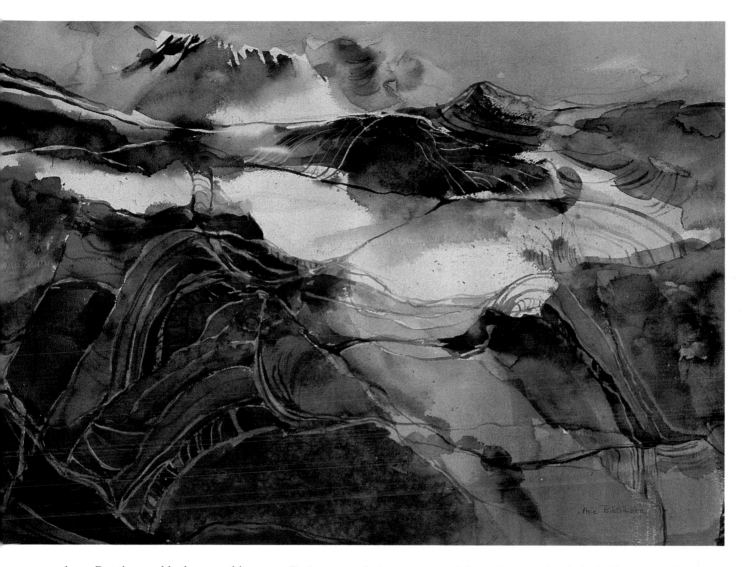

place. But then suddenly everything clicks again, and there's a kind of inner release that produces its own special warmth. And we may find that it's not our destination that's important but the journey itself. "Perhaps the biggest benefit you'll get out of the creative process and the act of painting," Beam says, "comes from the mystery of the whole ritual. You enter into the process, struggle with ideas, think, and explore your emotions. It's not always easy or fluid. But I know I always feel more balanced and more whole when I complete a successful painting. So I must paint for myself and then give the painting to history."

Trying out techniques or materials you've previously forbidden yourself can be a very liberating experience. But if you consider the resulting work a "failure," you may find yourself retreating to the safe and familiar even though you're not really happy with it. Instead, try making less drastic changes. For example, this painting by Avie Biedinger (Born of the Sun, 22x30) is easily recognizable as a mountain scene, but her interpretation and technique make it far from typical!

31

Imagining a New Reality

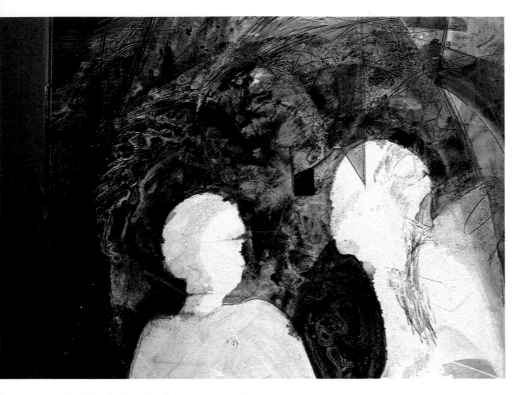

In Words Not Spoken *(watermedia, 30x40), Mary Beam focused on the feeling between two people who wanted to communicate but couldn't. By only suggesting the attitude and gesture of the figures without adding detail, Beam created a more universal sense of person. Applying most of the paint in the negative areas and using deep values and colors emphasized the space between the figures, and helped to visually and psychologically communicate the distance and barrier between them.*

*T*he creative process almost always defies attempts to describe it systematically. It's not like cooking, where you can easily break a recipe down into a series of steps and ingredients that produce a determined result. That's because once you give the process a specific order or number, you limit it. And creativity is an unlimited process. Each manifestation can reflect a unique approach, even if it's only substituting one new ingredient in familiar painting methods. Like the process of negative painting, the best we can do is to talk around the creative process itself—set up some broad goals that might result when the process is going well. How you achieve these is entirely up to your own ingenuity.

For Mary Beam, the creative process involves introspection as well as an openness to the outside world. Each can be a wellspring for new ideas; when one dries up, Beam simply looks to the other. "I may be riding in the car or watching television when the idea hits. Ideas are always churning around, and I can never get

away from my art; nor do I want to. I have chosen this state of mind, which is one that is always searching through or scanning my inner narrative for ideas about painting."

How you bring reflection, thoughts, and experiences together can take many routes. Exactly how you do it depends on your own unique personality and makeup. Beam combines her ideas, experiences, observations, and feelings into a highly personal interpretation, in effect creating her own reality.

The first step in painting, for Beam, is starting with a theme or an idea: "Since I paint in a mostly symbolic tongue, I must get a certain mindset about what I'm doing before I set out. A few moments of reflection into what is important to me at the time is all I need. To this I add my inner feelings and experiences. For instance, one day I was thinking about what people don't say to each other, I began painting two people, and then trying to communicate the feeling that they want to speak, but something is holding them back. I didn't spell it all out (see *Words Not Spoken*, on this page); I think the artist must suggest and let the viewer have his own experience."

One approach that Beam employs is the process of combining observations, pictorial ideas, and her "what-do-I-want-to-see" powers. "We are a reflection of our environment—the sights, sounds, emotions, spaces, textures and lines," says Beam. "But I try to be especially open to the spaces around me. And I find that the larger I work, the better my 'space' experimentation becomes. I need lots of room. Then, the paint and paper itself become the sounding board for my responses to space. For instance, the buildings in my town (Cambridge, Ohio) become excellent points of inspiration for spacing. I can block them out on paper in an abstract way, and then try to get in touch with what is happening in terms of closeness or proximity.

"As another example, an architect told me that one of the most impor-

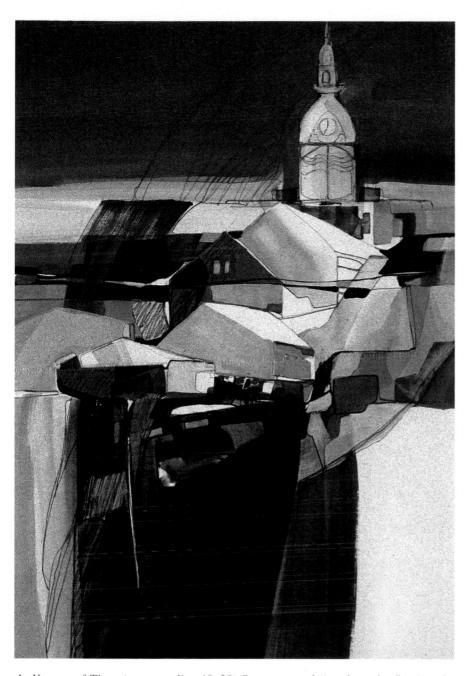

In Keeper of Time *(watermedia, 40x30) Beam wanted "to show the fleeting element of time. The courthouse is the repository of all milestones of our lives—births, deaths, property transactions, etc. But even that is fleeting. Just as I was finishing—and wanting a touch of color—a lady came out and hung up her wash. A red shirt provided just the touch I needed."*

tant spaces on an object is where it touches the sky. So I started looking and documenting with slides interesting angles that touched the sky. In painting, I compare these areas with other voids, such as a dark area or just an empty space. These voids don't have to even read as 'sky,' but they could. In this instance, all the electrical wires in my town became interesting lines that could tie together the abstract elements of a painting. I became much more aware of their presence and their possible function pictorially.

"Or, I'll get ideas from the hills where I live, and how they break up the horizon, adding a three-dimensional effect to the picture. I like to view them as flat planes and exaggerate their flatness and length to add drama to a painting. Winter is a great time to work on this idea because the masses of tree leaves don't block the view. Much more shows."

Translating these elements into an abstract composition is a challenge. "I try not to intellectualize the process too much," says Beam, "but just let all the wonderful shapes, colors, textures, forms, and rhythms filter through my mind and become real and new on the paper. Some days I'm more in tune with this than others. If I'm not particularly inspired, I can go on to phase two." This involves getting ideas from the paper and paint itself.

"In this phase," says Beam, "I simply start pouring paint on the paper and let it be the stimulus for the ideas. It generally will spark some hidden insight and have a life of its own. By working improvisationally, new ideas come to life that the conscious mind had not yet developed. These ideas can be recognized and offered growth. Sometimes they mature into a resolved painting; other times, they need to wait until experience and insight catch up with them."

But the creativity doesn't stop with the idea. It's also a strong part of the execution of any painting. "The artist," says Beam, "becomes much

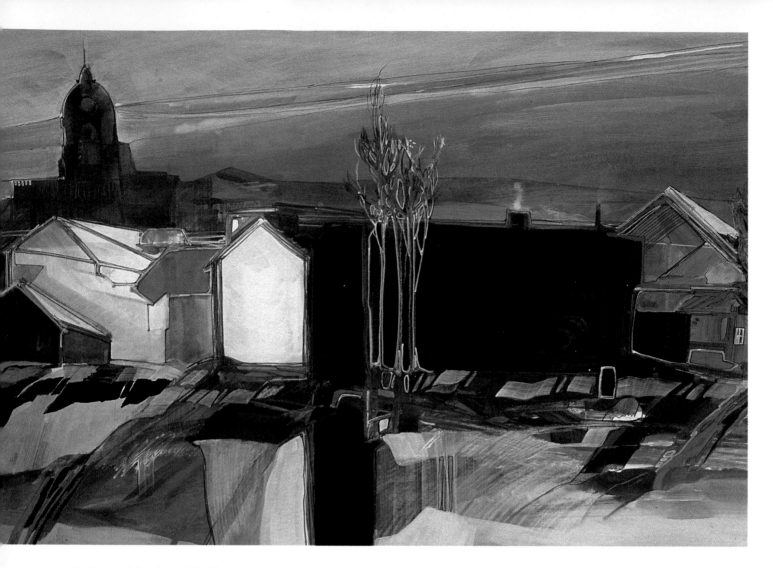

In Frosty Morning, *(20x30) Beam wanted to capture the drama of "freezing" time on a winter morning. To accomplish this, she used a horizontal format to create the feeling of a long street. And she "played with the pattern of lights and darks to define the visual areas that I wanted the viewer to peruse." She also outlined tiny "morsels," such as areas on the left side, that she didn't want viewers to miss. In passages in the foreground and sky, she used acrylics transparently, like watercolor, to create a feeling of fragility and sensitivity. Opaque passages in the middle stop the eye and "express a mellowing quality."*

like the fine actor who relaxes and makes every movement meaningful and a part of himself. In the same way, every brushstroke, every impulse, all decisions concerning the design and construction of the painting must come from the artist's inner being in a fluent, unrestrained manner. It seems that all strokes at this point come from the heart, through the brain, down the arm, and onto the paper. To do this, you must forget yourself and your self-consciousness and become completely submerged in the part. Study the strokes of Picasso; such strength and knowing are embodied in their structure. You sense moments of overwhelming concentration.

"When you reach this state, it lets you do the slightly mischievous acts that give your work its character. It allows you that flip of the brush, that wonderful unfinished stroke, brilliant color, or fantasy in the content. Without these qualities, your painting will be lifeless."

Cut and Paste a Composition

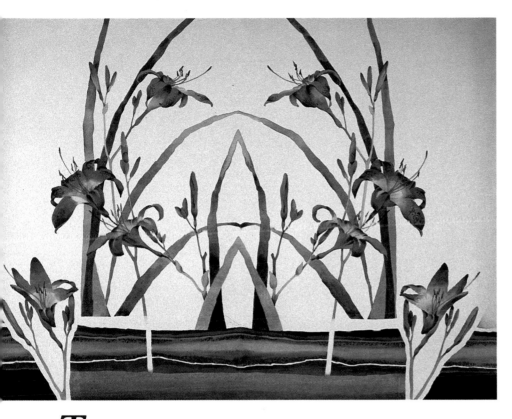

Growth Patterns *(22x30) was done in Rothel's "cut-and-compose" approach. After doing several sheets of drawings, Rothel cut them apart and reorganized the full-sized shapes into the composition. Against a mainly white background, the flowers take on emphasis, and the overall design suggests the tranquility of a church window. Then she transferred the drawing to hot-pressed watercolor paper and painted the image on dry paper, making use of separating, granulating pigments in the darker areas.*

*T*he success of any painting relies most heavily on the vitality of its shapes and their relationships to each other. Even a painting in only black, white, and gray, with exciting shapes, can speak to our emotions, moods, and attitudes. But just as important is the placement, arrangement, and scale of shapes on the page—the overall design. While it can be exhilarating to go out and paint something right on the spot, often our work can benefit from the more exacting composition done in the studio, where there is time to add more thought to the spontaneous observations made in the field. And this is where a composite approach to design comes into play.

One of the biggest disadvantages to completing an entire painting on an outing rather than making a sketch is the risk of missing the exact scene in the mind's eye. Perhaps there should be a barn or more trees, or there's an awkward arrangement of elements that just can't be fixed easily on the spot. And often, there's not access to that special scene—there's a bull in that particular field or there's an unfriendly dog or there's not enough time to do the scene justice. Making watercolor sketches and, especially, photographs of scenes can solve both these problems. They also provide a ready store of inspiration for times when you want to put a little bit more into your painting but have got to think about it first (and maybe change your mind a little or a lot).

Joan Rothel takes a cut-and-paste approach to composition. Working from actual flowers, Rothel makes pages of drawings of the whole plant—bud, flower, leaves, and all. "I turn the subject," says Rothel, "sketching from different sides and angles, taking time and care to make the drawings faithful to the spirit as well as the specific characteristics of the specimen itself.

"When I have completed the drawings, I cut them apart and, with a tableful of images before me, I begin

35

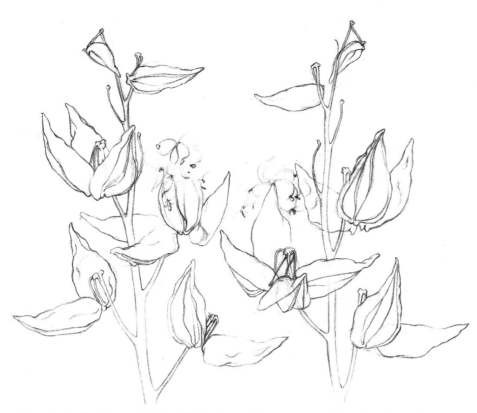

Step 1: Rothel began Hidden Birds *by making numerous line drawings of milkweeds. From a single stalk she drew all of the images you see here, rendering the stalk from various angles and sides.*

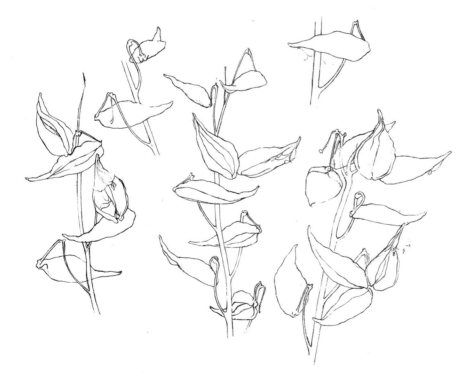

Step 2: The drawings were then cut apart into pieces so that she could maneuver them about at will. Rothel pointed out that you don't have to use original drawings; you can photocopy them and cut the copies apart if you want to save your pencil work.

the process of building a composition. With complete freedom and ease, I move the drawings on a thin white paper the size of the finished picture until the composition gels."

Rothel prefers to paint flowers in graphite and watercolor "against the purity of white paper—I want my flowers to show perfection, beauty, and glory, and that the viewer not be distracted by other pictorial elements." Hence, the negative space in these pictures becomes very important. Not only does it work to enhance the "purity" of the flower shapes, but it can also take on additional meaning. For instance, the negative spaces in *Growth Patterns* (see page 35) suggests a church window, an image reinforced by the association of lilies with religion. "Then," says Rothel, "when I'm satisfied with the arrangement, I lightly tape the papers in place and trace the major elements onto my watercolor paper."

In terms of design, Rothel finds no fewer than five advantages to this approach. First, she said, "You can concentrate on drawing the flowers and their parts while they are blooming, without worrying about making a 'finished' painting." Second, "This method works well in any size and with various subjects—they needn't be florals." Third, "this approach saves time and creative energy that might be spent in redrawing." Fourth, "Your watercolor paper remains unmarred by erasures and unstructured pencil markings that occur when you do your pictorial thinking on the finished surface." Last, but definitely not least, "Knowing you can retrace the drawing encourages you to paint more experimentally and aggressively. You have the freedom to try innovative and unusual ideas quickly."

Although it sounds rather haphazard, this approach creates a pleasing overall effect when combined with

graphite and watercolor. "It implies a growth of the painting as well as the plant," says Rothel. "In *Hidden Birds*, the pencil seems to capture the dryness of the milkweed and the emergence of spring flowers from their dried grassy beds."

On hot-press paper, Rothel first draws the whole picture completely but does this drawing a "value or two darker than I want in the finished picture." Then, with an art-gum eraser, she "swings" through the images, destroying the perfection and establishing new values and shapes that imply grasses. This light scrubbing with an eraser also literally bonds the image to the paper by grinding the graphite into the paper's fibers.

"The painting is then developed slowly," says Rothel, "as I gradually add watercolor, pulling edges with my brush to lose them, using double-loaded colors on my brushes and using granulating pigments in washes. At the same time, I reinforce the drawing with more pencil rendering. The trick is to keep the watercolor and pencil compatible, without having one steal the show."

Think about all of the parts to this approach to painting, and experiment with any or all of them. First, think about the drawing process and how you can faithfully capture the spirit and exactness of your subject. How can you expand or otherwise change what you've seen? How can you combine composite images? By using negative and positive space in a vignette style to make a statement? Or by carefully combining two mediums—graphite and watercolor? Remember that readjusting any one will alter the results.

Cutting and pasting (or projecting and adjusting) images gives you additional freedom to plan and adjust your ideas before you have to commit to a certain result.

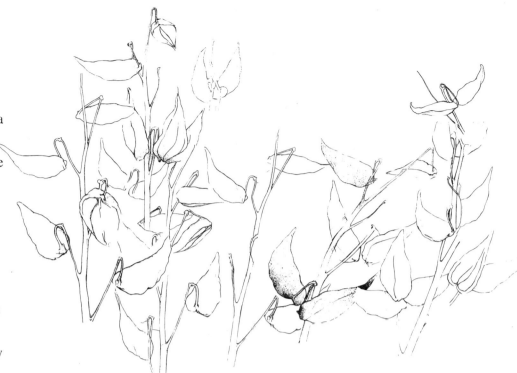

Step 3: The cut-out images are then composed in actual size on a separate sheet of paper. Rothel arranges the pieces until she achieves a good balance between positive and negative areas. This drawing was then transferred to her watercolor paper.

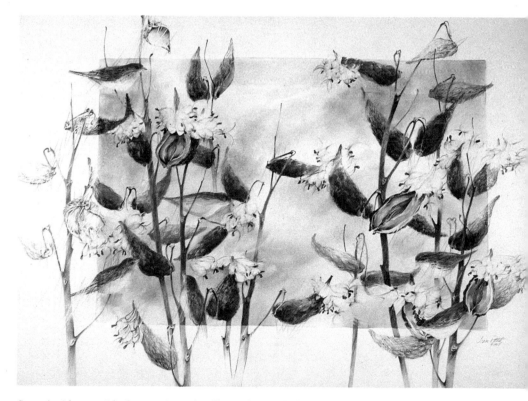

Step 4: Along with the tracing of milkweeds, Rothel enhanced the drawing with values a shade or two darker than she wanted for the final image and added the birds. She then used an eraser to remove areas, blend the graphite into the paper, and finish the drawing, before adding layers of watercolor. The lively linear effects of the drawing provide a good contrast with the even-toned washes. Neither watercolor nor graphite fight for attention.

Design from Geometrics

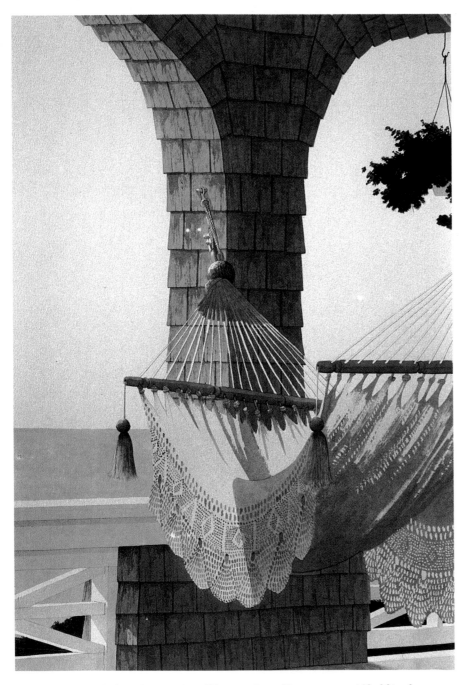

Barbara Santa Coloma's painting, Hammock at Narragansett *(40x30), demonstrates how effective tightly framing your composition can be. Like the image you'd see in the viewfinder of a camera, the space is flattened and tightly framed for maximum impact.*

*O*ne approach to the design of your paintings is to work with geometric shapes. In fact, as artists, we must consider form for its two-dimensional design possibilities. I think this heightened awareness helps us recognize the geometric and two-dimensional aspects of form in real life. And that's when a wonderful excitement occurs—when we find geometry in what we see in nature. We don't see a literal object anymore; we see a shape or form. This seeking-and-finding process can become an important route to creative composition.

Artist Barbara Santa Coloma stresses geometry in her compositions. Although she wants to capture the feeling of tranquility by exploring the play of strong light on white surfaces, she also uses these elements to compose with large, geometric shapes. As a painter, she's not solely intent on copying and recording nature as it stands but does look to nature for the geometry she finds so exciting.

The camera can play a major role in taking this route. It enables you to stalk your scene. You can wait for the exact lighting conditions that inspire you, and you can record scenes from vantage points that are difficult—if not impossible—to sustain. For instance, Santa Coloma often photographs seaside houses and may wait for hours for the light to change and create new shadow patterns. She also takes photographs that show her subjects from angles other than the traditional, straight-ahead, fill-in-the-box one to create some unique reference shots. And, because the camera has monocular vision, it has a tendency to flatten out space, which helps you find the innate geometry in the visual world. In fact, I would recommend composing through the viewfinder of a 35mm camera even if you have no intention of painting from your photos. It's the process of selecting and framing a small space from the 360-degree arena of your vision that's so enlightening.

So you have your camera in hand

and you're outside on a sunny day. What do you look for? Consider these suggestions for ways to find geometry:

1. Look for geometry everywhere. Houses, fruit, vegetables, automobiles, buildings, interior spaces. Can you find parallelograms, rectangles, triangles, or cubes in the pattern of fields, thickets of trees, mountains, or rolling hills?

2. Look for scenes and framing opportunities that geometrically break up the entire space of your picture; the relationship of your horizon line to a tree can give a geometricized feel to your painting.

3. Look for geometry within a pattern of negative spaces. Often, the space between positive objects can create a pattern or take on geometric formations.

4. Look for a geometric pattern of organic shapes. Sometimes, the patterns they form and the placement you give them in your composition can create a feeling of geometry. Think of leaf forms or a field of flowers. These are organic shapes, but they can still be placed in geometric patterns on your paper.

5. Finally, think how you'll handle the space that geometric forms and patterns can create as you look for compositions. If you're painting photographing a row of bannister spindles, for instance, with light shining through them and creating strong shadow patterns, you'll be working with strong geometry. This often has a way of flattening out the space of your picture. If this is the case, think about how you can create layers of flat planes that recede in space, about the activity and interplay of flat shapes that can occur at various depths. This may lead to interesting overlapping shapes and closures.

Almost any technique will do fine for your approach to the actual painting. The most important aspect here is the design and concept you take. Santa Coloma has a few tips to help you get started:

In St. Augustine Evening *(30x40), Santa Coloma was intrigued by the repeating geometric shapes of a white picket fence. The way the single pickets slowly move into one sweeping shape creates a strong movement into space. After studying photos of the scene, she completed a pencil drawing on T.H. Saunders rough watercolor paper mounted on triple-thick illustration board. She then worked with direct applications of watercolor, painting around the lights.*

Seaside houses on sunny days provide a good opportunity for Santa Coloma to photograph and create geometricized interpretations of the scene. In Houses by the Sea *(30x40), triangles, rectangles, and squares come together to create solid forms, one connecting the next as they recede in space. To keep the painting from becoming too "rigid," it's balanced with the more organic shapes of the foliage.*

In After the Fair *(30x40), notice the effectiveness of using the repetition of geometric shapes to create space. The light vertical and horizontal rectangles are repeated in various sizes throughout the composition, getting smaller as they move back into space. This repetition works to unify the painting and to create distinctive planes of space moving back into the painting.*

"Using a slide or photo for reference, I make a very detailed, precise pencil drawing on my watercolor board, usually putting in too much, rather than too little. Pencil can always be erased, and I never know until the painting is completed which lines of pencil will add interest and which are not necessary.

"My application of paint is very precise and controlled, brushing directly onto the surface. In addition, I use paint very thinly in light washes, as well as straight from the tube for more opaque areas. I never use white or Naples yellow because I believe they distract from the luminosity of transparent watercolor. In addition, I apply paint with sponges, tissues, crumpled paper, toothbrushes—any-

thing to give texture and to scrape back to the white of the paper.

"Finally, I'll only use black paint on rare occasions. Instead, I mix grays with various blues and browns. Depending on the picture, I may use mixtures of indigo and sepia, indigo and burnt sienna, cerulean blue and sepia, or cerulean blue and burnt sienna."

Designing with geometrics is first and foremost about new ways of seeing the world. It's like what happens when you look through a kaleidoscope, give it a slight turn, and see the whole "universe" change. Although it's useful to have a number of techniques to help you carry out these new perceptions, the change in your seeing has to come first.

Let Your Paintings Evolve

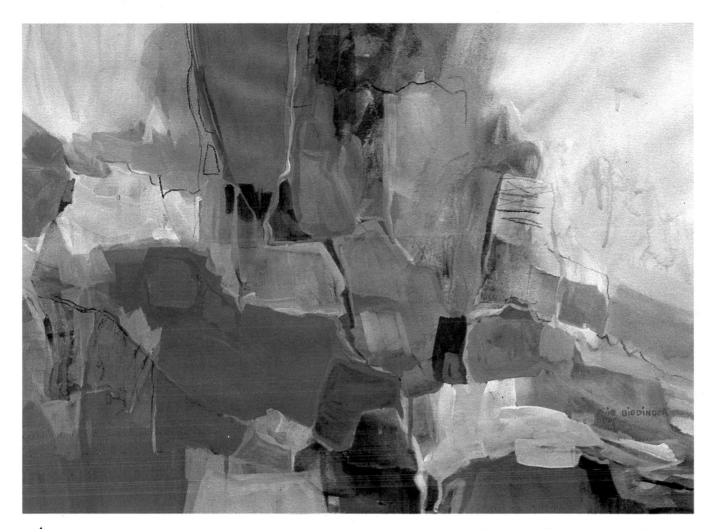

"A painting," says artist Avie Biedinger, "might commence as a figurative, transparent watercolor, but after the two of us have our 'what-are-we-going-for' conversation, a completely nonobjective, mixed-media work might evolve. This is what happened with my painting, *Knock on Silence*. This work originated as a transparent watercolor done from a live female model. The composition and color dominance interested me, but it kept pleading, 'Do something drastic; I don't come off as a figure painting.' Bravely, or perhaps even a bit recklessly, I destroyed the figure components and developed a more successful painting with the addition of acrylics, charcoal and pencil.

Biedinger's experience with *Knock on Silence* is a good example of the dialogue you can enter into with your painting while it's in progress. This often mystifying "dialogue" so many artists refer to is based partly on intuition, but the success of your interaction depends a lot on the ideas you have about what makes a painting good. The more open-minded and flexible you are about what a painting should or could look like, the more interesting the conversation you can have with your own work.

With each painting, you'll most likely reach a point when you need to step back and make some evaluations. When you begin, you're the one in charge, drawing and pushing the paint around, defining edges and

Knock on Silence (watermedia, 22x30) started out as a figurative work, but Avie Biedinger felt the painting cried out to be an abstract. So she listened to its "voice" and went with the flow. In knowing where to take a painting such as this, it's important to get in tune with shape relationships. Here, for instance, notice the seemingly simple variety of various shapes, the pattern and the size contrasts. Also, notice how the blues all close to form one underlying shape that forms a ground for all of the smaller shapes layered on top of it. All of these characteristics combine to form an interesting abstract composition.

41

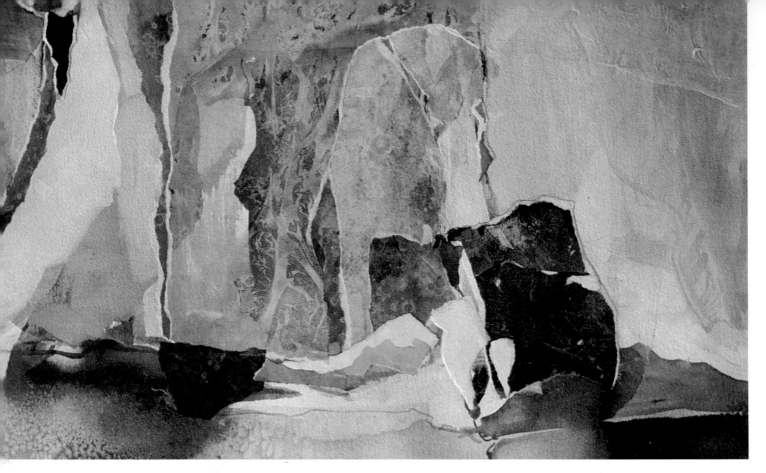

Push-pull dynamics can add layers of depth and space to your mostly abstract painting without linear perspective. In Wintry Forms *(watermedia and collage, 15x22), the foreground forms exert an advancing and receding pressure, based on their color and shape, to create layers of space. In addition, Biedinger makes use of more opaque acrylic passages to provide a strong contrast to the predominance of transparent watercolor. The strong areas of dark in the upper right and lower left are mixtures of thicker acrylics. Notice the atmospheric look of the watercolor and the eye-stopping density of the acrylics.*

shapes. And as you work through this spontaneous process there's almost no way to be completely aware of all of the relationships you create. Each shape and color and line will have an effect on all the other parts of your composition. When you step back to take a look at what you've done, very often there's a happy discrepancy between your intentions and what you end up with.

This is when your turn to talk is over and it's time to listen. Look carefully now at your painting in progress. Sometimes the painting talks in such a whisper that it takes time to adjust to its voice, to calm down enough to hear its suggestion. Biedinger shared the following tips for developing more dynamic, abstracted works:

Whenever we refer to shape relationships, we're talking about the tension and balance one shape exerts on another. Some shape relationships you might pursue in your painting are: the play of large shapes against small shapes and dark shapes against light shapes; a pattern of different shapes of about the same size; a pattern of different-sized shapes with similar form and geometric shapes against organic shapes. Remember,

your goal is to look for interesting similarities and contrasts of shapes within your painting, not to depict realistic forms or subject matter.

The dynamic quality of closure, or the attraction one shape has for another, is an especially important consideration. Picture in your mind's eye two half-circles a couple of inches apart. Now draw them on paper. The two half-circles just go together even though they don't actually touch and there's space between them. The two shapes attract each other, and through our perception we "close" them together as one shape: a circle. Now, look at the shapes in your painting to see if any of close value or color connect in this way. They don't have to be geometric shapes; any shapes can connect. Often, the line formed by the edge of one shape may point to or be completed by the line formed by the edge of another shape. When you can successfully close the large, (back)ground shapes in your painting, the energy that this closure creates will charge your painting with dynamic, visual power.

Look for Push-Pull Dynamics

Hans Hoffman was perhaps the best theorist of this dynamic visual inter-

play. Simply put, the push-pull effect depends on the interaction one color/ shape has on another. Basically, warm colors appear to advance, and cool colors tend to recede in space. Using these as the criteria of your painting, you can juxtapose shapes of different colors and color temperature to see how each pushes and pulls on the other. It's a very effective way to create layers of flat space.

Look for Ways to Add Opaques

Biedinger often adds acrylics to transparent watercolor. One of the guiding principles to the use of the medium is a variation on the push-pull dynamics of color. When you introduce opaques to your transparent watercolor, you set opaque places against transparent. Thin, transparent veils of watercolor by their very nature create the illusion of atmospheric space. Opaques sit on the surface, enhancing the surface plane of your painting. Thus, by contrasting opaque with transparent passages, you can create a push-pull effect of the transparent color pushing back into space; the opaque pulls the eye up toward the surface. "When I attempt one of these," says Biedinger, "I *always* leave some transparent color—

never half and half." In other words, use this dynamic interplay, but make sure that either the transparents or the opaques dominate.

Finally, if you've decided to give up the overall transparency of your watercolor, you might consider adding collage elements. Paint your own papers, or buy them prepainted. You can add shapes to your painting to strengthen the overall shape relationships, to make color adjustments, and to enhance the push-pull characteristics you're after. Collage papers, however, will look somewhat like the addition of opaque paint. They'll draw more attention to the actual surface composition of your work.

So as you paint, remember that anything can and does go. Don't try to dictate to your work; listen to its feedback and make changes. Feel free to do whatever the spirit of the moment moves you to try. Spontaneity can be beautiful as well as delightful, especially if you don't restrict yourself to literal pictures of everything you see. Try letting a figurative painting break out into swirls of light and color. Or try letting a landscape shift in exciting geometrics. Anything is possible when you work *with*, rather than on, a painting.

Winter Bloom *(watermedia and collage, 15x22) started as a ho-hum floral, says Biedinger, "but once I made my decision to give up the pure transparency it was easy to 'go bananas' with acrylic gel and prepainted papers, creating a whole new look from my original concept." Although we can never draw a straight line from creativity to a final painting, it's tempting here to see a reflection of the joyous spontaneity of this approach in this very dynamic painting.*

A Fresh Approach to Florals

Big Red Canna *(29x21) makes use of dominant warm, red shapes that give it a vibrant, exciting look. At the same time, cooler blue-violet shapes prevent it from coming on too strong.*

*B*right, transparent washes and glazes of color are the perfect choice for capturing the rich, velvety look, feel, and texture of soft petals. Denser, richer greens and darks can beautifully describe stems and leaves and deep negative spaces within the flowers. But the challenge artists face is turning what could be a trite subject into a painting that has the life, vitality, and freshness that you would feel if you were to see a rose blooming for the first time. The way to do this is to go back to some of the painting basics; no matter what your subject, it's the way you handle design, color and the medium that makes a painting great. So what follows are some ways to take a simple floral concept and make it fresh by manipulating color, design, technique, and your own thinking. Ideas are your most powerful tools.

Virginia-based artist Barbara Preston chose to focus on flowers as simple representational subjects when she was contracted to produce an exhibition of floral paintings. The concept was straightforward, but it needed greater focus to push it beyond just "nice" floral paintings. So Preston made two important decisions to give her floral paintings a special, unifying theme. First, she decided to limit her choice of flowers rather than depicting a wide range and variety. Second, she concentrated on flowers that had either very large petals or were clustered together to combine groups of flowers into harmonious shapes, which provided the powerful impact of a single strong image in each painting. These are some of the techniques she employed within that framework:

Make a Color Temperature Dominant

"Most often," says Preston, "paintings that seem to work best have a primary dominance in one color temperature. Just think about sunsets, fog scenes, night-time streets or pale candlelight and you'll most likely envision a dominant color temperature.

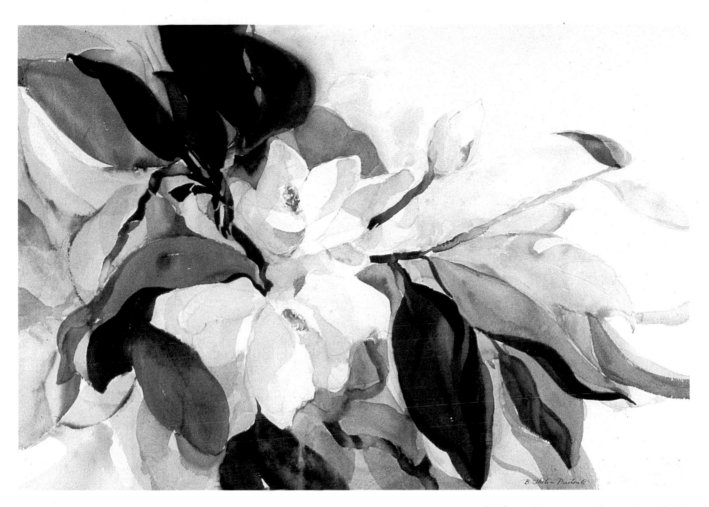

Barbara Preston used a series of thin underglazes in Magnolias in Sunlight *(21x29) to create glowing whites and subtle modulations of color that enhance the light areas.*

In painting florals, try out different warm and cool overall color schemes for various lighting effects and moods.

"This doesn't mean that your painting should be composed of primarily one hue or another. You can still achieve a temperature dominance by enhancing the main hue with colors of the contrasting temperature. In *Big Red Canna*, note that there is a dominance of large, warm red shapes. But these are played against cooler blue-violet shapes and rhythms in almost, but not quite, a checkerboard pattern. As a painter, I have a tendency to lean toward a warm palette, and I'm always searching for a slightly cooler undertone in my negative spaces. In this painting, however, I didn't want an aggressive hot/cold temperature contrast to advertise the striking red color in the painting. So I introduced a touch of warm color into the cooler areas to give the effect of a warm painting overall, but with a cool (but not cold) undertone."

Use Underglazes to Give the Glow

"I like to take a painting up to a certain point with a fairly limited color palette," Preston says. "I set the tone of the painting by beginning with a series of very thin underglazes in three primary colors of totally transparent pigments: aureolin yellow, genuine rose madder and cobalt blue. This underpainting helps me to establish where my whitest whites will be and my color dominance, and it allows a thin buildup of transparent pigment that leads the way to a beautiful glow that enhances the whites.

"As the painting solidifies, I introduce stronger, more opaque and staining pigments mixed in increasingly deeper values and colors. I also introduce 'surprise' colors in small touches of broken brushwork (see, for example, the tiny patches of very dark brown at the heart of the flowers in *Big Red Canna*, cover). These surprise colors have to be spotted around the

45

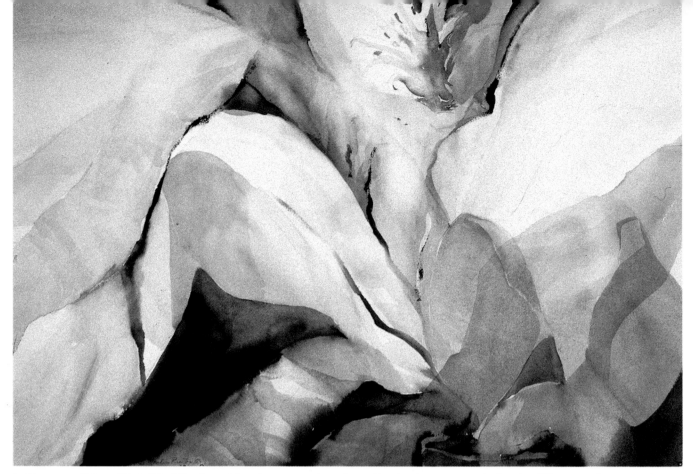

In Essence of Bromiliad *(21x29), the subject became a jumping-off point for a less representational painting with abstract, organic forms providing its main thrust.*

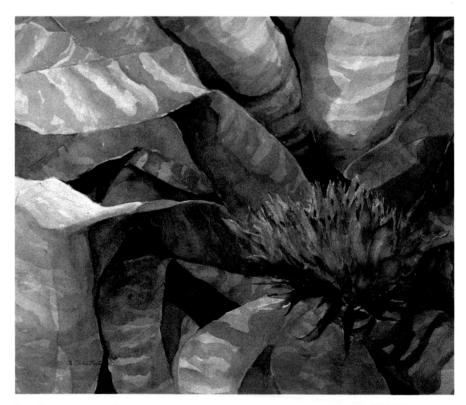

By changing to a downward point of view in Bromiliad #2 *(19x22), Preston was able to enhance the rhythmic pattern of the leaves. Here you can see how the circular, radiating rhythm creates a compelling contrast with the strong central image of the flower.*

painting in different values or mixes; otherwise, one might become a bull's eye color and not a subtly integrated surprise. I feel happily unsafe in doing this.

"In *Magnolias in Sunlight*, I discovered the big white flower shape that's strong and holds the painting together. It creates a strong center of interest because of the contrast with the dark greens and its placement just off-center in the picture. I discovered the shape first with underglazes brushed on around it. Then I shifted to a fairly warm palette of yellows and greens. Usually green straight from the tube is not only cold but very acidic and unnatural. So I mix reds and yellows in all my greens (and I mean all reds, including earth colors such as burnt sienna and brown madder). The painting then came alive for me when I introduced calligraphy and loose brushwork in cerulean blue around the leaf masses, and then edged in some cadmium red light in touches."

Absract from the Flower Forms

"Very often, after you've done a number of paintings on one theme, you can use the subject as a jumping-off point to do a more abstracted,

less representational painting. This is what happened with *Essence of Bromiliad*. I had painted so many of these flowers that when I approached this painting I departed from realism and this flowing piece emerged. One in about fifty paintings might evolve like this, in which the piece almost seems to paint itself.''

Create Rhythm with Pattern

"*Bromiliad #2* was my second painting of the same subject. I repeated the subject and the same overall painting style and color dominance, but here I changed the point of view from the first piece so that I would be looking more downward onto the flower to allow the pattern of leaves to emerge. In this painting, I first established a circular rhythm with the movement of the leaves themselves and an outward, radiating rhythm by the undulations of cool tones within the leaves. Then, within that rhythm of patterns, I created more patterns within the leaves themselves by using a series of cool, middle-tone to dark glazes applied one at a time.''

Use Large Shapes Versus Small Shapes

"If you're going to paint flowers in anything other than an up-close view, you'll need to find a way of relating the main subject to its surroundings. In *Protea and Rattan* I wanted to relate the flowers to the big 'mother' chair. At the same time this created some dynamic visual interplays and contrasts of large and small shapes. The large chair dominates the paper with its overall shape, but the flowers and leaves dominate the painting in value and color. By establishing the big shape, I felt comfortable plunking the darkest darks of the foliage in the very center of the design pattern. Notice the small variations of cool broken negative spaces in the rattan chair—hinted at in some places, stronger in others, to give the impression of pattern with light and space behind the chair.''

Protea and Rattan *(21x29) demonstrates the effectiveness of placing a familiar subject in an unusual setting—flowers in a chair rather than in a vase. The technical problem posed by the potentially overwhelmingly large shape of the chair was solved by making the small flower shapes dominant in color.*

47

Abstracting Realism in Still Lifes

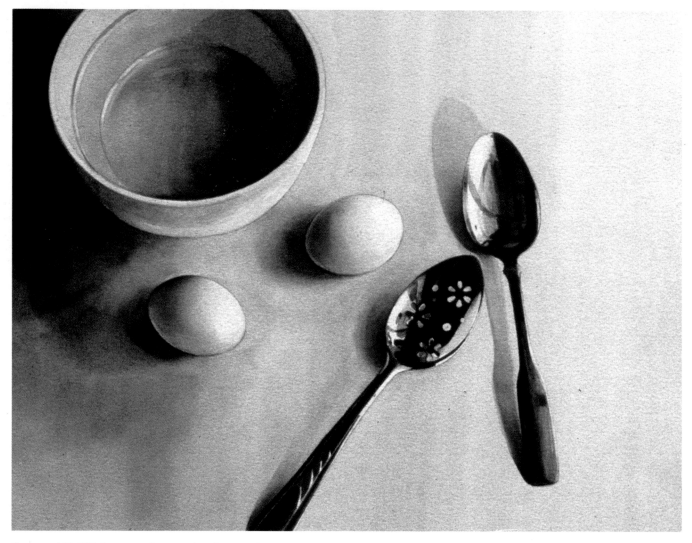

Spoons *(15x20) is a good example of how Pat Malone carefully arranges just a few objects into a seemingly simple composition with superb balance and plenty of white space, to enhance the objects. Because of this simplicity, abundant white space and careful rendering, the objects take on an added emphasis, elevating the commonplace.*

P at Malone chooses to heighten both the realism and the abstract qualities of the everyday objects in her still lifes. Although the objects are clearly recognizable—a spoon, a cup—the "almost-larger-than-life" realism elevates your awareness of the commonplace. The often geometricized and carefully arranged compositions give you the artist's unique interpretation of the scene. She has not painted just what she saw; she has tried to imbue it with a mood, an atmosphere, a feeling. In a sense, she lets her subjects "talk" directly to the viewer in a compelling way.

A few basic concepts and tech-niques are at work in Malone's paintings. She carefully mixes pure design affected by light and unusual perspective with very technically accurate renderings. All these elements merge beautifully to create a still life that may take more work than a simple copying of a plate on a table but that rewards its creator with a unique artistic statement about her world.

For Malone, "the composition is the most important aspect of my painting. To create the design, I arrange and rearrange many objects, adding and deleting until I'm pleased with the composition. With close observation, everyday objects cease to be commonplace and become ab-

stracted, pure design elements while still retaining their realism (see *Spoons*, page 48). I believe that some of my most successful paintings are those that make use of strong, simple forms and large areas of white paper.

"I'm always trying to capture a fleeting moment in which the light is constantly changing," she says. Because of this light, shadows become a very significant part of the composition "and are often granted equal importance to the objects themselves. Morning light is the basis for most of my work (because of the strength of the shadows and the angularity of the light), but I also have found late eve-

Dark Shadows (15x22) deftly captures a moment of strong, fleeting morning light. The shadows, which take on more importance than those in most paintings, form the major dark pattern that creates the foundation for the composition. Although the objects remain recognizable, the overhead viewpoint emphasizes the geometric design of the composition and the pure form of the objects. The flat table produces a shallow space that makes the objects look closer to the viewer and creates a more intimate feeling.

The subjects of Plum Good *(15x20) were rendered in a very technically accurate manner, but by subduing or accentuating various elements, the finished painting seems an exaggeration of reality; everything looks almost too good to be true. Light washes were used to establish the overall pattern. The colors and values were then strengthened by additional glazes to play light areas against dark.*

ning's shadows provide an interesting variation. In fact, nearly all of my work involved brilliant sunlight and the resulting patterns it creates, changing form and surface.''

The overhead perspective Malone often uses does two things. First, when looking down on your subject, it enables you to create a more tightly geometricized composition; from overhead objects tend to flatten out, and this emphasizes their pure form and can create a tighter design. Second, since the objects are resting either on the ground or some other surface, this backdrop creates a shallow space. Your eye stops, as the whole background of the painting becomes a solid plane. This also emphasizes the two-dimensional design qualities.

Finally, Malone strives to depict the object in her compositions in a

very technically accurate way to emphasize the realism of the forms.

"My paintings begin with a fairly careful drawing, which does not change significantly in the process. To work out the drawing, I often rely on the camera to freeze the light pattern, providing me with the necessary reference. And I supplement the photo by observing the tangible objects as I paint in order to interpret more into the painting than just the form.

"If the painting has a complex design, I'll begin to paint in an almost mapping process, putting light washes over the entire painting to establish the pattern. The washes are then strengthened and darkened with multiple glazes, playing light against dark and warm against cool. As the painting progresses, it becomes an exaggeration of reality, which I'm

able to emphasize by subduing or accentuating various elements in the painting.

"Overall, I'm constantly looking for some unique quality in my paintings—capturing the beauty of the commonplace and the fleeting moment in which the light is constantly changing in an often-overlooked or unobserved way. I look for the slight difference these subjects can make, and how I as the interpreter can convey this perception."

It is this desire to interpret what she sees that gives Malone's still lifes their greatest impact. How she translates this vision into a painting plays a vital role, but it's the thought behind her work that makes everything else possible.

An overhead perspective gives A Van Gogh Collection *(15x22) much of its impact. The shallow space and the flattened objects stop your eye while emphasizing the two-dimensional design qualities of the painting.*

Break Down
Landscape Boundaries

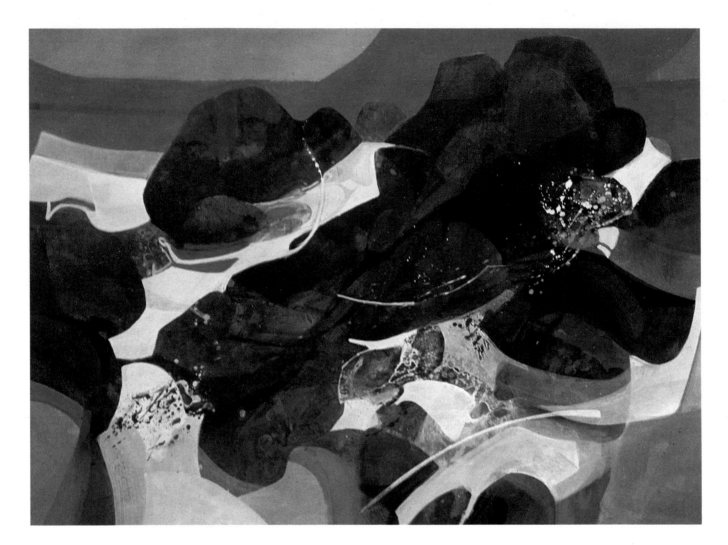

You immediately recognize Coastal in Red *(28x34) as a landscape image, but eliminating the traditional background, middleground, and foreground separations creates a unique space and a new experience for the viewer. The light-blue areas on the upper third of the painting form a transparent backdrop that recedes in infinite distance. The shapes in the middle third—the area normally reserved for the middleground—are larger than the shapes in the bottom third—normally the foreground. This was done to place the aspect of pattern first and foremost, and it also creates a kind of reverse perspective—shapes diminishing in size as they move "down" the painting. Thus, the foreground is pushed down and farther away than the middleground.*

Whenever we begin a landscape, it's all too easy to start thinking about the space of the page being broken up with a foreground, middleground, and background. After all, this is the traditional, time-tested approach, and it can be done with great simplicity and eloquence. But there are times when you'll want a more involved pattern and design, a painting with the space broken up in a more interweaving, interlocking way.

If you choose not to go with traditional landscape divisions, you'll be faced with the challenge of making all the parts of your composition share an equal importance in terms of their two-dimensional "surface" de-

Instead of the foreground gradually moving off into the distance, in This Good Earth *(28x34), Barnes makes the foreground a strikingly flat, upward plane that confronts the viewer head-on. The foreground takes up the bottom and the middle third of the painting—the area traditionally reserved for the middleground. The brown-colored shapes, because of their size, don't recede but stay on the same plane in space as the foreground. They advance more toward the surface of the painting, compressing the space and emphasizing the viewer's closeness to the scene. The bluish gray areas function as a simple backdrop.*

sign and pattern. For instance, if you think of a landscape, you might envision a watery wash of blue that covers the upper third of your paper. If the blue is transparent and fades at the horizon, you'll have created a sense of depth and atmosphere that will act as the background for the objects and activity in the closer space of the middleground.

But to break out of this pattern, you'll need to look for a way to make the sky a shape that links together with other shapes and patterns in your painting. Perhaps you'll bring the middleground higher up in the composition or pull the blue of the sky down into the area around a mountain. The same goes for your

foreground and middleground. Each one of these areas can traditionally be thought of as a horizontal band that increases in value as it advances toward the viewer (the background light, the middleground a halftone, the foreground dark). But you may choose to think more of pattern and shape relationships that move throughout the entire area of your paper to give your landscape an exotic quality.

Artist Carole Barnes works in acrylic watercolors, and nearly all her paintings are based on nature—rocks, trees, coastal areas, and mountains. She strives for an interest and excitement of shapes and colors moving in and out throughout the

page. Although clearly recognizable as landscapes, she seldom composes with the traditional horizontal bands of foreground, middleground, and background.

Barnes takes a loose, imaginative approach to layering shapes and colors. "Often the subject is unknown as I start a piece. I simply enjoy the playfulness of pushing paint onto paper, loosening edges with water, texturing areas with brushmarks, or stamping into the surface," she says. Her working process involves painting intuitively; critiquing the work she's done; then layering more shapes, colors and values; then critiquing again; and so on. And she works over the entire page at one

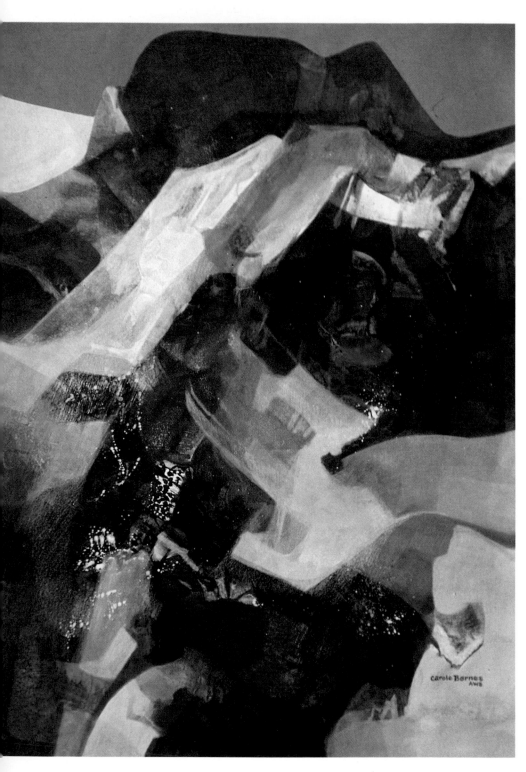

Like most of Barnes's work, Mountainscape *(34x28) began with "intuitive play" with loose washes on paper first coated with a thinned-down mixture of acrylic gloss medium. This produces a "hard" surface on which acrylic washes can be more easily lifted and manipulated.*

time to ensure that her entire picture area is well composed of interlocking shapes, values, and colors.

"After I've painted shape upon shape, color upon color, and slipped in some line and texture, I begin to respond or show enthusiasm for parts that look interesting," she says. "At this point, I may stop my intuitive play and begin to evaluate. I ask myself mainly these questions:

1. Is it more interesting as a vertical, or is it better as a horizontal?
2. Does it have rhythm or movement that is pleasing?
3. What subject am I flirting with?
4. If it's beginning to evolve into a subject, how can I strengthen this and the composition?

"I try hard to save the areas of the piece that fascinate me, or that I think have hope. And at this point I attack the areas that don't work toward the whole. More layers of acrylic are then added. Some areas may be whited out and painted again when dry.

"I prefer to work on Strathmore Aquarius II paper, which I have 'sized' with a thinned-down mixture of gloss medium. Because this produces a hard surface on my paper, I can erase layers of acrylic by dabbing with rubbing alcohol (on a cloth—a technique that is difficult to control and should be approached only after a little experimentation)."

This flowing, evolutionary approach can help you break your landscapes out of the traditional background/middleground/foreground formula. The key is in concentrating on the so-called abstract elements first and foremost. And be aware of variation. Your painting may have its major activity in, say, the middleground, and have a distinct background. You don't have to destroy this relationship if it occurs; just acknowledge the fact that you don't need to automatically paint in a foreground. The same is true with any of the formal landscape areas.

In this detail, you can see the actual layering of transparent acrylic washes. Each layer appears to mingle with and act on the layer below it.

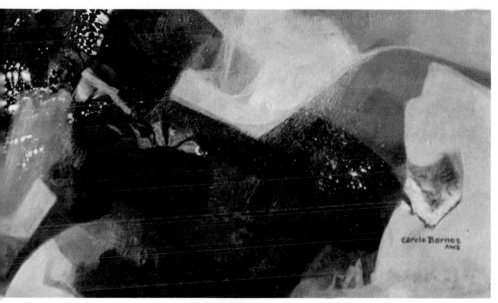

White acrylic, when thinned down, will create a milky transparency. In this area, white was lightly brushed over a dry blue form leaving a translucent haze perfect for depicting a mountain atmosphere.

Random spatters of opaque white acrylic create effective highlights here. Too much, however, can destroy the overall look and feel of the transparent layering technique.

Capture Motion in Your Paintings

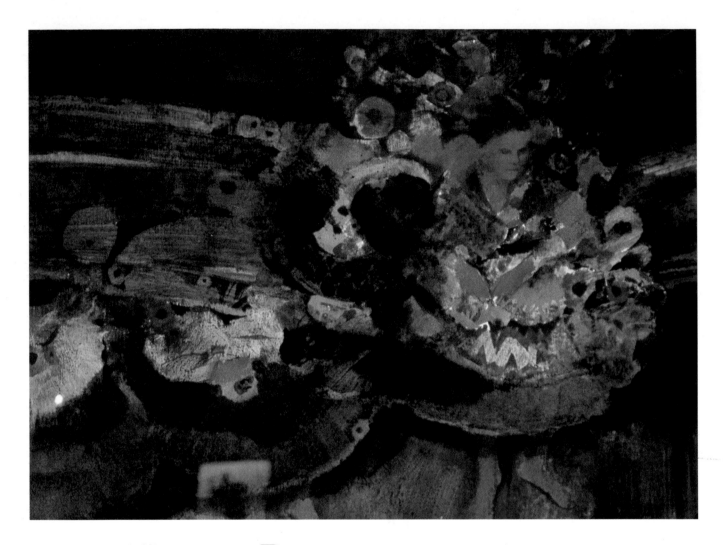

Mexican Dancer (22x30)
Oscar Velasquez

*P*ick up a copy of *Sports Illustrated* and you'll find some marvelous photography—John Elway with his arm looking like the Statue of Liberty's, frozen and locked upright into place, the football suspended in the air inches from his fingertips. High-speed film and telephoto lenses can stop the quickest action, freezing a moment in time. They can capture every bead of sweat flying off a boxer's face as he's hit with an uppercut.

But when we're sitting in the stands or at ringside, we don't perceive motion in that way. Our eyes don't see like the camera lens; they can't stop action or magnify detail from a distance. In doing a painting of motion you can, of course, choose to stop the action, or you can paint motion so that it more closely resembles the way our eyes actually perceive it.

Capturing motion live, as it were, can bring a new vitality to figurative painting. Think about the soft edges and fluid lines in Degas's pictures of ballerinas in motion, for example. You're drawn into the picture by that illusion of action, that feeling of spontaneity and immediacy. But how do you achieve that effect?

First of all, artist Oscar Velasquez recommends that you go with your first impressions and try to capture the overall color and gesture—the whole image—in one sweeping motion. Even a series of swift, complex movements, like those of a dancer

across the stage, can have one over-all gesture and effect. Look at the movement and then close your eyes. What do you remember about the entire scene? What blurs and streams of color and light stand out in your mind's eye? As you start to visualize your painting, think about these factors:

1. Can you incorporate multiple images into the work? You'll most often see this technique done in illustration—the kind of thing where you see, say, three images of the same body, each with a gesture showing the development of the motion, much like a series of Muybridge stop-action photographs. This is fine for illustrating a particular motion in a technical way, but it will probably be too stiff-looking if you stick to the concept with too regular a pattern. Instead, think about the way the human eye perceives. When we see, our eyes take in information in small, bite-sized perceptions; we can remember the main points of a moving gesture, but the spaces in between may appear just a blur. It's not like stop-action sequences; it's more like mini memories of the key, most influential poses. Where and how you choose to paint these pauses between actions can depend on your own vision, your likes and dislikes, and your composition itself.

2. Blurred edges are almost a given when capturing motion the way the eye perceives it. You can most effectively use blurred edges to indicate the direction of the motion. If an object, for example, is moving to the right, the leading edge may be much more crisp, while the motion may appear as a tail trailing behind it. By the same token, if all of the edges of an object are blurred, you'll achieve an effect more like an out-of-focus photograph—you'll capture a sense of distortion, but the viewer will see little of the object's directional movement.

3. Next, look for ways to force your composition left, right, up, or

down. A strong movement to a center of interest close to the perimeter of your painting can do three things. First, it will fill most of the area of your painting with motion itself, giving that a special emphasis. Second, it can make the viewer feel as if he's caught something just out of the corner of his eye, the way you might perceive a fish jump unexpectedly on the side of a still lake. And third, so many paintings are based on dynamic symmetry (the center of interest placed off center in one of the four quadrants of the picture) that you can give your viewer a mild shock by jarring his expectation. You might want to work on a long sheet of paper (horizontal or vertical) to project an even stronger directional thrust in your composition.

In this detail from Mexican Dancer, *multiple images of the dancer's feet and dress capture incomplete images of the way our eyes see in quick, mini-perceptions. The repetition of shapes creates a strong thrust to the right, emphasizing movement in that direction.*

The face of the dancer gradually moves into focus as she "slows down" in this detail from Mexican Dancer. *This is the way our eyes would actually see her movement. Finally, all the motion in* Mexican Dancer *is played against the crisper lines of the face, which show stopped motion, create a focal point, and effectively ends the movement as shown in this detail from the painting.*

Challenge the Viewer's Expectations

Eccentricities (74¹/₂x38) emphasizes layers of space and ambiguities of scale. By creating various movements in various layers of space with transparent watercolor, Joseph Way creates an infinitely expanding depth that makes you wonder if you're looking through a microscope or a telescope.

When you apply a crisp wash of watercolor to paper, its transparent quality naturally lends itself to the illusion of space and depth. A wonderfully juicy ultramarine blue can have a penetratingly deep look of sky, for instance. This quality of watercolor is particularly helpful in painting landscapes, other outdoor scenes, and atmospheric renditions. Basically, this deep, atmospheric quality is often used as a kind of backdrop, like a frame of reference against which you can anchor foreground subjects. This is a fairly traditional approach to picture-making.

Break this rule, and you encourage viewers to approach your work with a new attitude. They can't just look at it; they've got to respond or relate to what's in front of them. Take away the usual structures, and watch what happens.

Joseph Way wants reactions—not passive viewing—so he begins his large watercolors (sometimes 4x8 feet, done on rolls of Arches paper) by underpainting lines, and geometric and biomorphic shapes. At this stage, his intent is not to break up the pattern or space within his picture area but to create an overall layer of activity within one plane of space.

On top of this he overlays a "background"—washes of paint that represent another plane of space and activity. In this layer of space, he may push for dominance of shape, forms, or line, or his goal may be to create a layer of atmosphere to relate to subsequent, closer planes of space.

To further confound his audience's expectations, Way uses salt and sand to create surface texture and "craters of interest." And he often goes back to lift paint that's settled over underpainted shapes to reveal them in a new, lighter-value light. (See pages 142-147 for details on his technique.) He finally builds up to a painting surface that may be enhanced with small flecks of gold leaf that glisten and encourage the viewer to experience the painting from various angles and light directions, to lean around it and study it.

But the overall goal here is to

think of your entire picture plane as a series of layers of space. Within each layer of space, you can, as Way does, create shapes and "events" that intermingle and help define the position of each spatial layer. You can create a number of layers and work with the color, intensity, and value of your watercolors to push some planes farther back in space and bring others closer to the surface.

Because the emphasis here is on planes of space (not depicting form or traditional depth) and on creating an illusion of energy and movement, you can, as Way does, strive for an intriguing visual phenomenon. When painting shapes energized within layers of pure space, you realize that you could be looking at microscopic fields or landscapes as seen from space. Are you looking at the bug spots on your car windshield against a backdrop of blue, or are you looking at the forms of algae within layers of transparent water? There is no answer, nor is there a need to determine the exact subject matter. The

point is the ambiguity itself. By painting many layers of space, you can create that added sense of intrigue for the viewer—a sense of wonder and engagement with the painting. This opens up new, imaginative possibilities. Way, for instance, finds inspiration for a painting simply by looking at what he sees with his eyes closed.

Opening up new horizons is an essential part of expanding our creative consciousness and our artistic vocabularies. We need to recapture the wide-eyed, delighted view of the world we had as children and that innocent eagerness to share it with others. Although everyone develops his or her own creative style, like the mixed bag of artists you've met in this chapter, the joy of exploration runs through the idea of creativity like a sparkling stream. Good luck following your stream. Perhaps it will lead you on many exciting voyages of discovery.

In Alla Tedesca *(40x60), the small, yellowish spots and yellow squares are enhanced by the use of metallic powders. You can see the impact these tiny brights have on the painting as a whole.*

I M A G I N A T I O N 3

Take Ideas to the Limit

If the essential ingredients of creativity are finding ideas, then imagination is the art of interpreting and expanding those bare essentials. It's putting yourself in the right frame of mind to ask questions, explore possibilities. It's letting go of all your fears and inhibitions, doing what you feel is right—not what somebody else says is right.

Now let your imagination roam for just a minute. Imagine that you're small, so small the water drop you're swimming in seems the size of an ocean. Suddenly, the drop crashes down on a rose petal and you see thousands of water fragments bursting out in all directions, beautiful red light refracting through the entire atmosphere. Or imagine you're floating in space and with one stretch of your arm you touch Jupiter or Saturn.

Try another experiment. Make some random strokes and blobs of paint on a piece of paper. Look at the swirl of colors. What shapes—people, animals, objects—did you discover in there? This basic imaginative process depends on the flow of thoughts and images stored in your mind, and how your mind brings them together. It's no longer just what you've found but how you use it. It's what you bring to the process that counts now—it's carrying your ideas that one step further.

All the artists in this chapter explore external perceptions and inner images, but in different ways. For instance, some, such as Judy Richardson Gard, meditate, taking themselves on a mental journey. Other artists focus on reinterpreting what they see. They change the perspective or break the world into patterns and shapes. Still others carry theory to its furthest limits, painting what exists only in their minds. Remember these approaches as you make your way through this chapter and discover the processes and techniques that can help unleash your imagination.

Florida Sunset File *(28x22) Miles Batt*

Imaging a Painting

Sometimes imaging enables us to make giant leaps, connecting ideas and visions we wouldn't ordinarily put together. Judy Richardson Gard's mental images of mountains came from her mentally linking earth forces with the force of waves in the sea. Notice how these linkages are carried even further in Time of Frozen Tears (36x48). *No landscape like this—part mountain, part wave, part glacier—exists in nature, only in the land of the imagination.*

Suddenly, somewhere, anywhere, you see it. A patch of sunlight highlighting a small child's face. The first hint of fall coloring the trees. The exciting sweep of an exotic beach with glistening water and exotic foliage. Raindrops on a flower. Whatever sparks your imagination, captures your interest, you're fired up and ready to paint.

Of course, finding great painting subjects isn't always that easy. And the approach I described doesn't take into account the images and subjects that exist only in your mind, which are just as vital. The outside world is an endless source of stimulation, but the inside of your own imagination is just as vast. In fact, it's sometimes difficult to separate the two; what we see in nature becomes ingrained in our subconscious. Our internal, imaginative images are often formed by unusual juxtapositions and combinations of things we've actually seen and experienced. But where do these internal images come from? And how do we tap them?

As a living, breathing artist, you bring all of your experiences, insights, memories, and visions into the painting process. You become a reservoir of images imagined and seen. The process of pulling them out and putting them together can take any form you want. This is what makes you unique. The point is to be aware, and make use of, your imaging and conceptual skills—actually practice them. The results will arrive like an unexpected, but close, friend.

Developing and Rendering Visual Images

Judy Richardson Gard finds that "most of my paintings evolve from a

series of visual images, both real and imagined. These images are collected over many years, and they come from many places. There are times when they seem to automatically fall into place, and a painting results immediately. Other inspirations grow more steadily and slowly. They just seem to 'leak' out of the brush when they're ready."

Gard has adapted the techniques of meditation to the development of ideas in a process similar to that popularized by sports psychology. Her experiments with imaging evolved from her dislike of novocaine to control the pain of dental work. She began practicing relaxation therapy instead. "My dentist allows me time to be seated and to relax before he begins drilling. I mentally unplug my pain circuits and go elsewhere while he works. Once, I took an imaginary trip on the back of a big white bird flying over the Andes. From these pictures in my mind came the color and forms used in my mountain structures."

Once the visualization process is finished, "in the studio, I put a 32x40-inch piece of Crescent 100 percent rag board on my drawing table. I try to put myself into a relaxed state upon beginning. As I look at the paper's white surface I begin to 'see' mountains again.

"No preliminary drawing is needed. The work begins with textures achieved by painting directly on plastic wrap and stamping texture where I see ledges emerge. These indicate forms which are then glazed with other colors, or left with white paper showing through. Throughout the painting process, textures are formed with plastic papers layered into wet washes, then removed; or by blotting with paper toweling. I always proceed with the thought of the magnificent forces within the earth. I try to convey this feeling with the tipping and slanting of form against from, as well as in overall composition.

"The painting is periodically positioned on a vertical easel, and I look

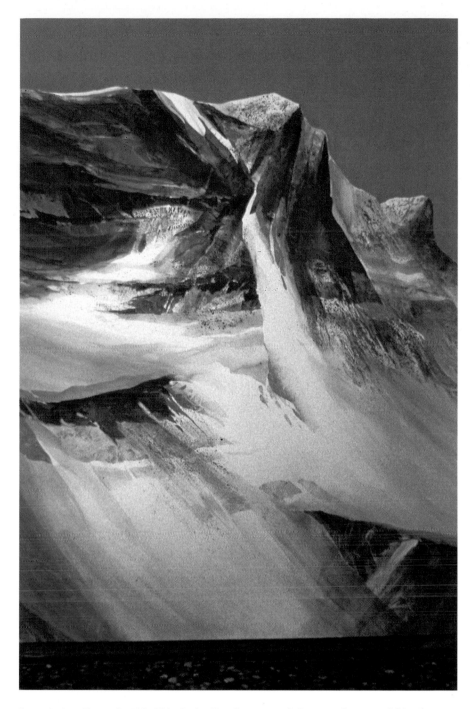

In painting Summit (40x32), Judy Gard conveyed the vast forces within the earth by building her composition around tipping and slanting forms that create dramatic thrusts and visual energy. She started this painting by stamping textures of paint onto the surface near the rock ledges with plastic wrap, then adding successive glazes of color to subdue some of those areas. In addition, thin, sweeping veils of color applied in very thin washes create a lighter effect that balances the weight of the darker, heavier forms. Texture was created in various areas by stamping and blotting watercolor onto the paper surface and allowing the undercolor (or sometimes white paper) to show through. In other paintings, she may lay a plastic sheet over a wet wash and pull it off, also creating texture.

Margo Bartel started Foxfire *(22x30) in her usual way, "with three very pale glazes, trying to let the paint 'tell me' its theme. Fairly early in the painting I saw the abstract tree shapes. The red glow was also there early. I added more glazes, following my early shapes and putting in the trees. I painted darker and darker glazes, especially in the foreground, to achieve a deep-forest effect."*

at it for a long time. Compositional adjustments are then made as the painting dictates. A thin, neutral wash will push an area back, while a key dark or brightly colored passage will bring an area forward.

"Contrast and surface variation are achieved by many layers of color in some areas, while in others, these qualities are conveyed by only the thinnest veils of color. Some passages remain white paper and are tempered only in the finishing process. Shapes are constantly monitored so that they link and interact. Occasionally, a wash seems too ethereal or atmospheric to convey the strength I want. When that happens I'll mix white opaque gouache with my colors for body. The surface of the rag board is very receptive to this layering, as well as with the many transparent glazes I use."

Try Gard's visualization techniques. Begin by closing your eyes. Let go of your body; concentrate only on the feeling of breathing in and out. Let any stray noises or impressions simply float through your mind. Now think about a place, a sort of person, or a type of object that you'd like to paint. Don't try to actively create an image; let it build up slowly in your mind. When you like what you see, open your eyes,

and go straight to your studio. Assemble the materials you need to render your vision. Try to visualize your mental picture on your surface, then let it flow out.

This technique may take a little practice before it feels natural to you, especially if you've never tried imaging before. Just relax (the original point of the exercise for Judy Gard) and tap your inner resources. You may be quite surprised and delighted by what you find there.

Transform External Images with Inner Visions

Now let's look at the way we can draw external images into our internal image bank. Begin by looking at the world around you. That doesn't mean just seeing what's there; it means being vitally aware of every aspect of an object or a scene. Margo Bartel often turns to nature for inspiration. These are four approaches she uses to focus in on what she sees and to tuck it away in her memory for later use.

1. Observe colors everywhere and analyze which are the most pleasing to you.
2. Find the subtle variations as well as the bold contrasts of the colors in the landscape, and position them in your memory.
3. Look for shapes that you like, both large and small, and store them in your memory, too.
4. Constantly sketch scenes or objects that are pleasing to you. Having sketched something even once puts it that much closer to your recall powers.

Although Bartel draws inspiration from nature, she doesn't drag her paints and easel into the field to paint in order to imitate what she saw. In fact, "I don't begin a painting with firm notions and preliminary sketches of what the imagery will be," she says. "Besides, (when I do that) I have a tendency to follow pencil lines with my brush—not very creative or spontaneous. Instead, I allow

the paint to guide me."

There are some preliminary decisions that set up the environment to begin the creative flow. This is where that process of internal imaging begins; Bartel doesn't want to duplicate an existing reality but tries instead to create a new one. "First off," she says, "I ask myself what color or mood I wish to create, deciding whether I want the colors to sparkle with warm reds and strong contrasts or whether I want a misty look with soft blues and violets.

"I start each painting with approximately three pale, abstract washes of acrylic paint (used like watercolor). Then I allow my imagination to take over, choosing images out of the shapes I see there. This process is like finding playful images in cloud or rock formations. If I see nothing, I apply more paint, searching for interesting color combinations, brushstrokes or areas that suggest subjects to me.

"I try to paint randomly, varying the direction of the strokes and the width, using the end and the side of a large brush to make angles and curves. I save several strong areas of white as major points of interest; one will become the focal point. When I've dried the first layer with a hair blower, I add the second layer in a different color, retaining the white areas. When the last of the three layers is dry, I take a break and let my imagination run loose.

"This is when I need to be most receptive. I look at the paint and try to consider all kinds of possibilities. I turn it upside-down, horizontally, vertically. I prop it across the room and study it carefully before deciding what to do next. I ask myself, 'Do I see mountains, cliffs, water? Do I see arches, high-rise buildings, bridges, figures?' If there is still no theme, I simply emphasize areas that I like by painting another glaze or two. I might add a few strokes at a time to develop both the darks and lights. I allow what's there to guide me, trying not to impose something entirely different on the piece. The

colors may change a bit as I work because I can build almost anything over the first acrylic washes if they're pale enough.

"When I have a clear direction, I search for ways to tie the painting together, and I make design changes. The images are then built up with layers of color or even white gouache thinned with water. I apply this in thin layers so that the original design shows through slightly. This keeps the area in context with the layers, while providing a lightened surface on which to make corrections and continue painting. Details brushed on with a small brush come last, and at this stage I also try to strengthen the focal point with added contrast."

Although Bartel's imaginary landscapes retain ties with the original reality (a tree is still a tree, for example) she builds on that first image to create a new image. Between her initial vision and the final painting lies a journey through an internal landscape that may change along the way. Around each bend is a potentially exciting discovery that can expand the original idea or concept. You can use this in your own painting by learning to see your own inner pictures. Find out what happens when you draw a vague memory onto your mental screen. Manipulate it

Evening Glow (24x30) started with thin washes of acrylic on paper from which a panoramic landscape image emerged. Again, Bartel brought the image into focus by applying more glazes of color to give definition, and adding the opaque blue shapes in the foreground for color contrast and visual weight.

To get a feel for Bartel's imaging process, try it yourself on these freshly started paintings. They were all begun with three washes of acrylics, allowing the paint to flow into interesting patterns. Now, just step back (as Bartel does) and see what unique images you can find here. Bartel offers the following insights:

1. I like the blue shape in the lower left and the cross strokes in the lower right. As I studied the painting, it gave me no suggestions about what it would be, so I strengthened the shapes I liked, accenting the darks and bringing out the lights. The only thing I see here is a field, suggested by the windswept look across the bottom.

2. Although too much water caused lost edges in the center, I see possibilities of mountains or fields but no flowers. I might emphasize the red mesa shape (above center, to the left), and make the area above it part of that shape. I'll also de-emphasize what I don't like, such as the dark-blue spot, but enhance other areas.

3. I don't have strong ideas about this one yet, though it would certainly be a red painting. I like the swirl of shapes in the center, and I'd save those as well as the ones above them. The lower right seems ambiguous, so I'd probably strengthen it with other reds.

any way you like. Then relax and let out your own realities.

Using Stored-Up Images and Concepts

Miles Batt draws inspiration from a slightly different source. He taps his unconscious mind for ideas and concepts, rather like painting a remembered dream. And like a dream, the connection to reality may be tenuous, but it will always be there.

Batt finds that "internal images are produced by the subconscious. I receive—rather than summon up. Often, I receive (mental) images of completed paintings. Recording these images in an idea book provides a reservoir of compositional ideas." However, these ideas "do not spring from a vacuum. I regularly search for subject matter, fresh compositional ideas, and symbolic meaning as a conscious, 'external' imaging activity."

Batt puts considerable energy into the thinking process before painting. Once he has a clear idea of the piece, he then begins painting. It's an

approach that's tighter in the actual painting process but incredibly open in the conceptual stage.

Then the process becomes a bit more complicated. What do you do with a storehouse of images and concepts?

The power in Batt's paintings comes mainly from the contrast and juxtaposition of the similarities and opposites within one painting. For instance, in *Grand Larceny*, he drew on the similarity in color and flatness of a warm sky and a manila envelope to blend two highly unrelated elements into a unified landscape. At the same time, the red tabs and string arrest our attention, calling our attention to how different from one another they are. The surprise stops the viewer in her tracks with wonder that two seemingly disassociated objects can come together in one creative statement.

Like Batt, you can play with perceptions of reality. What if there were no gravity? Would snow fall? And what would it look like? You won't find an answer looking out at

Grand Larceny (22x28) is a good example of putting together images that at first don't seem to belong together. It's both an envelope and a landscape. The buttons, string and border around the painting were first masked out. Then, Miles Batt built up the image with layer upon layer of watercolor applied to hot-press paper with an airbrush.

the external world, but you can find one looking at your own internal one. Try to visualize first the essence of falling, then apply that to snow. You probably won't come up with the same results Batt got in *New Snow, Boston Mill*—even though you've used the same technique of internal imaging. But you've tapped a totally unique source for expanding ideas—your mind's eye.

As an experiment, turn this painting upside down and backward. You'll discover an important insight into New Snow, Boston Mills *(22x28): no matter which way you turn the painting, you experience a sense of falling. Batt challenges our perception of snow. "It doesn't have to be white," he says, "and it doesn't have to look like snow." The important thing was to capture the essence of falling, and falling in all directions. To paint the piece, Batt did a number of drawings of the Boston Mills ski resort to get to know the architecture of the place and understand the shapes. But these drawings were used only to get the feel of the place ingrained in his mind. The actual painting was done spontaneously, with no direct reference to the drawing.*

From Your Mind to the Paper

Marilyn Phillis began Amalgam *(watercolor and gouache, 30x19¹/₂) by masking out the linear elements with masking tape, the larger, light-valued shapes with sheets of acetate. This created the overall structure of the painting, around which more spontaneous washes, spatterings, and drippings would lead her to the final image representing the forces of nature. The spontaneous drips and washes of color create exciting, organic shapes that play against the more hard-edged geometricized forms. Wet-into-wet blendings help create the soft edges and gentle transitions of color.*

"Planned spontaneity" may sound like a contradiction in terms but for some artists is actually a very effective way of working. Marilyn Hughey Phillis takes this route. She generally begins a painting with wet-in-wet washes brushed over her paper, without a concrete idea of what the final subject matter will be. "I try to begin a painting with as few restrictions as possible and let intuition be my guide as I respond to what is developing on the painting surface," she says. "By being open, I don't block the visual images which come through at this time. The relationships of shape, texture, and color all contribute to the creative action that gradually becomes the expressive concept."

"When this first stage of painting is dry, the hard work begins for me," Phillis says. The thinking part comes when I must look at the early evolving forms and try to read what they are suggesting. This, then, is the time to analyze, refine, decide on the direction the piece will take, and develop the emerging concept. It often takes me hours, days, or even weeks to work through this process. I may do some drawing or tear up pieces of various valued paper and place shapes within the painting to see where I need to adjust value or shape. I may wipe out color with a sponge, or I'll cut a stencil to the proper shape and then lift out color within the stencil. With practice, you can develop a real sensitivity to this process of manipulating shapes and colors until you see an image or a direction emerge.

"Once I make the decision as to the direction of the piece, the resolution of that may take some time, but it's not difficult. After my first stages are dry, the paper may be rewet in places or in its entirety, depending on what I'm developing. There may be areas where subtle color changes are made through successive glazes. Or I may adjust the color and texture with watercolor pencils, collage elements, metallic powders,

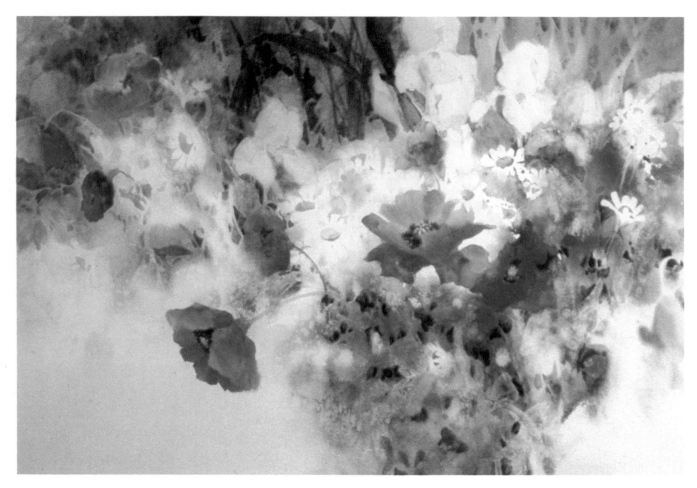

Garden Memories *(20x30) started out as purely abstract washes of color in amorphous shapes. But after Phillis analyzed the painting in progress and read the early forms to see what they suggested to her mind's eye, the flower shapes appeared. These were then refined with negative painting and the deliberate inclusion of more defined shapes and forms, such as the flower in the lower-left area, set against the light background.*

inks, acrylics, or over-glazing with gouache. However, I never like to have these elements distract or draw attention to themselves. They must be an integral part of the painting and should be discovered gradually on close examination. A painting should stand as a whole statement, not as some exercise in technique.

"There is a tremendous energy and a sense of structure within the earth. My two paintings, *Amalgam* and *Emergence*, evolved from the contrast of energy lines and color played against geometric symbolic shapes representing the powerful structural forms and forces of nature. I began these paintings spontaneously by laying down shapes of acetate and masking tape as beginning structural guidelines. Only the major shapes were placed and a few long, thin masking-taped curved lines added.

Then I added what now seems like a dance of color; I just had fun with the play of washes, spatters, drips, and fusions of color areas.

"Overall, my paintings are most successful when new discoveries are made with every viewing. In that way, the pleasure of seeing a painting is ever renewed, and the work becomes like an old friend who is a pleasure to see and never boring."

Obviously, this means more than simply doing what you feel. Your subconscious needs images to draw on; you must have built a storehouse of mental images for it to work with. Whether the painting that develops is more abstract or more representational, Phillis continually seeks inspiration in the world around her. "Keeping my mind filled with images and concepts for possible painting ideas is not difficult. I spend a lot of time

just looking and absorbing what is around me. I also spend a considerable amount of time reading a wide variety of subjects beyond art—psychology, philosophy, quantum physics, biological sciences, history, poetry and natural history. My original background in the sciences has had a profound impact on my work."

Planned spontaneity is freedom within discipline. It means being open, going with the flow. Sometimes that can be very hard to do; we're often made to feel that our art is only rewarding when we're working hard at it. Learning to work without a definite goal or structure can be very liberating. At the same time, we have to remember that painting without any direction at all is little more than throwing paint on paper.

Emergence (14¹/₂x21¹/₂) "evolved from the contrast of energy lines and color played against geometric symbolic shapes," Phillis says. Initially she went with the flow, doing what she felt. "I just had fun with the play of washes, spatters, drips and fusions of color areas." Then she studied what she had created and decided in what direction she wanted to take it. Now a wide array of techniques came into play. Phillis used wet-into-wet blendings (upper right), successive glazes for all of the medium-value transparent areas, spattering paint into wet areas (upper middle section), and lifting of minor details.

Painting the Feeling of Motion

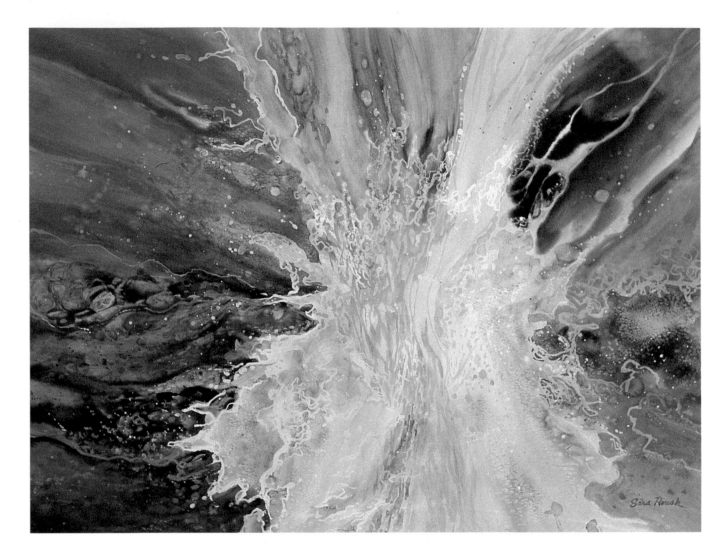

Splash #2 (30x40) depicts the motion that comes from water flung on a surface, frozen in action. The concept is not the actual depiction of water but the overall feeling of a splash.

*F*or Sara Roush, "turning off my conscious mind and tapping my subconscious is the only real resource I have." She even jots down titles, words, and images on paper to get into the thinking and visualizing process. This is not to say that the job is to record those visions exactly as seen. Instead, use imagination for bits and pieces of paintings and as a jumping off point to get into the work.

In the case of *Splash #2*, the idea of a splash led Roush into concentrating on the abstract element of frozen motion as the main focus of this piece. She was not after a realistic depiction of an actual splash. Instead, she was after the motion it-self—the kind of motion that comes from water flung on a surface. The fluidity of water and the action involved are the inspirations here. Roush then matched her technique and approach to the painting with the subject and motion she wanted to express.

To get this kind of energized motion down on your paper, you have to go at it with the same kind of energy. In a way, you need to empathize with your subject. Just make yourself feel wild and energized, and release everything pent up inside you. This is your chance to do anything and everything you've thought about in your wildest painting dreams. Spray on frisket. Fling your paint at the pa-

The painting started with applications of liquid frisket to look like foam and rivulets coming from the main, light shape.

per. Smear strokes of it across the paper.

Roush gets so caught up in the act of painting that she always gathers up all her supplies before getting close to the paper. She knows "there won't be time to locate them during the frenzy of the actual painting."

"If I feel lucky and creative, I choose a 30x40 sheet of heavy-weight, Crescent #1 illustration board with a cold-press rag surface, or a sheet of 140-pound Fabriano Artistico hot-press paper. Both of these surfaces require little drying time." In addition, she puts out paper towels, various synthetic brushes ranging from a 2-inch wash brush on down to a No. 8 round, a No. 8 Chinese brush, a rigger, a No. 6 oil-painting bristle for lifting, a spray bottle filled with water, a hard-bristle tooth brush, clear masking fluid, a small cosmetic brush, and table salt.

Once the preparations were made, the painting process for *Splash #2* flowed very smoothly. "Without drawing on the board, I applied masking fluid with a very thin brush to look like foam and rivulets coming from a main shape. I also flung some of the masking fluid on the surface for drops and let them dry.

"Then I wet the surface thoroughly with a large kitchen sponge, and allowed this to soak into the paper. I then applied the first brushstrokes, after making sure that the white area was well placed because that would be my center of interest. Having protected the white area with masking fluid, I flailed away at the paper, trying to create all sorts of mad, wild strokes. After this burst of energy, I applied salt sparingly where I needed its texture. Then I walked away. I never go beyond this stage without allowing for ample drying time, or all is lost. (It's also time to forget the painting and do something else.) When the painting had sufficient time to dry, I removed the masking fluid and assessed the 'damage' I had done to the beautiful piece of paper."

After that came the process of critiquing and adjusting the work to

Then, wild strokes of color were applied in bursts of energy to capture the feeling of motion.

To finish, color was layered over the top, some areas were lifted and lighted with a damp bristle brush, and salt was added and brushed away for texture.

It's easy to apply Sara Roush's techniques to subjects other than water. In Outer Banks Revisited *(26x32½), the swirling forms and interlocking patches of light and shadow convey the movement of the sand dunes. The subject is both the dunes and their perpetual motion in the wind.*

fit Roush's original vision. "Often," she says, "not being able to make much out of it, I turn it sideways or upside down. At this stage, I layer in more color or lift some out with my bristle brush. If the statement needs to be more powerful, or the surface lacks interest or depth, I add either acrylic paint or gouache."

Finally the evolution of the work is complete. "When the painting is finished, I carefully brush from its now-dry surface all the grains of salt." Roush is her own harshest critic. "If I can bear the sight of the piece after several days, my satisfaction is complete."

Painting the feeling and excitement of motion itself, not the actual depiction of water, was the main concern of *Splash #2*. The splash was just

the jumping off point for a work that's about energy and motion. Once Roush had her basic concept in mind, she set herself free to express it. Although Roush initially does what she feels, eventually she has to come to terms with self-expression so it will have meaning to others.

Expressing the idea of energy through, as well as in, your painting isn't the only use for Roush's approach. Think about other painting concepts and the techniques that might enhance them. Tranquil lakes might suggest juicy washes of transparent color. Ripples around rocks could suggest calligraphic brushstrokes. Rushing streams could suggest more vitality. Think of these scenes in terms of their intrinsic shapes, patterns, and energies.

Plan for
Maximum Effect

As part of the data-collecting process for Golden Pond *(22x26), Barbara Osterman made sketches of the scene to capture the shapes, colors, and patterns. In this sketch done with pencil and a warm-brown marker, she analyzed the movement, direction, and shape of the rock pattern.*

In this key reference photo, Osterman was able to capture the intriguing orange-colored light, strong shadow patterns, and light glistening through water, which she used for further study in her studio. Here the stream has already become a "pond" for Osterman; the emphasis is on the static area in the foreground. You have to look pretty closely to catch the ripples and movement in the darker background.

Whenever people listen to an artist about planning a painting, faces droop and eyes glaze over in boredom. Everyone seems to think that this means plotting out every tiny detail and brush mark in advance—thereby eliminating all of the spontaneity and much of the fun. If that was really the case, all this boredom would be justified. What planning a painting really boils down to, though, is the marriage of content, form, and medium based on some conscious choices. It doesn't have to be limiting. You can even plan to be totally spontaneous. The distinction is that you've made a deliberate decision rather than just tossing paint at your paper. In other words we're talking about freedom within a framework of ideas and intentions.

To start out, think about what you want your painting to do, say, or be. What is the *idea* behind your painting? Where else can you take it? What kind of mood or atmosphere do you want it to have? Do you want to do a very lifelike painting or something more abstract? Will design and composition be the most important elements? Maybe you want to experiment with new mediums? If you're working in a series, you're probably already searching out your idea in variations and exploring its nuances. If you're between painting ideas, rely on your sensitivity and simple whims, your likes and dislikes to guide you. Just remember that you're not locked into the decisions you make at this point. This is your point of departure, not your ultimate destination.

Artist Barbara Osterman, whose planning methods we'll explore here, starts each day open to new ideas and combinations of feelings based on her past experiences. How you interpret an event, a sight, or a situation gives it a significance that will in turn affect *what* you include in your painting and how you depict it. The more of yourself you bring to a painting, the more you can imbue meaning into the things you see. This will add a spark of excitement and drive into your work. For Osterman, past experiences help determine "what subject matter I will notice; so each painting begins with the past and helps me make new discoveries in the process of its evolution."

For an example, look at Osterman's painting, *Golden Pond* (see page 77). The concept began with experiments in portraying light with color. "In order to paint just pure light," she says, "I had eliminated subject matter by reducing the painting to grid patterns. However, pure light wasn't satisfying enough, so I began to paint layers of shifting grids in order to give a sense of moving light in space. This, however, was still too abstract, so I had begun to look at light through water." By keeping the process "open," she let one idea evolve into the next.

Osterman "was driving though the country on a beautiful fall day, allowing my eyes to wander. Since my interest was water, I stopped the car near a small bridge and walked out onto it. When I looked down I was amazed at the sight below. There was a magnificent orange light—a result of the warm afternoon light on the tan-colored stream bed. This was in contrast to the dark-blue tree shadows slanting across the stream, and the light-blue light patterns on the surface of the water. All of this caught my eye because it could accommodate my concerns with light through space. With more careful perusal, I also discovered the yellow-green reflections of distant trees beyond, two light rays slashing through the water, and a floating leaf on the surface. An image was beginning in my head, and I was excited enough to commit my energy to this in a painting.

"In the process of making *Golden Pond*, I next made careful drawings of the rocks, the shapes, the leaf, and other patterns. I made an on-the-spot painting to record the 'flash' of the image. I also took photos of the patterns on the water surface and

On two pieces of tracing paper taped to approximate the size of the finished painting, Osterman developed her composition with markers. At this stage, the emotions she projected on her painting are even clearer. The loosely shaped patch of light in the photo has become heart-shaped. You can see the overall emphasis that made it the underlying structure of the composition.

Osterman decided to build layers of thin, transparent glazes of pure watercolor. She planned the order of overlapping pigments and the color shift produced by each layer of wash. By drawing with the sheets of tracing paper overlaying each other, Osterman was able to get an idea of how the colors should be layered. To begin, she drew a pattern of shapes in marker on tracing paper. This established the overall composition.

made additional visits to the spot to absorb the atmosphere. Only then did I begin to know the scene."

Osterman found, "that the more time I spent at the stream, the more I understood the data and was comfortable with it, like knowing a friend. I now saw the stream as a golden pond, probably because I was contemplating marrying an 'older' man. A large heart shape injected itself into the painting. In fact, this shape became the underlying structure of the piece. The floating leaf became myself, so its color shifted from a dead tan into a bright red-orange, which represented my courage to make the move into marriage. By looking directly into the water from above, I put myself into the pond, also enabling the viewer to take the plunge.

"I chose watercolor because it best expresses the reflection of light, and I chose the layering technique because it enables me to depict a sense of space with a very two-dimensional medium." Osterman then decided that "a full sheet was about the right size for my message. A smaller size would have been too intimate, and I wanted to include not just my personal dilemma but to allow people to feel the universality of the problem of decision making—the feeling of a leaf floating alone on a busy stream. I went on to choose Arches 140-pound, cold-press paper because it receives paint well in layers.

"I began with small thumbnail sketches. First I placed the leaf strategically, then the large heart shape, which was the underlying structure. The shape of the light came next, and then the rocks and water patterns. I spent much time relating all these elements to each other, for instance, the way the heart curve extends to the curve of the leaf.

"My color decision was based on the combination of what I actually saw at the scene and the colors I felt. I chose a harmonious color scheme of yellow-green, yellow-orange, red-orange, and blue. Cadmium yellow, cadmium orange, cadmium scarlet,

and Permanent Blue (Winsor & Newton) were chosen for their compatibility and the staining qualities necessary for the layering technique. A No. 12 Reeves red-sable brush gave a quality of stroke that best expressed the water patterns.

"The layering took careful planning. It was accomplished by using markers on tracing paper. I could draw the pattern and place one sheet over another; this enabled me to see each layer of paint—and space—as its own pattern, as well as how it fit with the others. I began the final painting by putting on an overall wash of blue, saving (masking out) the leaf shape. Then came a layer of yellow-orange, but leaving the water patterns untouched. Next, the red-orange in the rocks and the yellow-green reflections. Finally, the darker shadows. This technique required great concentration since I had to keep in mind not only the pattern I was painting but all the other patterns as well. It took seven attempts before I was satisfied.

"After finishing the painting, I put it aside because I thought it was too predictable. After a month or so, the goldfish suddenly made its appearance. I like to think it's there as a surprise to the viewer (although it gave me great joy to add that cobalt violet eye), but it also serves another function. In the year it took to complete this work I was married, and the goldfish became a symbol for good luck.

"The process used to create *Golden Pond* can be generalized to all of my work. Each painting begins with the 'thing' that catches my eye, the commitment to the painting, and then I progress through the steps described above. I find that if I invest this kind of time and thought in a piece, my viewer is apt to receive more from my painting. In fact, we both gain from my experience."

With a clear-cut image, concept, and conviction about a painting, you can start to build the framework for it. This loose, organic process can often move you into the painting so

smoothly that you'll be surprised at how far you've come. As we've seen with *Golden Pond*, planning can be seen as part of the entire painting process rather than something totally apart. If you think you'd like to try adding some or all of Barbara Osterman's decision-making steps to your own planning process, you'll find them outlined below.

1. Collect data for the work.
2. Project your own symbols on the imagery.
3. Select a point of view.
4. Choose the medium and technique.
5. Determine the best size and proportion for the message.
6. Work out the composition.
7. Choose a color key.
8. Pick out the materials and the type of surface you'll need.
9. Get painting.
10. Review and correct.

To paint the final work, Osterman started with an overall wash of light-blue watercolor. When that was dry, she added patterns and layers of color in much the order she had plotted them out: layers of yellow-orange, red-orange, yellow-green, and finally the darker shadows. Each pattern of color was applied only after the previous wash was dry to prevent unwanted runs, bleeds, or color mixtures. This way, each layer modified and shifted the color underneath it without completely covering it.

Use Psychological Symbols

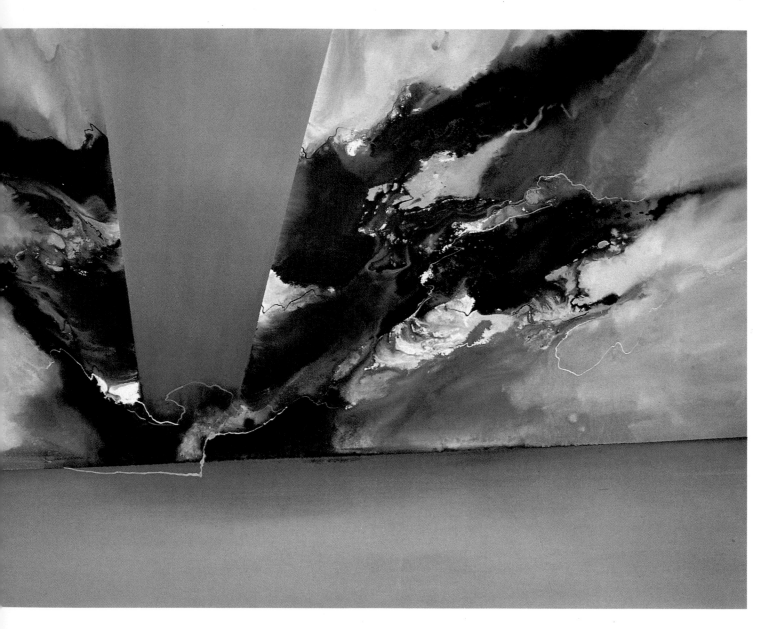

In Streaking Toward Home *(watercolor and gouache, 30x40), Janice Pollard used the flat plane (done in gouache) to show speed and direction, pulling the viewer deep into the distance. Symbolically, this provides a path, offering direction through the disorder of the organic-shaped atmosphere and sky.*

*B*ecause painting is such an intimate art, it's an undeniable fact that whenever we put brush to paper we'll say something about what we believe or the way we think. You can't hide the excitement or the anguish in a brushstroke, or the aloneness of a single mark on the expanse of white paper, or the confusion and entanglement of a painting gone awry. By studying your own work, you can find out quite a lot about yourself. There is a very old story about a man who made a habit of sitting for his portrait with various artists. He collected these portraits because he felt they were as much portraits of the artists as portraits of himself.

Since you can't completely screen out your personality from your work, you might want to put it to use. You can choose to get in tune with your own psyche and consciously use symbols and relationships that show the way you feel. These symbols can be as simple as adding a weeping willow to represent sadness in a land-

scape or putting a pair of champagne glasses linked by a ribbon into a still life to suggest a happy couple. Symbols may be as subtle as using a color to suggest mood—soft blues and grays for sadness, bright yellows and reds for happiness.

Janice Pollard uses symbols derived from nature and her imagination. "The ever-changing shapes of clouds, stormy skies, flowing water, or waves bursting over an obstacle represent my emotional response to a beautiful sunrise, the ending of a love affair, or just coming to terms with the way I feel on a day-to-day basis. Then, all of these churning, flowing shapes are played against straight-edged, opaque areas that block my view, interrupt the flow, and give me a protecting, isolating wall of safety—a place where I can retreat. Even though I have erected these barriers for protection, they are a reminder that I am alone, that I must come to terms with being alone and ultimately, that I must die alone." Another important element is getting in touch with your medium. For Pollard, watercolor "offers the most immediate and spontaneous connection to the way I feel. The paint is an extension of my deepest feelings—a direct expression of my soul. Whether I want to be bold and dramatic, or subtle and quiet, watercolor encompasses the full spectrum. I seldom rework any area. This maintains the spontaneity of watercolor that I love, and ensures a freshness and directness that enhances the psychology of this type of painting." (And think about how other mediums or combinations of mediums might symbolize different moods or ideas as well.)

"To begin a painting," she says, "I usually do several pencil sketches on 3x5-inch paper. I first consider the composition. If I change the direction of the flow of movement in the 'loose' areas, or move a straight edge even slightly, I can alter the feel (and meaning) of the entire painting." Straight-edged opaque areas can block the view and make you

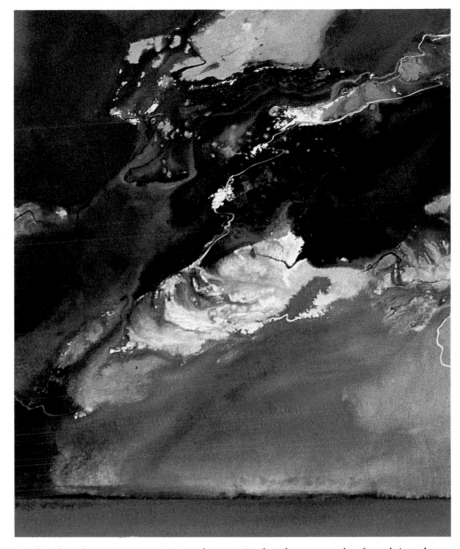

In this detail, you can see textured areas in the sky—a result of applying the watercolor with a palette knife and the pigment's resistance to soaking into the unstretched paper that still has starch in it.

confront the obstacle head-on. But such flat planes can also emphasize perspective and direct you along a particular path, allow you to go with the flow, or give you the sensation that you're falling into space. "I work all this out in the sketches beforehand so I can be completely free and spontaneous once I start work."

In *Streaking Toward Home* (watercolor and gouache, 30x40), Pollard used the flat plane (done in gouache) to show speed and direction, moving the viewer deep into the distance.

Symbolically, this provides a path offering direction through the organic-shaped atmosphere and sky.

Unlike *Streaking Toward Home*, *Criss-Crossing Paths* (30x40) has only an implied horizon line; but Pollard placed this at a diagonal, thus creating the feeling of being off-balance if you focus on that part of the painting. The geometric shapes, however, anchor the viewer to a different plane in space; while they offer a sense of ground, also create an off-balance feeling when seen in juxtapo-

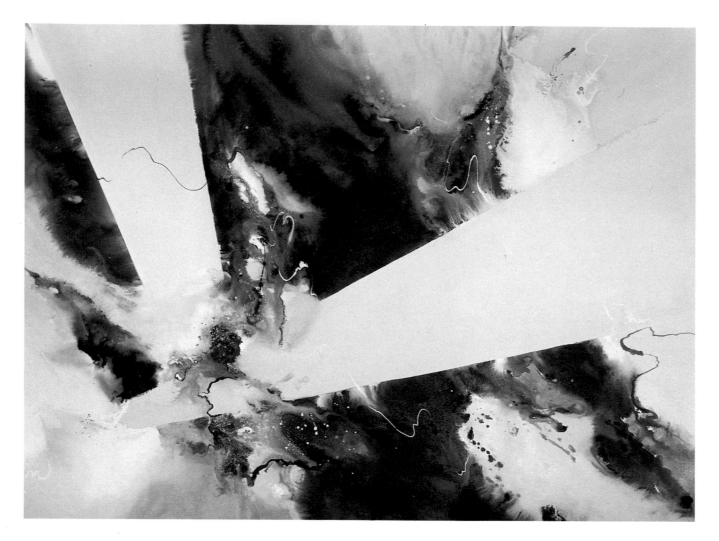

Pollard placed the implied horizon line at a diagonal in Criss-Crossing Paths *(30x40), creating a feeling of being off-balance if you focus on that part of the painting. The two heavy geometric planes form a sharp contrast with the loose, flowing shapes behind them, therefore intensifying the sense of disorientation. The soft shape visually separating the planes represents the psychological separation of people's paths crossing but not meeting.*

sition with the organic shapes, creating a unique feeling and point of view. This symbolizes the feeling of moving in and out of another person's life without ever really making connections, the incomplete feeling of ships passing in the night.

Next, Pollard decides on the surface and the colors. Each can affect the look and overall statement. "I do most of my painting on Strathmore illustration board with either a cold-press or hot-press surface." The stiff backing eliminates stretching, and the cold-press can add a subtle texture that enhances the transparent and opaque colors. "I like a lot of contrast, so I generally build my palette around a single dark hue and select other (lighter) colors in keeping with my mood. I use a limited palette, usually with a variation of the three

primary colors—several reds, blues, and yellows. I mix these for my secondary colors and grays."

Although symbols can run the gamut from the simple and obvious to the subtle and complex, taking the time to create unique ways of expressing emotions can be very rewarding. Look for elements that recur in your work, and think about what they may be saying about you. Then consciously let new symbols evolve from those. Explore alternatives to traditional symbols conveying mood or emotion. Experiment with highly personal symbols that force the viewer to try to discover interpretations of your paintings. Giving more of yourself to your paintings will make your work even more special and different as it grows and changes.

Make Light Your Subject

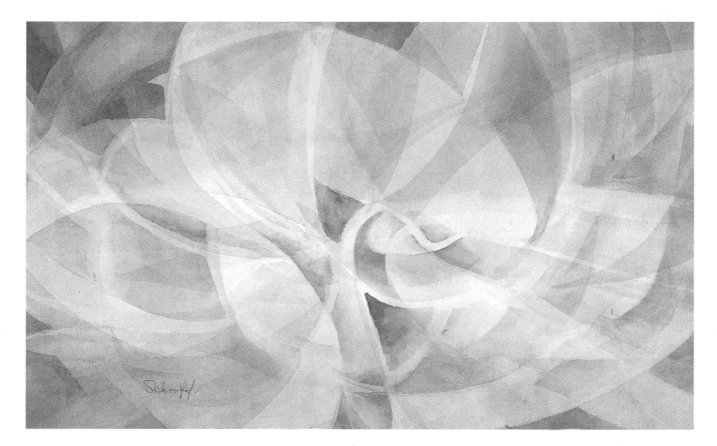

In Tree Forces #3 *(22x30), Lois Schroff used thin veils of transparent watercolor to depict the movement of light in space. The space is organized by the movement and the color of light. Movement behind the main light source is rendered in the cool tones, and the movement in front of the light source is done in warm hues. The directional swirls of color not only represent the upward and outward growth pattern of a tree but also show the flood of light into pure atmosphere and the movement the artist envisions it creating.*

Most artists begin paintings with a clearly defined subject: Landscapes have mountains and trees and clouds, still lifes have vases and flowers. Or the human form takes center stage. How the artist treats the light, mood, and tone of the piece is built around the subject itself. It's a very objective, subject-oriented approach.

But Lois Schroff completely reverses this basic notion of how a painting works. Her goal is not to capture the effects of light on objects, the way Monet depicted haystacks at various times of day. Instead, Schroff paints only light and the space, color, and movement it creates as it strikes the darkness of pure atmosphere.

This is based on Schroff's perception of the cosmos; what you might see if you swooped in from outer space and saw only the intermingling of light, darkness, and atmosphere creating new, unusual relationships of color and form. Close your eyes for a moment and imagine the existence of only light and atmosphere. Think about what you saw in your mind's eye, how the light and darkness interacted, how colors moved through the space around them.

Now that you have an image of the way Schroff's universe looks, try to imagine how this could be depicted. Here are the three basic premises underlying her depiction of the movements and interactions of light in space. First, you paint one strong, central light source. Second, you depict darkness behind the light source. And third, you depict darkness in front of the light source.

Schroff suggests three exercises using charcoal to explore these three areas of light and darkness and the effects of their position on one another. "By using only charcoal," she says, "you have a substance which is

Charcoal Sketch #1: *To get a feel for depicting the "darkness behind the light," try doing a charcoal sketch such as this one, with the light advancing toward the viewer and the dark void of atmosphere receeding behind it.*

Charcoal Sketch #2: *In this exercise, the goal is to show light receding in the background and darkness approaching the viewer in front.*

easy to change, and your thinking will not be confused by the beauty of color or the rules you may have learned about color relationships."

Begin each of the three exercises by covering a sheet of charcoal paper with a midtone gray. Rub it with your fingers to make it smooth, perfectly flat, dull, and boring.

Exercise 1: Darkness behind the Light

"Imagine a hazy atmosphere in front of a range of fir-covered mountains," Schroff says. "The trees appear much lighter than they are in reality, and their form is also not clear because of the mist. Then, a ray of light breaks through the mist, and the result is a further obscuring of the trees and mountains just behind the light beam. Now, think just in terms of atmosphere, darkness, and light, and free your imagination from the objects. Try it. Focus on the light in front of the darkness and the darkness behind the light.

"Remember that light always falls in straight lines, and the darkness responds by moving away to allow the space for the light. In your drawing, show the light by the way it illuminates the movements in the darkness. The light brings form when it touches the darkness behind it."

Exercise 2: Darkness in front of the Light

"From the movement gesture begun in Exercise 1, the darkness, which pulsates, continues to expand outward. The darkness wraps round in front of the light as it moves in large spirals seeking the light source. Behind the light, the darkness moves away into the cold recesses of space (from our point of view), but now it appears much closer to us and seems to move much faster in its rush to enfold and make whole again.

"Imagine smoke as it curls before firelight. It diminishes the brilliance of the light and can partially obscure even the most brilliant light. Now, get a strong mental image of this picture and try drawing it."

Exercise 3: Combine 1 and 2

"Remember that in these exercises you're concentrating on a strong, straight light source, the darkness behind the light, and the darkness in front of the light. So now make a drawing which combines all three of these areas. Begin by recreating Exercise 1 then place Exercise 2 on top of it, making the dominant area either in front or behind."

Once you've created an arrangement you like, draw this on a separate sheet. While you work there are several points you need to keep in the back of your mind.

"A painting (or in this case your drawing) should have its main action and movement either in front of the light or behind it, but not both," Schroff says. "You don't want to have two areas fighting for the viewer's interest.

But how do you handle this painting idea once you introduce color? Through years of painting, experimenting with the breakdown of light through prisms, and understanding how color affects our psychological and spiritual being, Schroff has developed a color perspective that works with her painting theory: She uses a very specific set of colors to depict the movements of light and darkness in space.

"When the brilliance of the overpowering light is mixed with sufficient darkness to allow the appearance of a color at all, that first color is viridian green. With a bit more darkness permitted (as we look toward the blackness of space), we can identify turquoise. As the process continues, we see colors in this order: cobalt blue, ultramarine blue, indigo, purple, and black.

"How do the warm colors appear? Observe the smoke from a campfire. When seen in front of a dark forest it appears blue. Walk around to the other side and view it against the fire light and the same smoke will appear yellow or orange or brown. Our perception of colors depends upon where our eye is in relation to the light and darkness. Hence, warm col-

ors are revealed in front of the light. Farthest away, but in front of the light, you'll see magenta. Next, you'll see carmine, scarlet, vermilion, orange, yellow and, lastly, yellow-green. Each successive color is lightened because it is nearer the light."

Basically, Schroff's theory indicates which color is seen depending on whether you're painting darkness behind light, darkness in front of light, or light itself. Schroff often uses viridian to depict the first color beyond pure white. But again, as the distances between the lights and darknesses change, so will the colors you'll use. Schroff recommends some additional color combinations to use depending on your position and kind of space and atmosphere you're trying to create:

Light: (1) turquoise, (2) cobalt blue, (3) pale vermilion, (4) viridian, (5) charcoal gray, and (6) cobalt blue.

Darkness behind light: (1) indigo (Payne's gray), (2) purple, (3) unseen, (4) violet, (5) charcoal gray, and (6) indigo.

Darkness in front of the light: (1) cadmium orange, (2) scarlet, (3) all reds, (4) raw umber, (5) orange, and (6) yellow-green.

Try some sample paintings matching up the color numbers from all three categories, using only one color for each light space. Keep in mind that you can mix each in a dark, middle, or light value, and you can mix any two or all three colors together to get your intermediate hues.

You can apply this color theory to any subject matter, as long as you keep in mind your light source, whether you're painting the movement of light on objects in front of or behind the light source, and the distance between objects relative to the light source. Try applying this to a landscape lit by the setting sun, for example, or experiment with a still life placed behind a single candle.

This chart shows how Schroff has organized the movement of colors in space, based on how deeply they appear to move backward and forward from the viewer. The chart starts in the center with viridian, which is used to depict light. As the light moves back in space, it gradually modulates to turquoise, cobalt blue, ultramarine blue, indigo and purple. As it moves closer to the viewer, it modulates to yellow-green, yellow, orange, vermilion, carmine red, and finally to magenta. Try out various combinations of these colors on different subjects. Just keep in mind whether you're painting the movement of light on objects in front of or behind the light source, and think about the distance between objects relative to the light source. You may want to add the lists of colors on this page to your own version of Schroff's chart for easy reference when you're working.

Look Down from Above Your Subject

For Par Terres *"the geometric pathways needed to be balanced with a lot of swirling rhythm within each area,"* Barbara Preston says, *"and yet I had to find a way to make the transition from area to area without it becoming a hard-edged coloring book image. So I worked around the entire border of the garden in sets of analagous colors to allow color to overcome the small value changes in the mosaic pieces."* This same effect is repeated in each of the small garden areas.

*E*very painting represents a creative problem that needs to be solved. Creativity comes into play when that problem is clearly defined and a number of solutions are considered. You can even redefine the problem in various ways in the search for unique and original solutions. Barbara Preston employed with delightful results this approach on a commission. She says, "In doing a series of commissioned paintings for Woodlawn Plantation, a botanical gardens in Virginia, I needed to come up with a depiction of the formal gardens, which grew seventy-two varieties of roses. As I was conceiving this piece, I began to see it as a whole entity, with a view from up above."

To design *Par Terres* (24x39), Preston imagined herself looking down from high above the gardens. This mental perspective made her intensely aware of the geometric layout

of the garden. Having picked up on this image she looked at how to translate it into a painting. She decided that the flower beds could become the positive spaces, and the hedge borders would form the contrasting darkest shapes, and that a wonderful bisecting brick wall "offered unity to the unbalance of the two gardens adjacent to each other."

"In addition," says Preston, "the viewpoint for this painting offered a jump-off point for a concept I had been using in small bits and pieces but not for a full-blown painting. The idea of a mosaic emerged, and it reminded me of a project I had taken on once with my husband—a mosaic coffee table (which involved hundreds of hours of cracking tiles into odd shapes)." Preston chose a double elephant-sized paper for the piece. "This seemed important to dramatize the big area of the garden in relationship to the hundreds of little mosaics of color."

Establishing the viewpoint as being high above the gardens and combining it with a mosaic motif caused a very dynamic effect to occur. The bird's-eye perspective lets you see every inch of the gardens at once. But because of the emphasis on the geometrics of the garden and the mosaic technique, pattern and surface design are emphasized. The big picture is paired with its opposite, intimate detail.

"Then, with a rigger brush, I built the mosaic color, keeping the tints as grouting or negative space between each piece. This, as it turned out, was a very gratifying, but time-consuming, way to work."

Come in for a
Close-up View

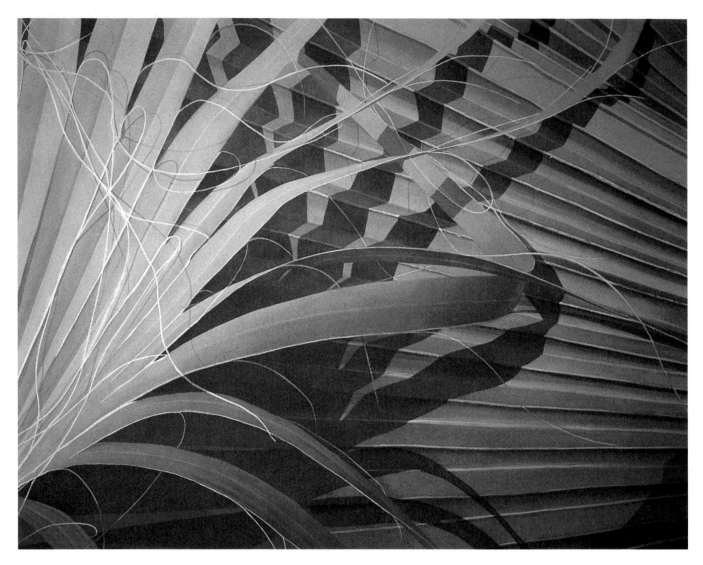

In Palm Patterns #102 *Edith Bergstrom created an intense intimacy between the viewer and the subject by both pushing the subject out of and drawing the viewer into the painting. The painting is all foreground, pushing the subject right up to the surface of the paper and compressing the space. Increasing a small section of the palm to this scale (29x38), pulls the viewer into the plant.*

*E*dith Bergstrom chooses to paint from a viewpoint that "is usually close-up, excluding most of the surroundings—buildings, sidewalks, etc.—unless elements of these promote the overall composition." This gives her paintings a sense of intimacy and immediacy by bringing the subject right to the viewer, close-up and personal. Working from this perspective lets you make a very personal statement about who you are and what you saw that made you want to paint this.

By positioning yourself and the viewer close to your subject, you can achieve four very important qualities in your painting.

One, you can create an intimacy among the subject, yourself, and the viewer. The close perspective helps you bring out the small, sometimes overlooked corners of the world. In addition, "the viewer and the artist have to take the subject seriously at this distance," says Bergstrom. "A tree is no longer generalized in a larger world; it becomes a specific entity. Dozens of people have told me, 'I never really looked at a palm tree before, but after seeing your show I will never think of a palm tree again the same way.' It pleases me immensely to know that my painting is changing someone's consciousness of the tree.

Two, you can compress distance. If you look straight out at the horizon or at the sky, you'll perceive great distance between you and the subject. But "close-up" subjects are literally at your feet. You can show your viewer something that's physically very near at hand. So when you choose to paint an intimate scene, you're making the viewer stop and find surprise and awe in a place he least expected to find it.

Three, you can create a natural design, a design that grows out of the subject itself. The composition of the piece is, no matter what the subject, one of the essential qualities of a good painting. Although you may be painting only one object—maybe only part of an object—you still must select what to emphasize and ignore. "I believe that all areas of the picture plane must be locked together as a whole," says Bergstrom. "My goal is a composition so tight that a change in a basic element causes others to have to be changed to agree."

And four, you can lure the viewer into your painting or push him away. For example, if you were going to paint a close-up of a violet, would you concentrate solely on the petals and their relationships to each other and their center? Or would you include the stem and leaves? Each of these compositions evolves from the natural design of the flower but will produce completely different effects.

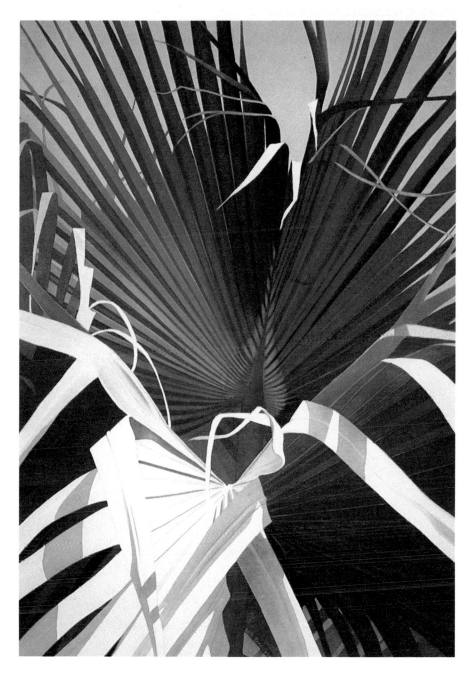

In Palm Patterns #104 *(38x29), the natural design of the palm leaves, with light and shadow defining their form, creates the composition.*

If you're painting an intimate subject in a size, say, 12x12 or smaller, this scale will naturally draw the viewer closer to your subject. You can practically make her get down on her hands and knees to examine a blade of grass or the stamen of a flower. On the other hand, think about painting small subjects in a large manner. For instance, Georgia O'Keeffe's large florals can make you feel about the size of a bug because of the paintings' scale and viewpoint. The incredible structure and scale makes a small bit of the world as large as the universe and shows us where we stand (literally) in relation to nature.

When you do a close-up painting, you're trying to intensify both your and the viewer's relationships to the subject. You need to make a single, strong statement in your painting to achieve maximum impact. Whether you draw your viewer down into your universe or enlarge the subject until it actively enters the viewer's space, every part of your composition has to flow together.

Work with
Multilevel Imagery

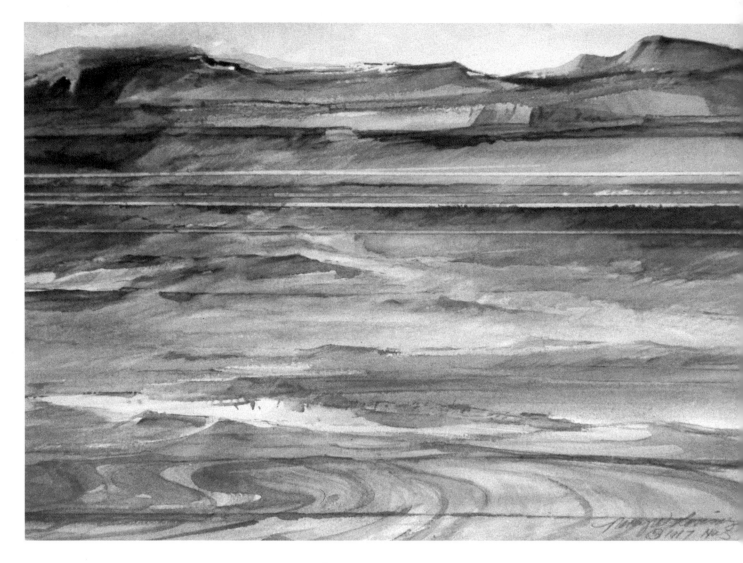

In Distance Fantasy *(25x40), Nancy Livesay has combined more than three landscape scenes for the viewer to see simultaneously, creating a composite image that simulates being in different places at the same time—a kind of timeless stasis. The horizontal bands, however, work to anchor the organic forms, and the colors move from one landscape to the next, tying together the painting's composition. Livesay layered her watercolors for gradual, virtually seamless transitions of color.*

*I*f you paint a traditional still life or landscape, you might choose to depict it from one viewpoint and with one fixed light source. Many exquisite paintings done in this manner capture the beauty of a single moment—the light sparkling through the dew on a morning leaf or the last rays of the sunset. But you don't need to confine yourself to capturing only a single moment in time. By removing your focus from the frozen image and concentrating instead on the total experience you can bring a new dimension to your painting.

Nancy Livesay achieves this by basing her paintings on her impressions of nature. "I like to express the

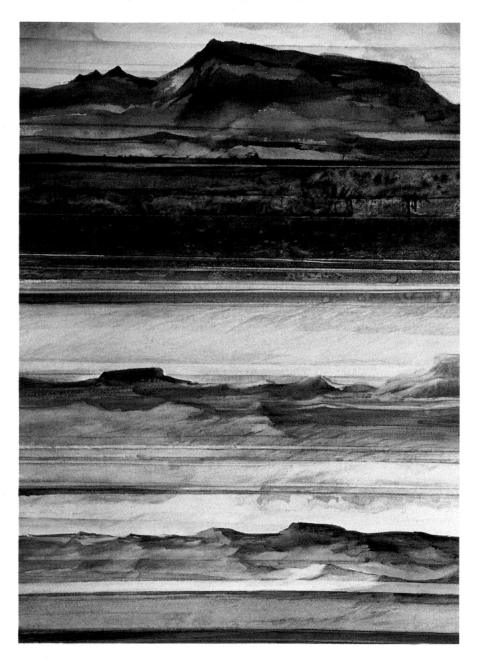

Arizona Strata *(30x23) was composed in distinctive horizontals. Livesay masked off each bar, painted the horizontal areas with loose washes of color on damp paper, and then proceeded to the next one. When all the masking was removed, she started to define the imagery with repeated layers of paint, adding texture in key places.*

whole impact of the experience, rather than one specific memory. I often choose the desert or ocean as a theme because they both impart a sense of timelessness.

"I'm made aware of the eons of time recorded in the layers of exposed rock in the desert, and the endless flow of the ocean, as I stand small before the vast horizon. I see the colors, feel the sun (or lack of it), hear the breeze, the birds or waves, and gaze at the distance that spreads before me. And, simultaneously, I can touch the tiny pebbles at my feet. I wonder who else has stood here, saw, smelled, and felt these sensations. How many more will follow? This all seems far too complex an array of sensations to paint as an isolated incident, so I usually do a painting that shows multilevel imagery. The viewer, then, cannot pinpoint one specific moment and say, 'This is just exactly how it was.' Instead, my paintings are designed to make the viewer suspend time.

"To accomplish this, my desert paintings, for instance, may have specific images represented, but still they present multiple planes, different times of day, or a flow of many landscapes you might see as you drive through them in your car (such as *Distance Fantasy*). In addition, I'll often show several views of one subject, use several lighting conditions, various horizontal bands, colors and textures. These are the elements that shift the emphasis of my paintings from image-specific works into 'layers' of time.

"I usually begin a series of paintings by visiting a site and gathering reference material, in the form of sketches, slides, photographs, and found objects. I may even do small paintings to help me get a handle on the local color and shapes. Back in the studio, I spread everything out before me, and paintings begin to take shape in my mind. Then I usually make a few rough diagrams indicating the overall composition, divisions of space, and areas of focus for

Here you can see the interesting textures that resulted from removing paint by blotting with a paper towel and a squeegee, allowing the initial underlayers of paint to show through.

several works. These plans, however, are far from detailed; they serve primarily just to get me started. I prefer the spontaneity of working directly on the painting. The idea just gives me a sense of structure for the work. Generally, my compositions play organic form against a structure of horizontal planes. The surfaces of my paintings are as layered as my stratified compositions, and they create intricate color harmonies and often a sensuous effect.

"I frequently start several paintings at once (no more than six) and work on them individually—one stage at a time while the others 'rest.' I use Arches 300-pound paper because it absorbs a great deal of water and maintains a consistent moisture content. I spray the back of the paper with clean water until it is soaked, and put it away for at least a day. I stack my paintings between layers of wet newsprint and sheets of clear Plexiglas to keep them damp for long periods. Controlling the moisture allows the paint to soak into the paper and create a velvety, flowing surface that I enjoy.

"I start each one by drawing freely with a pencil, indicating the major forms, movements, and important details. In the next stage, I begin to break the page with horizontal bars using masking tape, which I gently press onto the dry watercolor paper. These bars are arranged to create an interesting pattern, which will either reinforce the image or act as a foil to the organic forms I plan to incorporate into the design. The initial washes of watercolor are then generously spread across the paper with a 1½- or 2-inch flat brush and left to dry for a short time. Then I carefully remove the tape (wet paper around it will be very fragile), and remask another bar before I paint it. I continue painting and moving tape until a pattern of horizontals has been established. Then I remove all masking devices because they interfere with my response to the painting.

"At this point, I have an underpainting which appears as a jumble

In Spendrift *(25x40), Livesay kept the edges soft throughout the entire painting until the last stages of completion. Painting on damp paper causes the watercolor pigments to spread and flow evenly and to retain soft edges where washes are applied. Generally the artist applies details or sharpens edges by painting on dry paper. Here, however, she kept all of the edges but in the last stage of painting added the few lines that indicate horizon and edges of hills. The extreme contrast between soft edges and the very few hard ones pushes your eye immediately to the horizon line.*

of color, spaces, and lines loosely organized with little definition to indicate what I'm painting. However, I've been very careful to vary the width and placement of my horizontals; I try to create a sense of systematic variety with them.

"My next step is to paint the forms that I have chosen to express in my painting. Color choices, values, shapes and textures are all directed toward my feeling about the subject. I build my painting with repeated applications of paint. Freshly applied paint is often blotted with a paper towel or removed with the bevelled handle of a flat brush, a squeegee, or knife to permit underlayers of paint to show through. This produces new textures and patterns of color. Selective lifting of paint is as important as the application of new paint. In each painting session I add or subtract layers of paint, then rewet the back of the painting and place it in the stack.

"After several sessions, it's time to bring the piece into focus. I control the edge quality of every inch of the painting by keeping the edges soft until the very last. Then I may spend hours reinforcing areas and 'relaxing' the edges of others until the whole painting is brought up to a sense of completion. I let the painting dry slowly, and the final brushstrokes are done on a virtually dry page. This part of the process is the most fun— and also the stage where I easily get trapped into too much painting. I have to be careful not to overdo a

good thing just because it's fun."

Livesay puts a period to a painting by signing it, photographing it, and sending it on its way to the gallery.

Exaggerate
Light and Pattern

In Camouflage Series: Painted Lady #5 *(21x29), Donald Lake superimposed artificial light and pattern upon the human form. He used harshly geometric flat patterns as the counterpoint to the soft, organic form of the figure. To stage the actual setting, Lake projected slides onto the model. "The conditions of bright light in a darkened space, rich color from the slides, the distortions of the image flowing over the figure, and the abruptness of cast shadows all presented opportunities for painting. The challenge of this painting was to allow first the figure, and then the pattern, to become dominant, and to build color and drawing in ways which expressed these conditions more effectively than the actual setup."*

S trong light has the capacity to create an infinite variety of shadow patterns, depending on what's placed in front of it. Think of light passing through tree leaves, through water on a swimmer, striking the complex tangle of pipes in an oil refinery. Or imagine colored light shining through stained glass. Donald Lake takes advantage of these effects in his painting, especially in his figurative works.

The figure represents a multitude of shapes, created by the interplay of strong shadows and light on each unique human body. Many painters use a few simple shapes to describe the figure, choosing to convey the elegance or gesture in a simplified way. But Lake is bent on getting more complex results. He strives for the exaggerated behavior of light up-

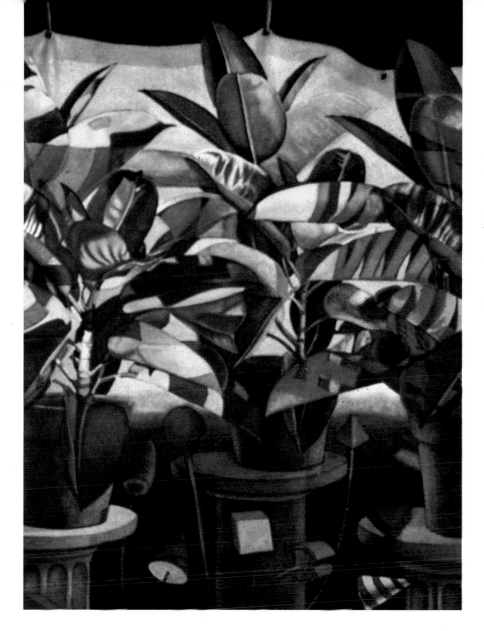

Occasionally, Lake will complete a drawing of his subject in color mediums, instead of graphite. A study was done in chalk and pastel in order to work out the patterns in Hybrids #2 (21x28). *The drawing is roughly developed, and in it Lake essentially worked out the patterns and composition for the left-hand plant in the finished painting. After doing the drawing, he also chose to abandon the background treatment in the final watercolor.*

on the figure and the complex pattern of shapes it creates across the surface of the painting. Design, shape, and color dominate the subject, creating an effect much like that of a stained-glass window. Lake uses a technique of building multiple layers of transparency into convincing illusions of space geared to this concept.

Lake wants to capture the sculptural aspects of the figure and to create a convincing illusion of a vaguely familiar event. The delicate balance here is to create something unusual but to keep it within the realm of possibility. Lake's subjects remain recognizable, though accuracy of rendering is less important.

Lake suggests either seeking out or staging conditions to make the most out of light and pattern. What you'll be looking for are extremes. In work-

ing with the figure, you'll most likely have to create your own set of lighting conditions to impose on it. Lake also suggests looking for elaborate surface reflections that create intriguing patterns, reflections, and bounced light into dark areas.

Once Lake has found or created a complex set of light and dark patterns, he depends heavily on the drawing process to solidify his composition and lead him into the painting. The idea is to get to know your subject thoroughly through drawing. "Sometimes," he says, "I become so involved in the drawing that I abandon the notion of painting it. I pursue the drawing to a tonal state, then lay washes of color over the (usually graphite) tonal passages."

But in the paintings you see here, Lake typically takes this route. "I

Step 1: Preliminary drawing. For Pool Series #6, Lake started with a full-scale line drawing in Prismacolor pencils on tracing vellum; the drawing could then be easily transferred to the watercolor paper when he was satisfied with the drawing. He also included shades of color to begin mapping out the shapes.

Step 2: Transfer and mapping. When the Prismacolor drawing was complete, Lake transferred it to watercolor paper. Then he began "mapping" various areas by underpainting with very faint washes of sepia umber while modeling the form.

Step 3: Build color and form. With the underpainting established, Lake then began building the color and value of the upper torso of the figure. Here, he used an exaggerated raw sienna color leaning very strongly toward the orange range. "I used that excess of orange," says Lake, "to counteract the eventual effects of several blue washes over the entire body to express the watery environment."

Step 4: Continue development. Lake then built up the swimmer's bathing trunks with several layers of transparent red washes, being careful not to paint over the white bubbles.

Step 5: Further development. With the water's surface already mapped out, Lake added layers of washes to deepen the color and value and define the form.

Step 6: Blue wash. Lake then added a blue wash, gradated from dark to light from the bottom of the page upward, as the water approaches the light source. Although this wasn't planned from the beginning, says Lake, this blue also balanced the design of the painting.

make a contour line drawing to full scale on a separate sheet. I began using tracing vellum a few years ago, due to its availability in large rolls, and have come to appreciate its possibilities. With that paper, I can piece together a variety of trial parts, changing them back and forth, which I often do long into the process of painting. I can then see the elements in context of the other drawn or painted parts." (For more on the cut-and-paste approach to composition see Chapter 2, "Cut and Paste a Composition," pages 35-37).

Although Lake enjoys the drawing process, he finds it can also be inhibiting. "When the line drawing is complete enough to guide me, I trace it off onto the watercolor paper by smearing, then hand-wiping, vine charcoal onto the back side of the drawing and retracing the lines. Too complete a drawing tends to foster an overly deliberate obedience in painting. Therefore, I try to operate with the fewest marks I feel comfortable with. I can, and usually do, alter or add drawing as the painting proceeds, anyway."

At this stage, Lake will have on his paper the approximate finished composition in shorthand form. He takes a moment to visualize the completed piece in his mind's eye, then takes one more step in preparation for the final image—underpainting, or what he calls "mapping."

"I paint a very faint initial version of the big areas, and specific detail passages I need to work out. I generally use a neutral color, such as sepia umber or a range of neutral mixtures heavily thinned with water. In some areas I underpaint not merely to find the image but as a setup for colors to follow. For example, I frequently underpaint with cadmium yellow or new gamboge in areas that will ultimately need to be a sizzling red."

"This mapping stage may give form to a few important areas, or sometimes an entire painting," he says. "I regard it as the last stage of drawing and the first stage of paint-

Step 7: Lift splashes and bubbles. To finish Pool Series #6 (21x29), *Lake used an eraser to add and lighten splashes and bubbles.*

ing. It completes the invention of the image and establishes limits upon what should be done next. The actual painting can now begin, and continue cohesively over a long period of time, since the image has a sort of completeness.

The painting then continues as a series of thin, moderate-intensity layers of watercolor. Each layer is built over the previous dry layer. Wet-into-wet variables occur in some areas, he says, but the principle of layering is constant. "With each layer I immediately work to soften or blur edges. This repeated layering and attention to edges creates a convincing sense

of atmospheric illusion by disguising any flat marks. It also allows enriched color via interleaved layers of various hues. In principle, this process is more akin to glazing over an underpainting than to traditional spontaneous watercolor."

In addition to layering glazes of transparent color and controlling edges, Lake alters the paint after it's applied and often removes color from the page. "I do a lot of lifting of paint, both wet and dry, with the dampened brush. And I frequently use a variety of erasers to alter or remove color from the dry paper."

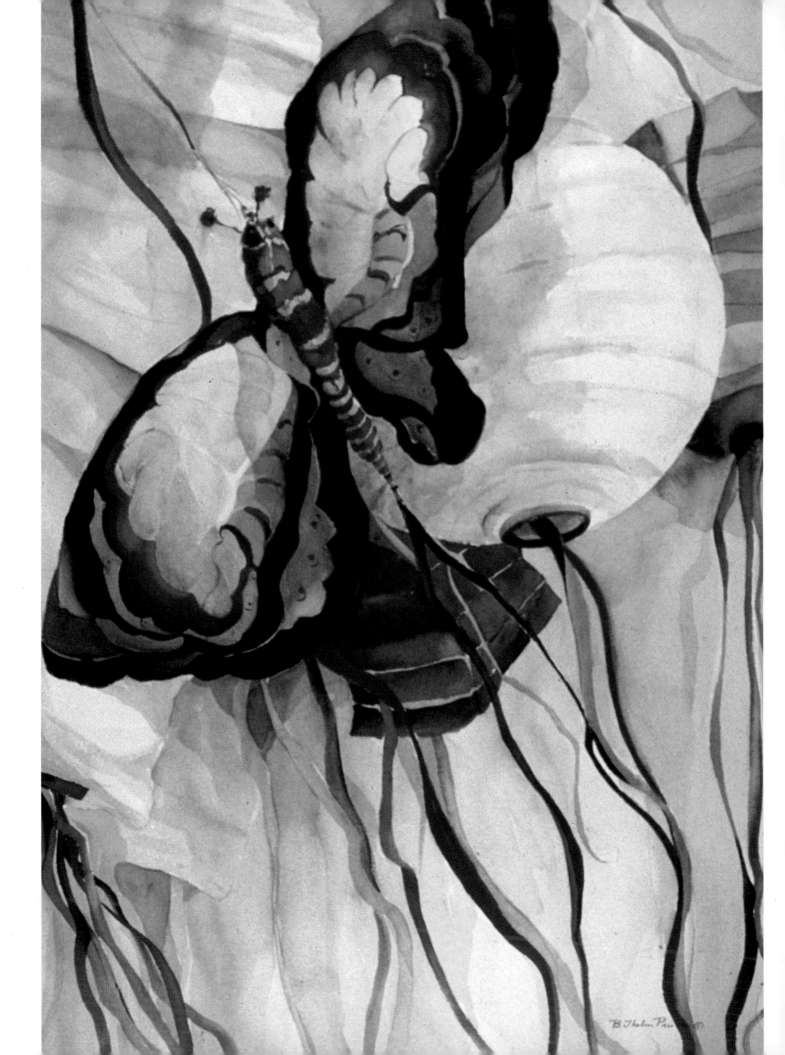

NEW TRADITIONS 4

New Effects from Familiar Tools

The title of this chapter might seem like a contradiction in terms. How can traditions be anything new? Well, this chapter is about ways to get the most out of the basic properties of watercolor. Ways to get new and exciting effects from traditional watercolor paints. So this chapter *is* about new traditions in the sense you'll learn to use your old, familiar medium in brand new ways. Your paints won't change, but your mindset about watercolor painting will.

You'll find that most of the artists in this chapter emphasize one aspect or characteristic of watercolor. For example, one may play up its flowing, liquid qualities; another its liftability. But each uses that characteristic to express something special and different, something very personal. Take a look at Lois Schroff's paintings for an example of how to successfully blend concept and idea, as she layers her paints to get the most from watercolor's transparency. Roland Roycraft reverses the traditional order of painting, working from dark to light for a distinctive look. But the technique in both cases buttresses the concept of the work and the message each artist has. Technique and idea work in unison.

Most of all, this chapter is about finding the characteristics of watercolor that best suit your mood, intuition, ideas, and personality. It also involves mastering the medium, knowing exactly what technique will work, making watercolor a natural, instinctive part of your thought process. Some techniques require patience and control; others are faster but require more preplanning. At times, a bit of luck enters into the process, and the medium will take over—to your delighted surprise. But no matter which route you take, by letting watercolor's unique characteristics show through, you'll have a painting with vitality and verve no other type of painting can match, all by making use of its purest, most characteristic qualities.

Detail from Red Silk and Butterfly *by Barbara Preston (21x29)*

Working with Water

The numerous layers of watercolor on damp paper give Palm Patterns #85 *(22x30) a soft, even look that represents the gentle filtering of light through the branches. Building layers also allows Edith Bergstrom to develop subtle modulations of color and value, as in the accordionlike shapes of the palm leaves in the left area. Damp paper keeps the edges of washes from becoming sharp.*

*B*ergstrom begins her work by planning a painting, using as her source her hundreds of photographs taken outdoors. She projects a print negative of the chosen image onto her paper with a slide projector. Then she manipulates the projected image "until it satisfies my design sense, and I sketch on the paper only those parts of the projection that promote what I'm after. The drawing will appear sketchy and incomplete. The important references and structures are included, but many areas are blank because I do much of the drawing with the brush during the process of painting."

Using Wet Paper

"After the sketch is done, I completely drench both sides of my paper with water and apply one or more of several yellows, depending on the effect I want to capture. I deposit more pigment in areas that will later be dark. I wait at this point until the paper has dried thoroughly before applying a second coat of color. By the next day the pigment is thoroughly 'set,' so it will not run or lift off the paper easily. Then I carefully rewet both sides of the paper, let it drain so that it's damp but paint won't spread by itself as it touches the surface, and brush on my second coat of

paint, which is usually cobalt blue. These two initial washes begin to establish the cool/warm, light/dark contrast and succeeding color harmonies.

"I continue to rewet both sides of the paper on a daily basis before I add colors. By always working on a slightly damp paper, the pigment distributes itself more evenly. This keeps the edges of shapes relatively soft, which is particularly important for dark, velvety shadows. Each day when I'm through working, the paper dries out thoroughly, and this "resets" the glazes. I do not use watercolor pigments like Winsor green or Winsor violet—these colors will not set up and always redissolve when the paper is moistened.

"Successive colors are added in layers of dozens of thin washes, which are usually overlapped in a new pattern with each new application of paint. They are not applied equally thinned in all areas. Shapes that will be darker often receive more pigment. Successive layers of color may deposit heavier pigment in those same areas or in other places depending on the color harmonies I want to build. Delicate adjustments of value and color harmony are possible by this slow layering. Drama builds gradually until only fine tuning is necessary at the end."

Paint with Water First

California artist Joan McKasson paints mainly florals, but her goal is to create compositions with dynamic movement, strength, and pattern rather than to paint exactly what she sees before her. In addition, McKasson strives to make her work emotionally charged; she achieves this by using a variety of colors and values and by making the most of the "mystery within the shadow areas." So her painting technique is geared toward giving plenty of color excitement and variety through the way watercolor washes run and blend together. But if her paintings had only this quality, they might end up as a chaotic mess.

In Palm Patterns #125 *(34¹/₂x57¹/₄), Bergstrom began by applying washes of various yellows. After this process was set up and she had remoistened the paper, she established the cool tones in layers of cobalt blue. This formed the beginning of the warm/cool color scheme seen in the finished work.*

Here you can see how a fairly wet wash can create textures on the damp paper by itself. The thin washes of color separate and settle evenly into the tooth and texture of the paper.

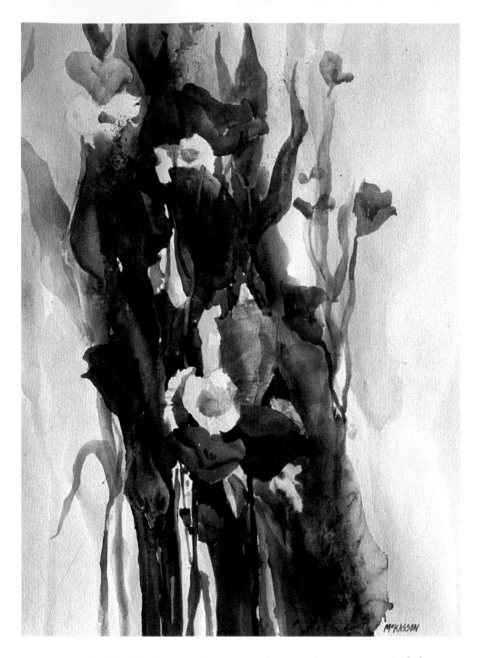

In Sea Garden *(29x21), Joan McKasson emphasizes the strong vertical thrust of the flower stalks to give her painting added dynamic impact. But within the powerful dark shape is an interplay of strong value contrasts—lights and darks. And within those darks, you'll find beautiful watercolor blendings; she makes use of watercolor's natural capability to flow freely within a defined composition.*

Instead, her trick is to let watercolor do its flowing thing, but to keep it under control.

To create compositions that are controlled but at the same time "loose," McKasson prefers not to draw on the paper first. Instead, she begins by painting with washes of clear water on a dry sheet of paper. "I paint in shapes with a 1½- or 2-inch brush and plenty of water," she says. "I might brush in a few flowers, some leaves, a group of trees, or whatever subject matter I've decided to paint. As I spontaneously brush in these patterns, many of the areas will run together, creating new or unexpected shapes and patterns. But what I'm left with is a wet and dry surface to begin painting on.

"At this point, I add partially mixed watercolor paint (color not fully blended on the brush), correcting the value and color as I work. The paint can now mix and flow freely in the wet areas, yet retain crispness where it meets the dry paper. If the paper gets too wet, I simply sponge off some of the excess moisture with a roll of paper towels."

This way, McKasson is able to establish the composition, form, and vibrancy of her painting, making the most use of watercolor's ability to run and flow—all within controlled areas. Once this stage is set and the pigments begin to settle, she often draws directly into the painted areas with Caran d'Ache watercolor pencils to develop the subject matter. Occasionally, McKasson will dry the paper surface with a small hair dryer and draw the images with a lead pencil. To finish, she first evaluates the painting by looking at it in a mirror about 50 feet from the easel. "By viewing the painting in reverse," she explains, "I'm able to see it with a fresh eye."

Whether it's soaking the paper to control the loose look of washes or "drawing" in shapes with water to create passion or variety in texture, there are always new techniques to try to get that look you're after.

Here's what "drawing with water" really looks like on your paper. The watercolor flows freely within the wet area yet is encompassed by the surrounding dry area. This makes it possible to get a loose effect under very controlled conditions.

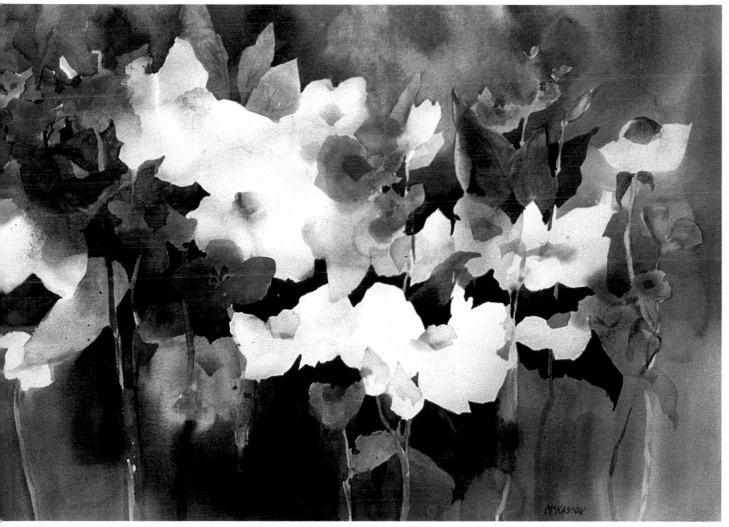

In After the Spring Rain (20x28), notice how sharp and crisp the edges of the white flowers are. McKasson started this piece by painting the negative space around the positive flower shapes with clear water. When pigment was added, the wash bloomed and spread until it met dry paper, giving the flowers clean, crisp edges. Thus, even the edges of dark, dense shapes can remain clear. Balanced with the softer wet-into-wet blendings, this creates a dynamic contrast.

Lift Sedimentary Colors

Sedimentary colors can be difficult to work with, but they produce beautiful effects that are sometimes impossible to achieve any other way. Their graininess alone serves to suggest weight and texture perfect for objects such as rocks. This effect can be enhanced by using the lifting qualities of these colors to create patches of light and shadow—without completely changing the texture.

"Sedimentary pigments," says artist Susan McKinnon Rasmussen, "are generally opaque in nature, often drying with a granular, textural quality. Unlike staining colors, which sink into the paper, these pigments sit on top of the paper's surface. If you work an area wet-into-wet, you'll see that the sedimentary pigments stay where they are placed, while the staining colors that you might mix with them tend to run from under-

neath. Notice too how in your water container the staining colors mix in with the water, while the sediments sink to the bottom.

"Glazing over the top of a sedimentary mixture can often result in unwanted streaks or 'mud,' due to the fact that the sedimentary pigment has not been absorbed into the paper and, as such, can easily be moved around. In order to avoid so-called 'mud,' I'm very selective about

In Autumn Confetti *(16¹/₂x29), Rasmussen was able to match the look of separating colors to an appropriate subject: river rocks. Layers of burnt sienna, French ultramarine, and cerulean blue were applied and allowed to separate. Thus, in many rocks, the burnt sienna sparkles through the separations of blue paint to form a shimmer of complementary colors.*

102

where I place my sedimentary colors. I use them strictly as the icing on the cake. If an area can be completed in one layer of paint, then sedimentary pigments are an option. Otherwise, these pigments are used as the last layer of paint to be glazed atop other staining layers. There are times when I feel I must glaze over a sedimentary mixture—perhaps a value needs strengthening or a color altered. In this case, I prewet the whole area with clean water using the softest, largest brush I can. Then, taking care not to disturb the underpainting, I charge in additional pigments with as few brushstrokes as possible.

"Knowing when and how to use these sedimentary pigments can be very beneficial. These colors can be made to work for, rather than against, you. Their nature alone indicates weight and texture, so you should be concerned with matching these pigments to the appropriate subject. In *Autumn Confetti*, I used cerulean blue, French ultramarine, and burnt sienna in various combinations to paint all the rocks. Each rock was painted directly using no further glazes. Cerulean blue and French ultramarine both separate, producing wonderful textural effects so indicative of river rocks. In that both of these pigments have no staining qualities and can be lifted, I was able to use a bristle brush to lift out the sunlit areas and leave the shadows. Applying the paint to a damp surface and lifting while the pigment is still wet allows one more time to manipulate the paint and still end up with a soft-edged shadow. Allowing the paint to completely dry and then lifting off the highlights results in more definite or harder-edged shadows.

"In my painting *Magnolias*, cerulean blue and French ultramarine were again used for their textural effects and their lifting qualities. Magnolia petals have a certain density in comparison to the tissue-thin petals of an iris. A sedimentary mixture can convey this quality to the viewer. Several of the petals on the blossoms were painted first with slight tints of

In this detail, you can see how all of the sedimentary pigment in the light-struck areas on the rocks had been lifted with a damp bristle brush when wet. However, once the wash has dried, lifting with a brush leaves a more distinct edge. Compare the edges of the lights on a range of rocks to get an idea of how dry or wet each area was when the pigment was lifted away.

This detail shows the separation of French ultramarine as the pigment particles settle into the tooth of the paper, leaving a textured area indicative of river rocks.

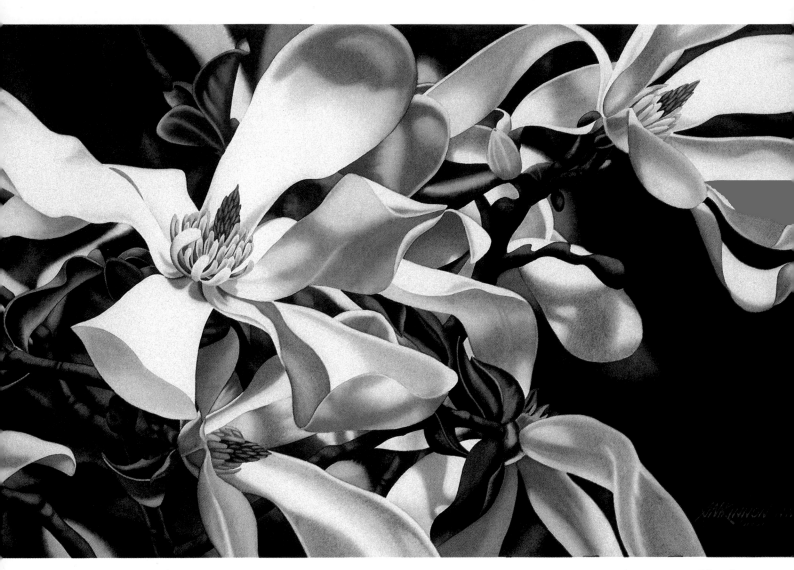

In her painting Magnolias *(18¹/₂x29), Rasmussen chose cerulean blue and French ultramarine for their textural effects and their lifting qualities. A sedimentary mixture such as this will convey the density of magnolia petals to the viewer.*

staining colors and allowed to dry completely. Then, a sedimentary mixture was glazed over the top of the stains, which, when dry, separated, showing the glow of the underpainting. In several other petals you'll see how the permanent rose or rose madder alizarin, which, when mixed with a sedimentary color, seeped from underneath the heavier pigment. This small staining rim makes a nice transition from the white of the paper to the weight of the shadowed area.

"The green area of the flower's stamen was painted with a combination of French ultramarine and new gamboge over an underpainting of

Winsor yellow and brown madder alizarin. Each layer was allowed to completely dry, and then, using a No. 4 bristle brush (bright), the dark-green mixture was lifted off to reveal the yellow underpainting in what might appear to be the finer details of the stamen. This technique works great for indicating veins on the underside of a leaf.

"Sedimentary pigments are wonderful once you understand how to control them. They produce effects that staining colors could never hope to achieve. They certainly have become an important part of my palette and my approach to painting."

This magnolia petal, like several others, was first painted with light tints of staining colors and was allowed to dry completely. Then a sedimentary color was glazed over the top of the stains, which separated when dry, showing the glow of the underpainting. The two colors together create a vivid color contrast and give a realistic texture to the petals.

In this area of the magnolia leaf, rose madder alizarin and French ultramarine were premixed and applied as a wash in just one layer of paint. But because of the different characteristics of the two pigments, the alizarin runs and bleeds from beneath the blue, creating a transitional halo around the area.

In this detail of the flower's stamen, Rasmussen first underpainted in a staining color and then completely overpainted with a sedimentary color. While the wash was still damp, she used a bristle brush to lift the sedimentary color and reveal the staining color underneath. This is also effective for revealing white paper that hasn't been underpainted with a stainer. Since the wash was still damp, this technique allows the edges of the shadows to remain soft.

Glazing for Special Effects

In Tree Forces #2 *(30x22), Lois Schroff used dozens of layers of watercolor to build up the color and flowing forms. Each wash was diluted heavily with water so that, when brushed on, it only tinted the paper. She never applied subsequent washes before the previous layer had dried. This prevented the glazes from mixing and producing less intense color. Throughout the painting, you can see the effects that a transparent veil of color has on the one below it—enhancing the color, neutralizing it, or changing it altogether. This approach provides a way of working that offers maximum control and transparency.*

Y ou can produce a wide range of beautiful effects by building up your paint in layers. You can use this technique, often called "glazing," to convey light and space or the absence of light and space. You can also use these layers to "mix" your paint right on your picture.

In this section, you'll learn how Lois Schroff builds delicate layers of color that glow with light and how Barbara Preston combines underglazes to create a wide range of colors in her finished paintings.

Building Veils of Light

Schroff is a painter who works entirely with a slow, build-up approach to glazing. The pure glazing technique is perfect for Schroff because her goal is to capture the color of pure light as it filters through the atmosphere. She wants us to see in her paintings the color of light behind the atmosphere and in front of it.

You'll notice in her painting on this page that her work shows strong color harmonies and subtle modulations of color. Glazing to build up her colors is what creates the rich glow of light and atmosphere. Schroff's work is very high-key; that is, it's formed predominately with lights and middle tones. Space is created by the use of color (playing on the principle that blues and cool tones recede in space and warmer tones advance). So she's not trying to achieve the deep darks, since color in its most intense saturation is basically a midtone phenomenon.

Schroff starts her work by applying washes of various colors—mainly the most transparent ones, such as cobalt blue, indigo, and purple for the cool tones "behind the strong light" that streams through her painting. (See pages 81-83 for her painting concepts.) In front of the light source, she applies washes and glazes of yellow-green, yellow, orange, vermilion, carmine red and magenta. Again, these are mainly the brilliant, staining pigments.

Schroff works on 90-pound Arches

cold-press watercolor paper, "which provides sufficient tooth, strength, and beauty. . . . When paper is properly stretched, it will remain flat as you apply glazes over and over again. Each one must be thoroughly dry before the next is applied, and each veil of color should be brushed in a slightly different place and shape. Your goal is to weave the colors into a harmonious melody. Because the layers of color are dry and are not disturbed by subsequent washes, each remains transparent, and we look through veil after veil of weaving colors, each in its individual movement and position, creating a luminous whole.

"You may work on an easel with a low gradient (French watercolor easels are good, but expensive)," she says, "or at a tabletop with several blocks under the far end of your board. This keeps the liquid washes and glazes flowing in one direction and results in control of the medium.

"If you must move your board while a wash is wet, keep it elevated in the same direction to prevent fluid areas from running back into a less-wet area and making an unwanted edge. For the early veils in particular, and for the dark areas behind the light, start and end a veil of color with a border of water. This prevents hard edges and allows the colors to play into one another. At a later stage in painting, hard edges may be useful. A hard-edged veil is painted directly without softening the edge with water.

"Begin with very light color. Only enough paint should be added to the water that a veil can be seen after it is dry. Each application of each color should be the same from start to finish, so be sure to mix a sufficient quantity of the desired color to complete the veil. The early veils should be light, and then gradually build up areas of the color with additional glazes, never covering exactly the same area with two glazes. Don't go back into a semidry area seeking to make a correction. Wait until it's

thoroughly dry. You can always correct it with future veils. Remember, the fewer the strokes, the better. Don't brush over and over as in oil painting—this loosens the veils beneath and results in diminished luminosity."

As you begin a painting using this method, keep in mind that you're not only slowly building darker values but also that you have the opportunity to modify your colors. By glazing any two primary colors over one another, you can create secondary and tertiary colors. And by glazing all three primary colors over one another, you can create duller, more neutralized tones. You can also just glaze over a color with its complement to neutralize it.

Manipulating these underglazes into creative color harmonies is an art in itself. First of all, when working in thin glazes on dry paper, you can actually create the color on the paper itself. One glaze after another acts like a tinted sheet of acetate, transforming the color beneath it. For instance, if you apply one wash of aureolin yellow, let it dry thoroughly, and glaze over it with cobalt blue, you'll create a greenish tint. The exact green cast you come up with de-

The setup: Schroff works on a slightly tilted board. This way, each wash of color flows in the same direction. "I find it helpful to put all materials to the right of my paper (I'm right-handed)," Schroff says. "Color can then be squeezed from the tube onto a palette and from there transferred in dabs by brush into small clear or white cups (baby-food jars are good). Then it is diluted with water to make a very fluid mixture of the desired strength."

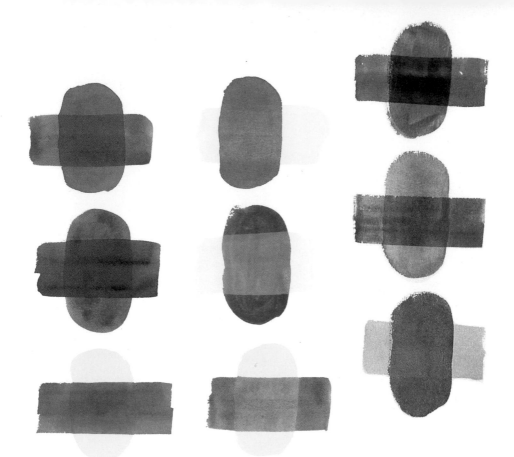

These are the various effects you can get by glazing one primary over another. These examples were made with aureolin yellow, genuine rose madder, and cobalt blue.

When you glaze a color over its complement, you neutralize it. These are just a few examples of the effects this technique produces.

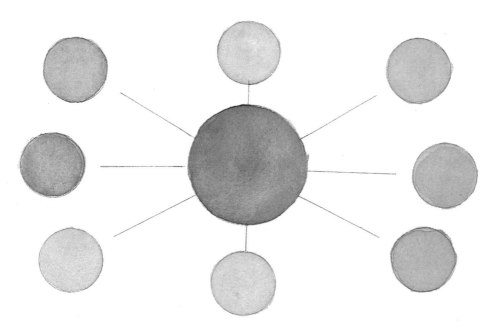

Whenever you layer the three primaries, you're heading toward a neutral color. In the center is a balanced neutral made by layering (wet-into-wet) equal amounts of red, yellow, and blue. To create neutrals with a warm of cool dominance, strengthen one of the primaries by adding more pigment (above and below center). The other circles show the variety of neutrals formed by glazing over dry colors with the neutral mix from the center.

pends on the strength and density of each wash.

Overall, you can glaze two primary colors, one over another, to create secondary colors (green, orange, and violet), or you can glaze all three primaries to create subtle neutral tones. If you glaze red over blue over yellow, however, you'll end up with a true neutral tone only if each glaze is pretty much the exact same strength and density. If one of the primary glazes is made from a stronger mix, the color will remain somewhat neutral but will lean toward that stronger-mix color in dominance. A stronger red glaze will produce a subtle neutral red; the same goes for yellow and blue.

Underglazing

Barbara Preston, a Virginia-based artist, uses glazes primarily to form an underpainting that she manipulates in color and transparency. Preston does her first washes with three primary colors: aureolin yellow, genuine rose madder, and cobalt blue. She starts with this triad of pigments because they have a staining effect on the paper, and they're very transparent compared with other watercolor pigments.

"I use the underglazes," says Preston, "to flow in and around the whites of my paintings. No matter how small the lightest passage is in a watercolor, it will speak the loudest. So it naturally follows that enhancing the whites is important. The underglazes also create a delicate transition from the lightest lights to the more brilliant and 'weighted' parts of the painting. This, too, is important, because I seek to have the eye flow easily through the work."

Since Preston underglazes with only three primaries, she builds her colors in the following manner: "Starting with aureolin yellow, a flat wash is applied in any area of the painting where I plan to develop a yellow, orange or green tone. Then, I let this wash dry completely.

"My second application of the underglaze is the genuine rose mad-

Preston began Red Silk and Butterfly *(21x29) by building up layers of underglazes, using in the following order, aureolin yellow, genuine rose madder and cobalt blue. She made these underglazes flow in and around the whites to provide smooth transitions among areas of the painting and to "punch up" the whites for a subtle contrast. With the underpainting set, Preston was free to build up other colors and values with denser, more opaque pigments for contrast and brilliance.*

der. I apply this wash wherever I want a red area; or I apply it over the yellow areas to create an orange underglaze; or I use it to lay the groundwork for the violet underglazes. Again, this should be applied to thoroughly dry paper.

"The final pigment, cobalt blue, is applied to areas where blue is desired; over yellow for a green tone; or over red areas to create a violet color."

With fairly balanced colors—washes of the same intensity and strength—Preston usually begins the underglazing in the traditional order, from yellow to red to blue. "But a totally different effect can be achieved by glazing in the reverse order. The shimmering effects of going from blue to red to yellow are strikingly different. In addition, any time the paper is dry, I can reapply another glaze to strengthen a primary color or build up a secondary color," she says.

Once Preston has built up the underglazes to the desired depth and

In this detail from the butterfly's wing, you can see how Preston used glazes of rose madder for the background, while the green tint in the wing was created by layering cobalt blue over aureolin yellow. Then, cadmium red and deepened cobalt blue formed the strong colors and darker values that work harmoniously with the underglazes and provide visual punch.

109

Dragonfly *(21x29) is a fairly high-key painting built up primarily with the underglazes. Although the piece is predominantly in a blue color key, layering red, yellow, and blue in various densities and orders created a great range of colors from pure cobalt to blue-greens to neutrals.*

Beachtime and Teatime with Van Gogh *(21x24) demonstrates how you can add deep darks over the underglazes. To capture the darkness and the weight of a lacquered tray, Preston first underglazed the area with four layers of reds and blues. Then, she made a fairly dense mixture of Winsor blue, Winsor green and purple-violet and added a touch of cadmium yellow to produce a rich, deep violet color, which Preston brushed over the area. Wherever the light hit the tray, she allowed the underglaze to show through.*

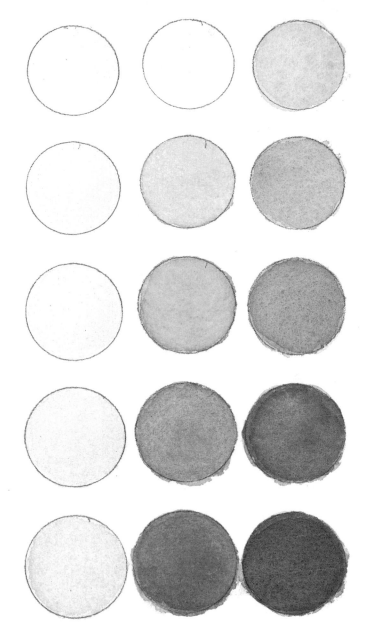

Preston usually begins her paintings with thin layers of the most transparent primaries (top row): cobalt blue, genuine rose madder and aureolin yellow. Then she adds more opaque pigments such as ultramarine blue, cadmium red, and yellow ochre (center row). Then come the intense stainers (bottom row): phthalo blue, alizarin crimson, and new gamboge.

The order in which you layer underglazes greatly affects the final color. The first color applied usually dominates the color layered over it. Therefore, you can create a red-violet or a blue-violet, depending on which color is applied first. The violets, oranges, and greens above lean toward the underlying primary color shown at the top of each square.

The left and right columns show a progression of one, two, four, six, and eight layers of underglazes of the same color. The middle column shows the result of layering glazes of red over yellow. Even if you layer the underglazes two dozen times, light will still reach the white paper and reflect back with a glow.

color, she's free to "pursue painting with a full, unlimited palette using the more opaque pigments for weight and the other intense staining colors for brilliance and power in color."

When the underglazes have established the painting's overall design, value, and color, Preston moves in with the more opaque colors, such as the cadmium pigments, yellow ochre, ultramarine blue, light red oxide, and cerulean blue. These add the final weight and intensity to the painting that give it a full, rich, glowing look.

If you haven't already tried glazing in your own work, consider it as a new way to produce your favorite effects. Or see how it can create a different kind of light and space. Or explore all the possibilities of "mix-ing" your paint right in your picture. Try bringing out the subtle nuances of color in a flower or a sky with different underpaintings. (You might also find this a handy trick for correcting a spot that didn't come out quite right—if it was too light or too blue, for example.)

Viewpoints from Outer Space

You can literally see the effect produced by layering over a grid in Memory (22x22). *You can see both the grid itself and the ambiguous space in which the various images float.*

A s a painter," says Osterman, "I'm very excited about the depiction of outer space. This comes from a shift in observing our world from here on earth to seeing it from outer space." But Osterman's paintings are not views of earth, per se, such as the kind of photographs NASA has shown us of the blue globe with swirling layers of atmosphere. Instead, they are views of pure space that use light, color, and grids to define our viewpoint.

The first problem that Osterman faced in pursuing this concept was in depicting a space that has no horizon or perspective. In terms of viewpoint, this places the viewer in a floating position in space. Our perception of the world is with perspective and a horizon. The basic as-

sumption in painting has been to create viewpoints from the earth. The artist and the viewer are grounded to land; the earth is our overwhelming frame of reference. But by depicting pure space, Osterman has gone beyond that realm to bring us a brand new viewpoint—one from outer space.

In developing this concept, Osterman has moved through several phases of painting that you might want to try. Throughout these stages, she used lines, grids, ovals, and layered watercolor to depict the various effects of outer space.

The first phase was the depiction of pure light. "Space," said Osterman, "is invisible, so I needed to add light to make it visible." The flow of light shows the atmosphere.

Osterman's next phase was to depict outer space, but with light coming from an unknown source or bouncing off of unseen objects. Her painting, *Secrets of Universe IV*, shows this. Here, Osterman has used an underlying grid pattern and layers of transparent color. Without objects, perspective, or horizon, the grid pattern forms a structure in pure space. The colors represent light and its break-up through layers of space.

What does all this have to do with viewpoint? It positions the viewer in a floating space, groundless. It creates light moving from the distance toward the picture plane. And it produces an ambiguity of scale that challenges our sense of distance. At first glance, the layers of space we see in this painting are somewhat compressed; that is, you can perceive layer upon layer. When you look again, you realize that without a frame of reference this seemingly compressed space could represent a vast distance, since light alone has no scale. One of the most significant aspects of this type of painting is that it reconciles the very flat depiction of space favored by some schools of art with the depiction of deep space used by others. The result is rather like having your cake and eating it, too.

In Secrets of the Universe IV *(22x22), Barbara Osterman started with gridded pencil lines on paper, then built up the value and color with layers of transparent watercolor. With no horizon line or perspective to anchor the viewer to earth, space itself becomes the subject of the painting. The individual geometric shapes depict various levels of space as light breaks through it; their value lightens with greater depth as they near an unseen light source, until just a speck of white light peeks through. The only direction the viewer perceives is straight ahead, toward the light: but the pattern of shapes move off all sides of the page, creating what seems to be an unlimited field.*

Intersecting spirals of color in Secrets of the Universe II *(18x22) create an optical illusion, an ambiguity of space. For the most part, the spiral segments remain uniform, changing only in length. Without perspective, only the illusion of overlapping in places creates any frame of reference for space. But the overlapping is not consistent, which creates a constant ambiguity —the rings move in and out as they only relate to each other.*

Layer Color to Make Opaque Areas

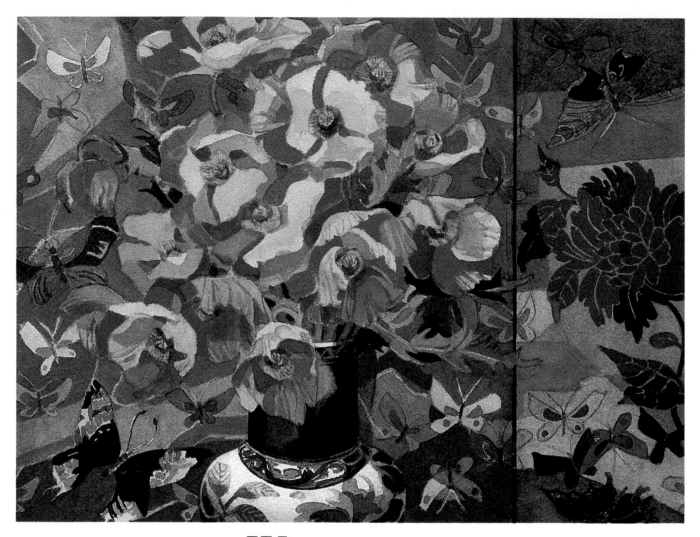

It's the weight of the flowers in Poppies (23x30) that make them appear real. Arne Nyback continued to layer more naturally opaque watercolors over transparent pigments, and used heavier densities to build up that weight.

We most often talk about watercolor as a transparent medium. And it is. But that transparency is a relative description. There are degrees of transparency, depending on the pigments you actually use; some are more or less transparent than others. Artist Arne Nyback prefers to control this transparency in his floral paintings, often building strong opaque passages. This gives flowers—or any other subject you might choose to paint—a certain weight that could well be appropriate for your painting.

Nyback builds opacity in his watercolors in three ways. First, he concentrates on using the more opaque watercolors, such as yellow ochre and raw sienna. Second, he controls the mixing of his washes and layers and combines colors. And third, he says, "If you thin your paint with enough water, the pigment particles will spread apart; the result will be less dense, and more transparent. A very thin wash of even the most opaque color will allow the white paper or the color beneath to show through."

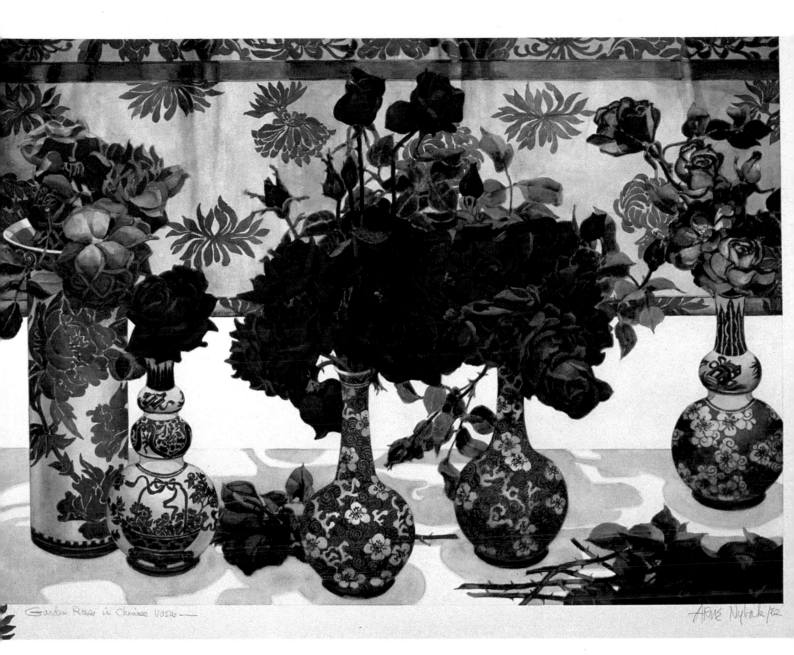

Garden Roses in Chinese Vases — Arne Nyback/82

"How I layer and combine these transparent and opaque paints is what creates exciting color depth. The more layers of color you apply, the more opaque your result will be. But opacity isn't that simple. Which colors you layer is important, too. For example, yellow layered over purple (when dry) will mix optically to form gray. When an earth or opaque color is used in one of the layers, the result will appear even more opaque. But I keep each layer quite thin. What I create is an opacity that's gradually increased. This combina-

"The white in the vases in Garden Roses in Chinese Vases *(29x40) is not the white of the paper, but rather the result of many layers of blue, yellow ochre and Chinese white," says Nyback. "The color in the vases needs to be built up as much as the color in the flowers so that it has the same weight, authority and believability as the rest of the painting."*

tion of layers is like very thin veils of different color placed in a stack. Even through the top veil, you can see the effect of the bottom one.

"Layering not only increases the opacity of the colors, it also enhances the color itself. For example, I might build a rich red by enhancing an alizarin crimson wash with a layer of cadmium orange.

"I use all of these principles separately or in combination in my paintings, depending on the effect I'm building. I also like the emotion and vitality of the lines to show through some areas of the final painting.

"Layering the colors requires planning, so before I begin building the colors, I create a detailed line drawing. After I finish the drawing on paper, I transfer it to Crescent illustration board; hence, I don't have to fasten watercolor paper to a backing when I want to work on it.

"When the transfer is complete, I usually begin my floral works by painting the vase, since it's essential to the structure of the painting. Because I like my flowers to be active, I need something basic to visually contain the movement (the vase provides a stable element that grounds the picture in contrast with the flowing, visual movement of the flowers). These vase shapes are so important to the structure of the painting that before I draw them, I cut them out of heavy paper, like templates. Then I can see how the form of the flowers will relate to the vase."

Once Nyback gets the vase shape he's after, "the way I paint the vase is a microcosm of the way the entire painting is handled. I begin with a light wash of the basic color (usually a transparent pigment) and allow that to dry. Then I alter the color layers until I achieve a density that looks natural for each object. As I apply additional washes, I allow some of the original color to show through for more depth and luminosity." For example, the white in the vases is the result of many layers of blue, yellow ochre, and Chinese white.

Step 1: Nyback first transferred his original drawing for Tulips Posing in Secretness *(30x20) to illustration board by rubbing the back of the drawing paper with graphite and then tracing the lines. The lines of the drawing have such vitality that Nyback lets them show through in certain areas of the final painting. Once the lines were transferred, he began building the vase with a light wash of cobalt blue.*

Step 2: Nyback then painted the porcelain vase with a light wash of yellow ochre and shaded it with a mixture of yellow ochre and cobalt blue. Over that, he added patterns freehand. Then he painted the stems with a wash of cerulean blue and followed that with lighter layers of Winsor yellow, sap green, and more cerulean blue. He used the more opaque colors, since the stems needed a heavy look.

Step 3: Nyback built up the light-valued tulips with approximately fifteen layers of paint so that their opacity would match the weight of the rest of the painting. To build opacity that wouldn't look flat, he layered first ultramarine blue and then Chinese white over yellow ochre.

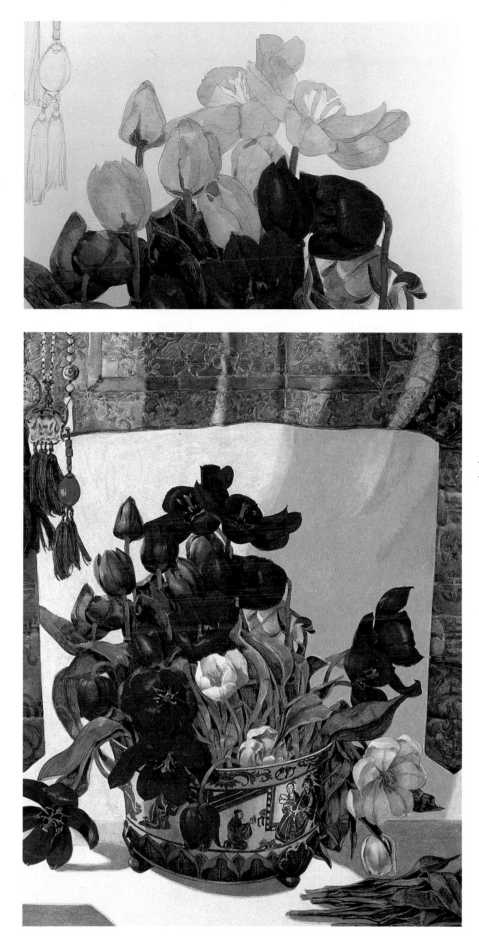

Step 4: The top area of this detail shows the tulips in the initial stage of development; below them, the tulips are closer to their finished state. At top, you can see how transparent the first wash of alizarin crimson is, with pencil lines still showing through. Nyback continued to build the opacity and weight by adding a thin wash of yellow ochre. He then intensified the color with cadmium orange applied thickly so that the brushstrokes would help shape the petals. He used cobalt blue for the shadows. Since blue complements the orange and crimson, they work together to form a slightly gray tone.

Step 5: Although it was painted last, the background provided the important foil to the flower heads. Nyback found it difficult to select the colors for the background, "but I decided on a mixture of cobalt blue, cadmium yellow and Chinese white because these colors blend with others in the composition." The result: Tulips in Secretness, *30x20.*

Photos and research by Sara Richardson.

Drybrush for a Different Look

*T*o use drybrush technique in your watercolor, you simply load your brush with paint, remove the excess, and stroke it over your paper.

With drybrushing, you have a lot of control over where the paint goes and how densely it covers. In addition, you can control the drybrush effect by your choice of paper. Rough paper naturally will allow a rougher, coarser texture; smooth paper will give you less texture and more control and will require more touch with your brush.

When it comes to using drybrush technique you can take two routes. One, as demonstrated by artist Gary Akers, is to use drybrush to add details and refine form. The second approach is to use the drybrush effect as a major part of your painting, establishing mood or theme.

Akers's *Paper Smoke* was painted on Strathmore Bristol 500 Series paper with a five-ply smooth finish. The smooth finish allows Akers to gain greater control over his brush and each minute shape in a drybrush stroke.

"I began the painting with a contour drawing of the subject," said Akers. "Next, with loose watercolor washes of cerulean blue, cadmium red light, yellow ochre, and white acrylic, I blocked in the areas of the face. In the shadow areas of the face I added raw sienna, Hooker's green, and Prussian blue to create a mysterious cool value. These values worked well for contrast against the warm, sunlit areas of the face.

"After the initial warm and cool values were established with loose washes, I used a No. 3 brush to refine the forms with the drybrush technique. When I then apply the brush to paper, many multiple lines are made at once. For me, drybrush then becomes like weaving. I layer these brushstrokes one over the other to develop the form, color, and texture of my subject."

In Paper Smoke *(28x19), Gary Akers used the drybrush technique to enhance the detail and form of the subject. He began with loose watercolor washes to block in the form with warm and cool colors.*

Take a close look at the modeling on the child's face and neck in this detail. You can see the individual brushstrokes made with the drybrush technique. These strokes were built up layer by layer to slowly increase the values. Up close, they also add an exciting texture to the form.

Akers often uses two types of drybrushing. In one (upper right), he wipes excess moisture from the bristles and splays them when he wants to use a rubbing motion for rough-textured areas such as weeds or grass. In the other (lower right), he leaves the brush hairs close together and uses slightly more pigment for detail work.

In B.C. Coast *(22x30), Amy Storey's drybrush technique is not only more obvious than the techniques Akers uses, it's actually a central focus of the painting. She found drybrush to be the perfect answer to her search for a technique that perfectly matched the look of shimmering water. You can see the texture created by the dry brush on dry, rough paper and the visual effect created by brushing from left to right. You can affect the amount of texture your brush creates by controlling the wetness of the paper and the amount of watery painting in your brush. With more pigment in the brush, the strokes are more solid and saturated, giving a more solid coverage of the paper. But as the brush depleted its load of paint, the texture of the paper took over, leaving pigment on the ridges of its rough tooth. In fact, you can create drybrush effects at the end of almost any watercolor stroke for a rough but subtle touch.*

On the other hand, artist Amy Storey used the drybrush technique as a major element in her painting *B.C. Coast*. In this work, the drybrush technique was used to model and define the form of the water with light reflecting off its surface. "While doing a series of tiny landscape paintings," says Storey, "I picked up an old acrylic brush, dipped it in paint, and dragged it across my paper in gentle, steady strokes. Before me was an aspect of the ocean that I recognized, and thus appears in my work.

"I soon found that variations in pressure on the brush and in the wetness of my paint altered the character of the sea, mostly in terms of light."

Paint Dark-to-Light in Three Values

If you're working in a traditional way with watercolor, you might build your value and color using a light-to-dark approach—layering glaze after glaze of color on white paper to slowly deepen the middle tones and then the darks. But artist Roland Roycraft takes a different route. He first paints his darks completely at one time—richly textured areas that define foliage, land, and shadows. Then he paints all the middle tones starting on white paper, which creates the gleaming, transparent atmospheres. Then, all the brilliant lights that have been saved along the way create a radiant glow by contrast. Artist and writer Bee Sloan described the process for us:

"At the conception of each painting, Roycraft does a few thumbnail sketches for form and composition, and from those he creates a precise pencil drawing on his watercolor paper. Then he divides it into its three principle value areas: The darks— those areas of a 60 percent value or more; the middle tones—30 to 60 percent value; and the lights—sky, snow or water reflections where the value range is zero to 30 percent.

"To achieve the spontaneity and looseness in the dark foliage areas, Roycraft applies liquid masking to all of the light *and* middle-tone values so that they remain untouched. He then dilutes the masking fluid 50 percent with water. Straight from the

The contrasting values—light snow against dark foliage—creates the drama in Winterized *(14x21). To create the transparent atmospheric colors, Roland Roycraft pours a sequence of glazes onto the sky and snow areas while the lights are preserved with masking. Moving the glazes by tilting the paper, rather than using a brush, builds the layers without disturbing the colors beneath them.*

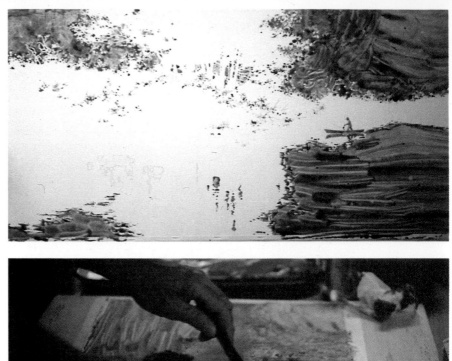

Step 1: After a few thumbnail sketches, Roycraft pencils the major forms onto 140-pound Arches cold-pressed watercolor paper. Then he applies diluted liquid masking to all of the areas that he wants to be a light or midtone area. This enables him to see the major abstract pattern of values.

Step 2: With the lighter areas protected by the masking, he works freely on the darks. Throwing paint from a large, fully loaded brush provides the "accidentals" that visually combine to form leaves and other vegetation. He occasionally uses some salt to give the leaves an out-of-focus look.

Step 3: He continues to add wet-into-wet washes to create interesting runs and color blendings, slowly building the values and forms.

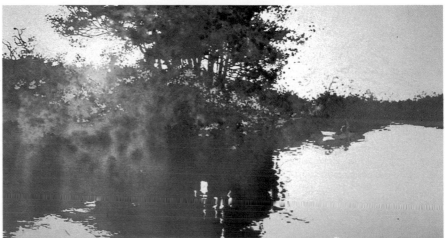

Step 4: When the masking is removed, Roycraft has a lot of visual excitement and spontaneity in predominantly dark values. Yet the painting hasn't lost its clean edges. At this stage, it looks stark, but the middle values are yet to come.

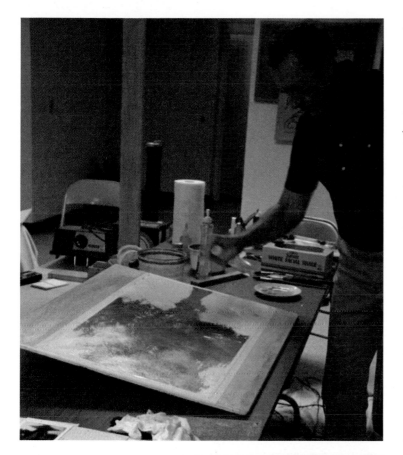

Step 5: Roycraft then masks out all of the light areas of the painting, leaving the darks and the areas to receive midtone colors exposed. When the masking is dry, Roycraft wets the paper with a spray bottle and then pours the colors—yellow first, then red and blue—onto the surface. To keep these transparent colors fluid so he can move them into certain areas, he again uses the spray bottle. He mists the areas where he wants less color, then tilts the paper so that the paint crawls and rolls over the surface with ease. These transparent layers of color create the rich atmospheric look in his paintings.

Step 6: To finish a watercolor, Roycraft removes all of the masking. He then adds the final details—in this case the fishing boat and fisher. He may also use a damp brush to soften some of the hard edges left by the masking.

The Lone Fisherman *(29x10¹/2) is a good study in edges, color, and value transitions. Along the lines of snow in the foreground, the initial layer of masking produces hard, crisp edges. But, keeping with the laws of perspective, the edges blur as the space recedes into the distance. The glazes of Winsor red were poured onto the paper and misted with a spray bottle to warm the background and gently flow forward into space—without disturbing the underlying layers of paint.*

bottle it's too thick to create crisp, fine lines. 'Then, as I apply the masking,' says Roycraft, 'I'm thinking of the light shapes AND the negative spaces between dark shapes, such as the small irregularly shaped light spaces between branches and twigs.'

"Roycraft then brushes, drizzles and splashes on the darks. When the masking is dry, he can get extremely wild with the paint, applying it in any manner conceivable. 'I begin,' he says, 'by forming a pattern of abstract dark shapes that holds the composition together.'

"The masking is then peeled off, and Roycraft evaluates the contrasts. He may lift some of the paint with a sponge, or wash the whole paper under running water to lighten and correct the value. Then come the transitional middle values."

Once the paper has dried, "All the light areas are again masked out with liquid frisket. He uses Winsor yellow, Winsor red, and cobalt blue,

and he pours on washes of these colors from saucers. These colors are very transparent staining pigments that are basically cool in temperature, which is great for glazing layer after layer of outdoor light. Also, by pouring the color instead of brushing it on, he doesn't disturb any existing darks—each layer of poured color just rolls in and lays on top of other ones.

"The washes are applied unmixed. To create secondary colors or to neutralize tones, he simply pours one thin wash over another. Each transparent layer mixes optically. To create a lavender, for example, he might alternate glazes of blue and red until he achieves the effect he wants.

"He usually begins pouring the yellow first, tilting the saucer over the area where he wants the color to be most dense. To spread the wash around without a brush, he uses a spray bottle, misting the areas where he wants less color, and tilting the paper so that color crawls and rolls

over the surface with ease. When he has spread and moved the wash to his satisfaction, he pours the excess paint from the paper and allows it to dry before adding the next primary color. He generally works in a sequence of yellow, red, blue.

"Although he pours and rolls watercolor onto his paper, the results are far from haphazard. With repeated glazing—sometimes as many as ten to fifteen layers—he can create gentle color nuances, rolling each glaze carefully into place. There is, however, room for surprise, as colors flow of their own volition into unexpected shapes. Since there are no brushstrokes to disturb the colors already on the paper, the glazes keep blending and building on each other, remaining brilliant and unmuddied. When the atmosphere is what Roycraft desires, he peels off the masking, and the tree values—light, middle and dark—are apparent. The painting is 80 percent complete.

By breaking the composition down into three values, Roycraft was able to take a visually complicated scene in Stormy Seas *(14x21)—ocean waves with light refracting through them—and simplify it into a strong design. To capture the luminosity of light, Roycraft used a damp brush to soften many of the edges in the foreground, creating a bleached-out effect. The dappling of small highlights are where the last traces of spattered masking were finally lifted.*

NEW TECHNIQUES 5

More Mediums For Your Message

Watercolor painting is more than just pigments and brushes; it's a way of thinking. You mix washes and select the right brushes for the job automatically. You know just how to make a shadow rich, deep, and full of texture. You see scenes in real life or in your mind's eye and think of them in terms of contrasting opaque areas with glowing layers of glaze. The techniques have become second nature. Idea flows automatically into image and image into execution, and that's when the whole process is at its peak.

But sometimes it doesn't all click. The image in your mind just doesn't work when you paint it. You fumble with different colors and brushstrokes, but it's not right. That's when you need to re-examine your concept of what watercolor is and to experiment with new techniques and materials. For instance Paul Melia's developed a vast repertoire of fast and easy techniques based on how well watercolor works with gouache, inks, charcoal, or pencils. Joseph Way takes this a lot further, adding elements like sand (sand!) to his watercolors, for beautiful effects he wouldn't get any other way.

Nancy Blair Closson uses traditional washes and glazes of acrylics instead of watercolor. Acrylic medium layered over watercolor makes painting easier and lets you hold onto parts of your work. It can also give your paintings a unique glowing look, the kind J.D.M. Welborne's have. The emphasis here is on how another medium sympathetically reacts with the watercolor way of working. And I think you'll find acrylics work quite well.

It's a great creative release to do a painting in which you break some—or all—of the rules you've been taught about watercolor. This chapter deals with a little breaking and a lot of stretching of the rules—and some experimenting to find out what works for you and what doesn't.

Hidden Conch *by Nanci Blair Closson (30x40)*

Introduction to Mixed Medium Techniques

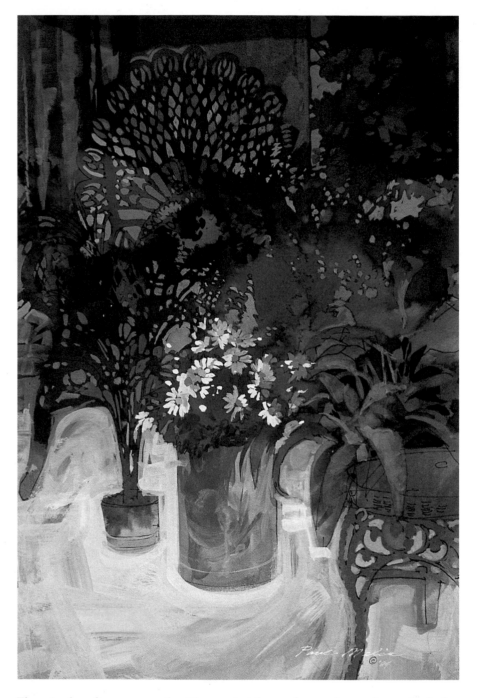

The mixed-medium approach with pastel, inks, and gouache works particularly well with florals because of the exciting contrast between the transparency of the washes that create the blossoms and the opacity of the background. The density of gouache provides a nice foil to the free-flowing, and intense delicacy of the watercolor inks. In this painting, the foliage and other positive shapes were done with the inks. The heavy whites were added freely with a 3-inch brush loaded with white gouache.

The glowing richness and purity of color is the distinctive hallmark of watercolor works. But you'll sometimes find an image in your mind's eye that begs for a different look. Perhaps you envision a portrait with energized pencil lines showing through to symbolize the intense character of the subject. Or you imagine powerful opaque tints and exuberant hues for a harbor scene that begs for an interpretation with gouache and inks. Or you're looking for the control, subtle buildup, and detail that colored pencils can add to a montage of faces and architecture. Whatever direction your thinking takes you, watercolor mixes well with other mediums.

Small changes can bring big results. It takes only the slightest turn to completely change the world you see inside a kaleidoscope. And the same is true of your approach to watercolor. Different mediums produce different effects when mixed together; some are good, and others aren't. There's nothing wrong with combining gouache or colored pencils with watercolor or with each other. Don't let yourself be limited by what you paint with. Do whatever is necessary to get the image out of your mind and onto the paper.

Paul Melia uses a 35mm camera to record images that can then be turned into paintings, and he draws constantly from the figure. "I have files of photographs (and drawings)," says Melia, "and some images are in my subsconscious for several years before they are developed as a painting." Once he locks onto an image, he lets the image itself suggest the meaning of the painting. And this in turn tells him which technique and combination of mediums he'll use.

"Once I have an image to be painted," says Melia, "I work spontaneously and quickly to finalize the image. I don't like to do many sketches—maybe a quick value sketch, but that's all. I like to save all my creative energy in transposing the ideas into the final painting.

"Then, I try to put my thoughts down quickly so that the final painting has energy, spontaneity and a definite life of its own. The time it takes for me to create a painting can vary from three to four hours to three to four days. But, except for very intricate commercial commissions, I rarely spend more than four days on even the most involved paintings."

Let's look at some examples of how Melia turns his ideas into finished pictures.

Pencil and Wash for Quick Portraits

"This is a very spontaneous technique that I use mostly for portraits. I start by using black charcoal pencils (General 4B grade) on 65-pound gray cover stock. I then fix the pencil drawing lightly with a workable matte fixative and paint over it with transparent watercolors and gouache. This is like a modern-day version of underdrawing, which the old masters used, and it works very well for this type of informal portraiture.

"When I start the drawing, I begin by doing the eyes first and then building everything around the eyes. I do this for two reasons. It somehow seems the logical place to start for this type of drawing; and second, the eyes are probably the most important part of the portrait.

"While drawing in this manner, I look for geometric shapes on the face, such as squares, rectangles, circles, and triangles; that is, in the drawing process I don't think about noses, or mouths, or eyes per se. I just concentrate on shapes and their depiction. If I form the correct judgments and my mind is transferring the correct signals to my hands, the squares and rectangles, etc., will turn into noses and mouths and eyes. This is a very exciting way of working.

"I draw with the picture plane at right angles to my eyes, and the paper is drum-mounted on a piece of mount board so that it won't wrinkle too much when I later apply watercolor.

This portrait is a good example of how Paul Melia combines pencil, watercolor, and gouache washes in one study. The portrait was started entirely in pencil, beginning with the eyes. Melia then built up the forms by concentrating on geometric shapes that constitute the face. Notice that the pencil lines are alive and free in key places, such as around the neck area where they emerge from the watercolor. Melia added watercolor washes over the top of the pencil watercolor washes for color and additional form. He added gouache for a few details on the hat.

In this study, the same method was used with pencil and washes, but a different approach makes the form of the face emerge strongly. After depicting the features in pencil, Melia used several applications of dark-valued washes to merge the head with the background. This strong contrast between light and dark places special emphasis on the face and produces its special character.

Step 1: To determine the composition for Tarpon Springs Gulls *(pastel, inks, and gouache), Melia began with quick, loose drawings on pieces of Mylar. Working in the actual scale he wants the painting to be, he positions them to create his composition. Here you can see how these have been overlapped and arranged as well as Melia's notes on position and color.*

Step 2: With the composition established, Melia then drew directly on white, double thick illustration board with dark-valued Nu-pastels. Some of the pastel lines will show through the finished work. The completed drawing was sprayed with workable fixative to keep it from being smeared during the later steps.

"In applying the color, I lay the drawing flat and use large, 3-inch brushes for the background and a 1-inch sable to apply the basic skin tone. I work very quickly because the paper will not stand up to working back into the color. I blow dry the watercolor so that any wrinkles will flatten out. Then, working upright again, I put in the final details of the portrait.

"Although I use some gouache in the painting, these pieces are generally 90 percent transparent watercolor. This type of painting has the advantage of a 'just-sketched,' spontaneous look, and it takes about two hours to finish."

Pastel, Inks, and Gouache Make Rich Paintings

"This technique (using these mediums) is a fun way to work. I use it whenever I want a more 'painted' look or richer, darker colors. The approach works especially well for floral and organic subject matter. It stresses painting negative areas and is a spontaneous, bold and colorful way to work.

"I like to work large (30x40 inches or larger) on double-thick illustration board, such as Crescent #110. Again, a value sketch is about all I'll make. If the composition is very complex, I may compose the painting actual size by drawing on pieces of

paper and Mylar and positioning them on the board. After I have established the composition, I begin to draw directly on the white board with Nu-pastels. If the painting is going to have a low-key (dark) overall look, I'll use black Nu-pastel. If the painting is to be lighter in tone, I'll draw with a lighter pastel. The idea is to choose a color and value that will show through the painting. After I complete the drawing, I spray it with workable fixative and let it dry.

"After making sure the drawing will not smear, I wet the whole surface quickly with clear water and then pour and flow Pelikan special inks right out of the bottle directly

Step 3: The whole surface is then wetted with water, and Melia pours inks right out of the bottle, allowing them to flow freely over the surface of the painting. In some areas, he's used a brush to move the colors around and mix very slightly. Melia does this to tone the whole surface. When he's satisfied with the effects, he blows the painting dry with a hair dryer.

Step 4: After the inks dry, the pastel lines show through and act like a map for the painting. The opaque blue gouache was applied between the lines of the map, allowing the pastel lines and burnt sienna under-painting to create exciting linear elements in a complementary color. The brushstrokes and application are very direct and solid.

onto the surface. The idea is to tone the whole surface area quickly. I then use a brush in certain areas to push the ink around so that the colors flow and intermix, but not too much. This must be done rather quickly and then blown dry to 'freeze' the action of the inks.

"When the inks dry, the pastel drawing shows through very much like a map. Then I fill in the map with gouache or gouache mixed with acrylic soft matte medium. I paint very directly with the gouache, and, depending on whether or not I use the medium, I can go back and lift color or glaze over the top with other tints and shades."

This technique really makes the colors in *Tarpon Springs Gulls* (see page 132) "pop." The variety of textures and the contrasts between the softer pastel areas and the flat opaque gouache passages pull the eye into and across the entire painting. The Pelikan inks give it that classic transparent watercolor glow as well. If you've been feeling that all your work is rather flat or lifeless, maybe this is the cure.

Mixed Mediums for a Broader Range of Color

It's what you say, not how you say it, that's important in painting. Any tool is the right one if it translates

Step 5: *Melia continued painting with applications of gouache. He generally works from large to small shapes, continuing to refine throughout the painting process.*

Step 6: *The finished painting sparkles with light and energy created by the contrasting areas of opaque gouache, the delicate brilliance of the ink, and the dynamic pastel lines showing through in selected places.*

the image in your mind onto the paper. If you're looking for intensity and eye-popping color, it may be simpler and more effective to use mediums other than straight watercolors. "Whenever I want the full spectrum of color, especially when doing commercial assignments," says Melia, "I use this technique in the following four steps. The essence of this technique is in painting dark to light.

Step 1: For the first step, all of the components of the composition are drawn with markers on white illustration board. I use markers in this stage because they can capture incredible detail.

Step 2: Then, after all of the elements have been placed, I wet the surface with clear water and flow and pour Pelikan inks over the surface. Then I blow dry them.

Step 3: I then use the colored pencils to build up color and tone. Colored pencil adds an interesting, dry-brushed-looking texture to the painting, which particularly fits architectural subjects.

Step 4: After I apply the colored pencil, I paint over with gouache wherever I need to strengthen lights and define shapes.

While the most immediate results can be seen in your finished paintings, there may be unexpected dividends to continually experimenting with various mediums and techniques. "The various styles and techniques that I use constantly force me to be flexible, so that I approach things from a different perspective each time I paint," Melia says. "This, I hope, keeps me from becoming repetitive and falling into the trap of painting by formula and becoming stale."

Melia began this piece by drawing with markers on white illustration board to capture the many details. Once all the elements were in place, he wet the surface with clear water, pouring Pelikan inks over it, allowing them to flow. Then the painting was blown dry. Next, Melia used colored pencils to build up color and tone. This technique is especially appropriate to architectural subjects such as this one. Finally, he used gouache to strengthen lights and define shapes.

Soft-edge Acrylic Layers

In Ocean Series: Deep Blue *(22x30), you'll find a variety of hard and soft edges. The hard edges were masked out by tape, the softer edges by starch. The hazy acrylic forms are built up in layers of shapes, and as with the large dark area on the right, shapes are added between the background and foreground to condense the space in the painting, pushing the background forward. Notice the Rapidograph ink lines that show through the acrylic washes, adding a linear element that's repeated in various areas, tying the painting together.*

anci Blair Closson started out as a traditional watercolorist, working strictly with transparent pigments on white paper. But later on in her career she decided to make the change to acrylic watercolors; that is, acrylics applied in washes on watercolor paper. Her acrylic watercolors are built up in layers in a way that creates the look of hazy, soft-edged forms floating over hard-edged forms, and vice versa. The technique and the results are surprisingly close to those of transparent watercolor.

"I used pure watercolor when I first began to paint," says Closson, "but the aspect I liked least about it was that it could be rubbed off the surface of the paper. It allowed me almost too much leeway in decisions

for change. Acrylics, on the other hand, can be lifted while still wet or damp, but once they're dry, I know that whatever is down on paper will stay there and become a permanent part of the finished piece. Because of this, it was at first more difficult for me to use acrylics; I trashed a good number of pieces because I had paint where I later didn't want it. But I've always painted with the idea that less is more, and I try to leave plenty of virgin, untouched white areas when working with acrylics. I also spend much more time making decisions regarding what to leave out, instead of what to put in. A major part of painting for me is the time spent thinking. In fact, a painting for me can be two-thirds thinking and one-third execution."

To create the hazy form-over-form look in her paintings, Closson works on 300-pound Arches cold-press watercolor paper. "Less heavy paper will not withstand repeated soakings," she says. Closson then applies masking tape to produce hard edges and brushes on liquid starch. Like the tape, the starch acts as a resist to the acrylic paint, blocking it out for some areas. In addition, the starch generally doesn't leave a sharp-edged white area but will allow the watercolor to slide and mottle at the edges, similar to the way washes might resist unstretched watercolor paper.

"After the starch is dry," says Closson, "the entire paper is sponged wet [only soaking will remove starch, although wetting the paper may loosen it at the edges] and my first application of pigments is applied. This is done either by pouring the paint for large areas or using a No. 5 or 6 sable round.

"For mixing washes, I water down Grumbacher and Liquitex tube acrylics, and Golden brand 'liquid' acrylics; each has its own unique characteristics. For instance, the Golden acrylics don't bleed in the same way as the tube acrylics; they may leave a more jagged edge if the paper is the right wetness.

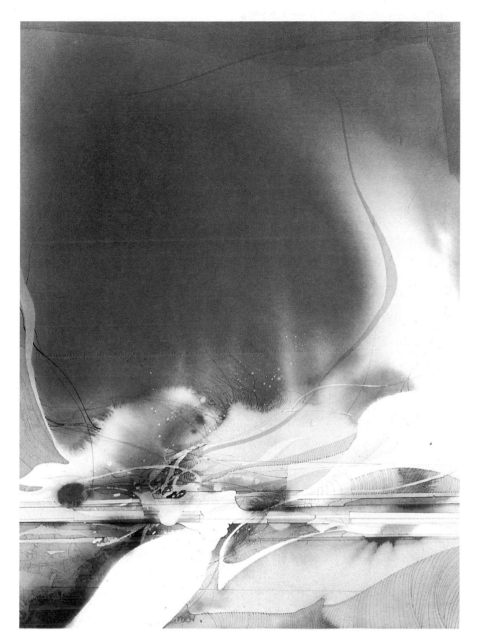

Soaking off and reapplying starch lets you create some very dramatic effects. Float (40x30) shows some clever uses of this technique. You'll find both clearly defined and very hazy whites here as well as an interesting area at the bottom of the painting, where a strong white area rests on one that has received some color.

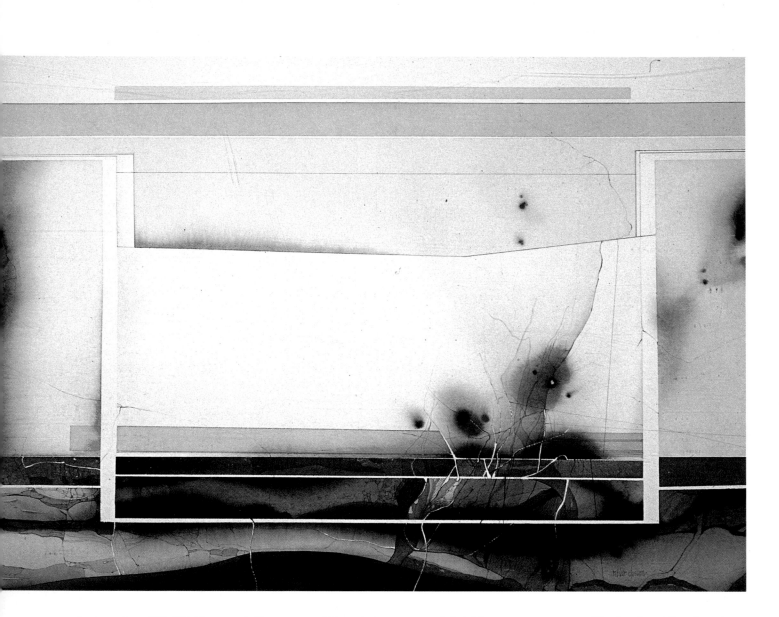

In Aquarium *(22x30) it's especially easy to see the hard-over-soft-edged effect. Nanci Blair Closson created the very thin white lines by cutting the painting with a sharp knife. You'll get thinner, crisper whites this way than by using opaque white and a thin brush.*

"The whole process of finishing an acrylic watercolor, then, involves a series of taping, wetting, applying washes, allowing them to dry, then repeating the process several times. Finally, the starch is then soaked off with plenty of water, and whites or hazy whites will then appear depending on the stage at which the starch is soaked off. Starch can also be re-applied and, after drying, the paper rewet and washes again added. This (layering) process is what produces the hard-over-soft-edged effect with the hazy forms floating in and out.

"I apply Rapidograph ink lines at later stages to define edges and details where I want them. These lines are very effective in adding just the touch of detail to establish a more condensed background space. That is, instead of simply creating a foreground and background, I often incorporate into the painting shapes that are in the distance, that seem to emerge from the background, but that condense that space, bringing it closer to the viewer. (See *Ocean Series: Deep Blue*, page 134.)

"This is how I achieve the look of one transparent form over another. But during all these stages, it's necessary to use plenty of 'think' time to decide which forms will be defined and which will remain hazy and phased out."

Three Ways to Use Acrylic Medium

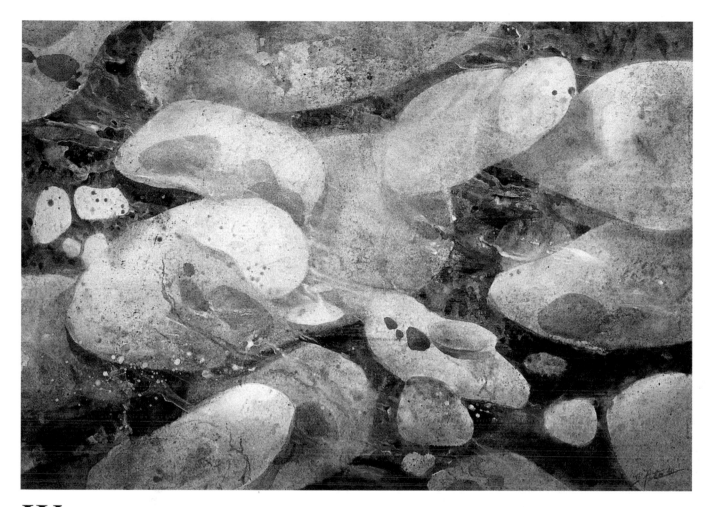

Watercolor by its very nature is an unstable medium in the sense that it can be resoluble. Because it lifts and melts so easily, layers of color can mix unexpectedly, creating a muddy amorphous statement that lacks any power or punch. This problem has led to artists describing watercolor as an "unforgiving" and "one-shot" medium. There is a simple solution, however. Acrylic medium, when applied over layers of watercolor, can act like a transparent barrier protecting your underpainting, allowing you to add more paint to a surface that's clear and locked into place. This doesn't mean you have to give up the look of glowing, transparent watercolor either, as you'll see in this section.

In Underwater Rocks, *Diane Peters found the perfect marriage of content and technique. "I was engrossed with the clarity and fresh color of pebbles under water and the action of the river rippling over top." She started the painting with transparent watercolor, using "loose" washes in some areas. She then let the painting dry completely before applying a fifty-fifty mixture of water and acrylic medium to form an impermeable, transparent barrier over the whole painting. That locked the washes into place and allowed her to add more layers of watercolor without disturbing the underpainting. Finally, Peters made a thin mixture of water and gesso and poured it across the painting in the direction of the water flow. With the layered buildup of watercolor, acrylic barrier, and gesso, she created the translucent look of seeing through water.*

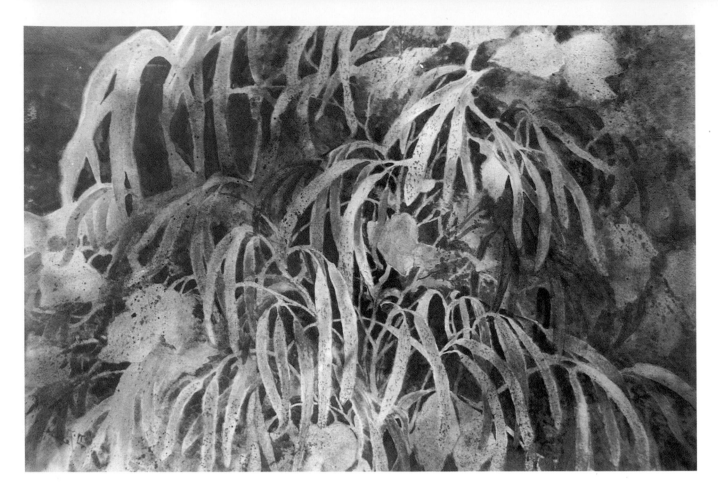

In Cocks Comb *(30x40), Peters first soaked her paper, then splashed washes of color over a previously drawn sketch. After this had dried, the entire painting was covered with an acrylic barrier and allowed to dry again. She then did a lot of negative painting with loose washes around the plant leaves. The light-red tints on the leaves were washed over the top of the medium to produce a rich glowing color.*

Lock in Color

The key to this technique is knowing when to apply the acrylic medium. Once you've locked your underpainting into place, there's little chance of making corrections or modifying your underpainting. You do need a concept and an idea of where the painting is heading. Diane Peters, who uses acrylic medium extensively has found that the "prepainting," or "psyching-up" stages are the most difficult and necessary part of a successful painting. Peters offered some tips to help you "psych-up":

1. Find the subject you have some strong feeling about.
2. Get to know the subject well through your sense: touch it, smell it, etc.
3. Choose colors that reflect the mood of what you're saying about your subject.
4. Next to the sketch in your sketchbook, write all the adjectives that describe what you're trying to portray, such as cold, sunny, etc.
5. Make a value sketch and work out the color chords.

"In other words, digest your subject before you even begin to paint," Peters says. "Each painting should have a dominant mood and theme, with everything else subordinate to it."

With a loose but clear plan, you'll have a better idea when to lock in on your painting. Peters begins work on paintings such as *Underwater Rocks* (see page 137) by first soaking her paper thoroughly with water. Then she splashes washes and color over her previously drawn sketch. This allows her to take advantage of interesting color runs and bleeds and to create a loose, undefined statement.

Once the washes have dried, she locks them into place by coating the entire surface with a mixture of one-half water and one-half acrylic matte medium and allows this coat to dry thoroughly. The medium creates an effective, transparent barrier that she can then paint over. Using the matte medium rather than the gloss helps to prevent the shiny glare or any reflection that would be more characteristic of an oil painting than a watercolor. Then Peters proceeds to paint the

138

negative spaces surrounding her subject to create definition and depth.

You'll also want to experiment a bit, finding out what happens when washes are applied over the top of the acrylic barrier. Depending on the density of the medium and your watercolor, the paint could sit up on the surface and slide around, or it could quickly settle into the valleys created by the paper's texture. My only caution is that a surface with too heavy a coat of medium could cause some problems with your watercolor's adhering well to this surface. Try to leave a bit of the paper's tooth and mix the medium with water to keep it fairly thin. The tooth will harden up, but will still provide plenty of small recessions for the watercolor pigment to nestle in.

In essence, you can use acrylic medium to "freeze" parts of your painting in progress. You might consider experimenting by applying the medium only to portions of your painting for various effects, making use of the resist quality of thick passages. Just remember that you can't make changes to the underpainting once you've applied the protective barrier.

Acrylic Barrier for Backlighting

By backlighting your scene, you can create silhouette effects that are great, especially when working with the shapes of the figure; silhouetted people with few details can create a sense of mystery and mood. But J.D. Wellborn doesn't stop there. By matching the right techniques with the backlit design, she works toward a transparent "light transmission" that gives the glow and overall surface energy to her paintings. She uses acrylic medium to create the illusion that light is generated in the back of the painting and flows through the underlying layers of paint to the surface and on to the viewer.

This all adds up to paintings that have a very strong sense of design—paintings that lend themselves to de-

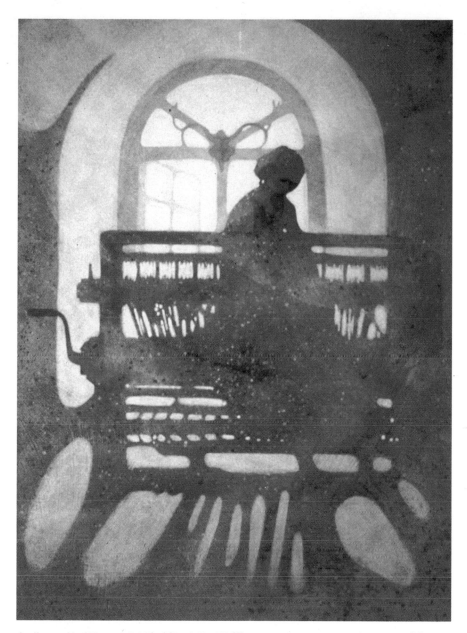

In Santa Fe Weaver 1 (40x30), J.D. Wellborn creates a mysterious mood by using backlighting and "light transmission." The backlighting enables her to create strong silhouette shapes and merge shadows and figures into large, overall patterns that build a strong composition. To counterbalance the fact that little three-dimensional modeling is done, Wellborn developed a surface that seems to radiate light—her colors apparently glowing from within the surface of the painting. In addition, free-flowing washes, wet-into-wet blendings, and spattering create the lively surface textures and visual excitement.

139

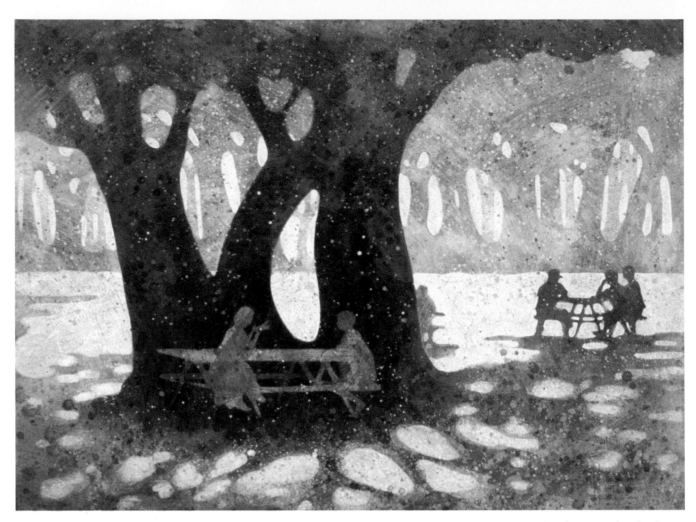

sign through the light-dark patterns you're able to create. Look at Wellborn's painting, *Santa Fe Weaver I* (see page 139), and you'll see that the silhouetted figure, the weaving components and the approaching shadows all merge into one shape that forms delightful patterns against the light. And Wellborn is able to capture a very still, quiet moment that freezes the activity of the solitary weaver at her craft.

Wellborn generally works on heavy (550-pound) handmade watercolor paper and begins with very thin, transparent acrylic washes to establish the broad, overall shapes and forms. She works the initial underpainting either wet-into-wet or wet-over-dry washes, basically pushing the paint around until the piece "feels" right.

Then she often applies a barrier of acrylic matte medium, brushing over the entire painting with the medium. The brushstrokes establish an underlying texture that shows through in the final piece, giving the painting a lively variety in texture. The acrylic

The acrylic barrier/texturing technique was also used for Conversation in the Park *(30x40). After she applied the initial loose, transparent washes, she brushed a heavy coating of acrylic matte medium over the entire surface of the painting. When dry, the brush marks create interesting textures and a fairly slick surface on which additional acrylic washes will puddle and shift.*

In this detail, you can see the texture of the painting created by the layer of acrylic medium and the layers of acrylic washes and spatterings.

medium barrier also enables her to manipulate the succeeding paint layers in ways that would be more difficult if the underpainting weren't protected.

On top of the acrylic barrier, Welborn adds mainly transparent washes, and drops of color in different densities, and a fair amount of spattering. But because of the acrylic barrier, she's able to create color flows, wiping it away and blotting, and adding thin transparent washes. This loose buildup creates delicate color harmonies, a vibrant surface, and an internal glow of light.

Diane Peters uses acrylic medium with collage papers in her watercolors. "I can start these paintings with a transparent watercolor wash over a brief sketch," she says. "Then I be-

gin to formulate colored patterns with previously tinted rice paper scraps, which are glued onto the painting with the matte medium. With this process, you can work layer upon layer to form a painting." Depending on the thickness of the rice paper, it will retain some transparency, which will enable you to layer and modify colors. This method can also be used over unsuccessful watercolor attempts.

There don't have to be any limits on your creativity; you just have to be open to all the ideas and techniques you can find. What should be important is what you want to say or show in your paintings. Then look at all the different ways you can express yourself, and pick the one that works best in each case.

In Fourth of July *(30x40), Diane Peters combined watercolor and collage. She first applied the light washes of color to create the light-valued areas. Then, scraps of previously-tinted rice paper were attached to the surface with acrylic medium, forming the colorful darks. The rice paper in these areas retained its transparency. Acrylic medium was then applied over the rice paper, and additional washes over that brought the painting to completion.*

Innovative
Layers

In Double Fugue *(24x38), Joseph Way employed nearly the entire range of techniques in his painting process. Starting with an underpainting, he then added additional layers of watercolor before covering the entire wet painting with a layer of sand and salt. The salt draws the damp pigments from parts of the painting, but the sand holds others in place, creating a frosted effect (like that of frost on the windowpane). The French curves in this piece were painted in the underpainting, then retained throughout the painting process.*

What is watercolor painting? It can be more than working with only watercolor paints and water. You can add other mediums such as ink, or acrylic, or gouache—or all of them together. You can apply salt or acrylic medium or collage elements such as paper or string. You can even layer all these elements together in what Joseph Way describes as a "polyphonic" composition, a musical term suggesting layers of melodies and harmonies coming together in a single whole.

Way's abstract pieces are built up with layers of paint, salt, and sand. The unusual texture creates a complex spatial sense of movements in several different areas. Although they are not "pure" watercolor paintings, they are watercolors. Way has "arrived at ways of working with water-

color paint on paper that, though quite different from the usual application and use, is nonetheless unique to the medium and virtually untransposable to other types of paint and surface."

Way often works on Arches coldpress 140-pound paper in various size sheets, as well as rolls for large-scale works (many of his paintings measure 40x60 inches and *Arimathean Rag* measures 44x78). "I mount the paper on a sheet of plywood (thus the largest single size paper I can use is 4 feet × 8 feet) by means of staples. I usually staple the paper down dry so that when it is wetted, being stapled will make it buckle, forming hills and valleys, so to speak, like a miniature landscape. Then I put a border of masking tape around the perimeter of the paper. The paper will be stretched, either wet or dry, numerous times during the entire painting process."

For the first stage of painting, Way works on the dry, masked-off paper, applying an underpainting. "This (preliminary painting) is meant to be seen through the subsequent layers of paint in this multilayered approach. Geometric shapes, biomorphic shapes, lines of various widths and color form this stage of the painting."

In the preliminary and later stages of painting, he selects pigments based on their sedimentary or staining characteristics to contribute to the multilayered surface. Way uses "Winsor & Newton transparent watercolor. Along with using the paint from the tube and mixing it with water, I also squeeze out paint from the tube into dishes or onto a plastic palette and allow the paint to dry out, so that I can use it in conjunction with brushes and sponges."

After the initial underpainting has dried ("I often use a hairdryer to speed up this process"), Way proceeds to the "background" layer of paint. "The next layer I apply with large, wide flat wash brushes. This paint has been premixed with water in large bowls. The application of

The texture in the upper left portion of this detail from Kirlian Suite #7 *was created by stamping leaves, scraps of paper, and other texturing devices into the wet paint for various effects.*

143

In Pangaea *(38¹/2x60), Way used masking and lifting techniques to create the triangle forms floating throughout the painting. First, masking tape was applied to the area, then the triangles were cut and lifted off. Next, the topmost layers of paint were lifted with a damp brush. Although not shown here, these areas can be tinted or shaded with color with a sponge to give an even tone without unwanted blending or additional lifting.*

this layer, which will appear as the 'background' of sorts in the finished painting, must be applied quickly. The colors can range from a light sandy burnt umber to something as dark as black. I usually work on this stage of the painting outdoors. After I've brushed on this coat of paint, I can press on or into it while it's still wet leaves that I've painted or scraps of old paintings or paper of various kinds.''

The next stage of Way's painting actually produces the surface depth and texture that make his paintings stand out. ''I cover the entire wet painting with a layer of 'playground' sand and Kosher salt. The salt ab-

sorbs the water from the paint, forming patterns like frost, depending on the amount of salt. The sand holds the wet paint in place as it dries. I then spray the salt- and sand-covered painting with a plant mister or atomizer. I can now draw into this wet sand/salt with the wooden end of a paint brush, as you might draw into wet sand at the beach. I further spray clean water into these channels, creating distinct linework. At this stage I can also spatter paint or clean water onto the sand-covered surface, forming 'impact craters' around the periphery, or introduce other colors into the sand. I then allow this to dry. Slow or rapid drying will affect the outcome.

"When the paper and the sand/salt mixture have dried, I carefully remove it by scraping it off with a knife and/or by brushing it with a wallpaper brush. This part I imagine to be like an archeologist uncovering an ancient floor or wall. The painting will have a stonelike glint from the salt.

"After removing all of the sand/salt mixture (which I always save, since the sand and salt have picked up color from the paint, which can be used in subsequent works), I'll usually restretch the painting to remove unwanted buckles. I do this by removing the masking tape and staples and laying the painting face down on terry-cloth towels. I use a plant mister to spray the paper with water and allow it to become wet, making sure to mop up any excess water that puddles on the paper. When the paper is sufficiently wet, I turn it back over onto the plywood board, staple it back into place, and allow it to dry.

"The next stage, or layer, of painting involves masking and removing paint. First, I'll mask the borders of the restretched painting with masking tape. I also use the tape to mask off

Stage 1: Way starts a painting with flat, masked-off shapes—lines of various widths and geometric shapes. In this panel from what will be a four-piece painting, you can see the simplicity of shapes and color. These areas will be covered over, but most will show through in the final painting.

Stage 2: Working outdoors, Way covers all the panels with washes and puddles and blues and blacks, with the underpainting showing through only slightly in areas.

145

areas, lines, and various shapes, cutting and tearing the tape into shapes. The paint in areas that are unmasked are then lifted with a wet sponge. My intent is to remove only the topmost layer of paint, revealing the colors and shapes that lie submerged beneath it. All of the small triangles in *Pangaea* were revealed in this manner.

"The areas where paint has been removed will be lighter than their surroundings, and they can be tinted with other colors or made into darker shapes that seem to float across the painting. I usually apply the paint to these masked areas with a sponge. I never use an airbrush or masking fluid in any of my paintings.

"As yet another layer in these works, I often apply gold leaf, usually in the form of tiny geometric shapes or hairlike lines. There is often an interplay of real 22k gold with the 'fake' gold and silver of sumi watercolor paints, i.e., bronze and aluminum powders. The gold doesn't often show in the photographs, but its glint forces the viewer to move and to change position in relation to the painting.

"While working on these paintings, I always visualize them in my mind with their covering of glass. Glass, which unfortunately puts people off because of its glare, is the final layer enhancing the idea of multi-layered images, moving at different velocities, sometimes reinforcing, sometimes contradicting and obscuring each other. The discrete layers can be viewed independently or as a whole. Tiny areas are meticulously masked and painted with great distances between them like telescopic or microscopic views, aerial landscapes, the ground immediately at our feet, the moving landscape through the windshield. These are the things I've tried to present through these paintings."

Stage 3: All four of the panels have been covered with the sand/salt mixture and paint and water splashed and spattered onto the sand-covered painting. Note how the drops of liquid have formed "craters," which will show up later in the painting. At this point, Way drew lines into the wet sand with a brush handle. Then he sprayed clean water through the channel to lift paint and create lighter-value lines.

Stage 4: After the sand/salt mixture and the paper have dried completely, Way used a soft brush and a knife to scrape away the mixture and reveal the image.

Here's a spiral drawn into the wet sand in Stage 4 after the salt/sand mixture has been completely removed.

Here's a panel at about 90 percent completion. "This forms the background for which will undergo other painting applications/removal stages before coming to completion as a multi-layered Paper Fugue, *says Way.*

INDEX

Improve your skills, learn a new technique, with these additional books from North Light

Art & Activity Books For Kids

Draw!, by Kim Solga $11.95
Paint!, by Kim Solga $11.95
Make Clothes Fun!, by Kim Solga $11.95
Make Prints!, by Kim Solga $11.95
Make Gifts!, by Kim Solga $11.95
Make Sculptures!, by Kim Solga $11.95

Watercolor

Basic Watercolor Techniques, edited by Greg Albert & Rachel Wolf $14.95 (paper)
Buildings in Watercolor, by Richard S. Taylor $24.95 (paper)
The Complete Watercolor Book, by Wendon Blake $29.95 (cloth)
Fill Your Watercolors with Light and Color, by Roland Roycraft $28.95 (cloth)
Flower Painting, by Paul Riley $27.95 (cloth)
How To Make Watercolor Work for You, by Frank Nofer $27.95 (cloth)
Jan Kunz Watercolor Techniques Workbook 1: Painting the Still Life, by Jan Kunz $12.95 (paper)
Jan Kunz Watercolor Techniques Workbook 2: Painting Children's Portraits, by Jan Kunz $12.95 (paper)
Painting Nature's Details in Watercolor, by Cathy Johnson $21.95 (paper)
Painting Watercolor Portraits That Glow, by Jan Kunz $27.95 (cloth)
Splash I, edited by Greg Albert & Rachel Wolf $29.95
Starting with Watercolor, by Rowland Hilder $12.50 (cloth)
Tony Couch Watercolor Techniques, by Tony Couch $14.95 (paper)
Watercolor Impressionists, edited by Ron Ranson $45.00 (cloth)
Watercolor Painter's Solution Book, by Angela Gair $19.95 (paper)
Watercolor Painter's Pocket Palette, edited by Moira Clinch $15.95 (cloth)
Watercolor: Painting Smart, by Al Stine $27.95 (cloth)
Watercolor Workbook: Zoltan Szabo Paints Landscapes, by Zoltan Szabo $13.95 (paper)
Watercolor Workbook: Zoltan Szabo Paints Nature, by Zoltan Szabo $13.95 (paper)

Watercolor Workbook, by Bud Biggs & Lois Marshall $21.95 (paper)
Watercolor: You Can Do It!, by Tony Couch $27.95 (cloth)
Webb on Watercolor, by Frank Webb $29.95 (cloth)
The Wilcox Guide to the Best Watercolor Paints, by Michael Wilcox $24.95 (paper)

Mixed Media

The Artist's Complete Health & Safety Guide, by Monona Rossol $16.95 (paper)
The Artist's Guide to Using Color, by Wendon Blake $27.95 (cloth)
Basic Drawing Techniques, edited by Greg Albert & Rachel Wolf $14.95 (paper)
Blue and Yellow Don't Make Green, by Michael Wilcox $24.95 (cloth)
Bodyworks: A Visual Guide to Drawing the Figure, by Marbury Hill Brown $24.95 (cloth)
Business & Legal Forms for Fine Artists, by Tad Crawford $4.95 (paper)
Capturing Light & Color with Pastel, by Doug Dawson $27.95 (cloth)
Colored Pencil Drawing Techniques, by Iain Hutton-Jamieson $24.95 (cloth)
The Complete Acrylic Painting Book, by Wendon Blake $29.95 (cloth)
The Complete Book of Silk Painting, by Diane Tuckman & Jan Janas $24.95 (cloth)
The Complete Colored Pencil Book, by Bernard Poulin $27.95 (cloth)
The Complete Guide to Screenprinting, by Brad Faine $24.95 (cloth)
The Creative Artist, by Nita Leland $27.95 (cloth)
Creative Basketmaking, by Lois Walpole $12.95 (cloth)
Creative Painting with Pastel, by Carole Katchen $27.95 (cloth)
Decorative Painting for Children's Rooms, by Rosie Fisher $10.50 (cloth)
The Dough Book, by Toni Bergli Joner $15.95 (cloth)
Drawing & Painting Animals, by Cecile Curtis $26.95 (cloth)
Exploring Color, by Nita Leland $24.95 (paper)

Festive Folding, by Paul Jackson $17.95 (cloth)
Fine Artist's Guide to Showing & Selling Your Work, by Sally Price Davis $17.95 (paper)
Getting Started in Drawing, by Wendon Blake $24.95
The Half Hour Painter, by Alwyn Crawshaw $19.95 (paper)
Handtinting Photographs, by Martin and Colbeck $28.95 (cloth)
How to Paint Living Portraits, by Roberta Carter Clark $27.95 (cloth)
How to Succeed As An Artist In Your Hometown, by Stewart P. Biehl $24.95 (paper)
Introduction to Batik, by Griffin & Holmes $9.95 (paper)
Keys to Drawing, by Bert Dodson $21.95 (paper)
Master Strokes, by Jennifer Bennell $27.95 (cloth)
The North Light Illustrated Book of Painting Techniques, by Elizabeth Tate $27.95 (cloth)
Oil Painting: Develop Your Natural Ability, by Charles Sovek $27.95
Painting Floral Still Lifes, by Joyce Pike $19.95 (paper)
Painting Flowers with Joyce Pike, by Joyce Pike $27.95 (cloth)
Painting Landscapes in Oils, by Mary Anna Goetz $27.95 (cloth)
Painting More Than the Eye Can See, by Robert Wade $29.95 (cloth)
Painting Seascapes in Sharp Focus, by Lin Seslar $22.95 (paper)
Painting the Beauty of Flowers with Oils, by Pat Moran $27.95 (cloth)
Pastel Painting Techniques, by Guy Roddon $19.95 (paper)
The Pencil, by Paul Calle $19.95 (paper)
Perspective Without Pain, by Phil Metzger $19.95 (paper)
Putting People in Your Paintings, by J. Everett Draper $19.95 (paper)
Realistic Figure Drawing, by Joseph Sheppard $19.95 (paper)
Tonal Values: How to See Them, How to Paint Them, by Angela Gair $19.95 (paper)